RYOKO AOKI

YISO BAHC

CAI GUO-QIANG

CAO FEI

FLYINGCITY URBANISM RESEARCH GROUP

HIROSHI FUJI

G8 PUBLIC RELATIONS AND ART CONSULTATION CORPORATION

HUNG YI

HEE-JEONG JANG

SOUN-GUI KIM

KIM YOUNG JIN

LEUNG MEE PING

MICHAEL LIN

MITSUSHIMA TAKAYUKI

SHAO YINONG AND MUCHEN

WILSON SHIEH

TADASU TAKAMINE

WANG JIANWEI

WANG QINGSONG

YANG FUDONG

YANGJIANG CALLIGRAPHY GROUP

SHIZUKA YOKOMIZO

PAST IN REVERSE
CONTEMPORARY ART OF EAST ASIA

Essays by:

Betti-Sue Hertz
Taehi Kang
Li Xianting
Midori Matsui
Zhang Zhaohui

Curated by:

Betti-Sue Hertz

In memory of Yiso Bahc (1957–2004), a dear friend and innovative artist and thinker, who steered

us toward experiences of the ephemeral and reminded us of the fragility of time and memory.

Past in Reverse: Contemporary Art of East Asia
Exhibition organized by Betti-Sue Hertz
San Diego Museum of Art
November 6, 2004–March 6, 2005

Kemper Museum of Contemporary Art
Kansas City, Missouri
June 3–September 4, 2005

Hood Museum of Art, Dartmouth College
Hanover, New Hampshire
January 15–March 12, 2006

Library of Congress Cataloging-in-Publication Data
Past in reverse : contemporary art of East Asia / essays by Betti-Sue Hertz
... [et al.] ; curated by Betti-Sue Hertz.
 p. cm.
 Catalog of an exhibition at the San Diego Museum of Art, Nov. 6– Mar. 6, 2005; Kemper Museum of Contemporary Art, Kansas City, Mo., June 3–Sept. 2005; Hood Museum of Art, Dartmouth College, Hanover, N.H., Jan. 15–Mar. 12, 2006.
 ISBN 0-937108-33-2 (alk. paper)
 1. Art, East Asian–20th century–Exhibitions. 2. Art, East Asian–21st century–Exhibitions. 3. East and West in art–Exhibitions. I. Hertz, Betti-Sue. II. San Diego Museum of Art. III. Kemper Museum of Contemporary Art & Design. IV. Hood Museum of Art.
 N7336.P37 2004
 709'.5'074794985–dc22
2004018893

Production Manager: Susannah Stringam
Project Assistant: Lucia Sanroman
Designer: Dan Meza
Editor: Michelle Piranio

This exhibition is made possible by an Emily Hall Tremaine Exhibition Award. The Exhibition Award program was founded in 1998 to honor Emily Hall Tremaine. It rewards innovation and experimentation among curators by supporting thematic exhibitions that challenge audiences and expand the boundaries of contemporary art.

Front cover, top: Cao Fei, *Game Series: Plant Contest*, 2000, detail of page 94; bottom: Wilson Shieh, *Musical Instruments Series: Cello*, 1999, detail of page 58 left
Back cover: Yiso Bahc, *We Are Happy*, 2004, billboard project for Busan Biennial; Photograph by Eungie Joo; Courtesy of Mr. Daeyeol Ku and friends of Yiso Bahc

Photographs of various artist's studios and environments:
pp. 1, 52 top, 52 center, 142 top: Hiroshi Fuji's studio/office, Fukae Nijo-town, Itoshima-gun, Fukuoka, Japan
p. 52 bottom: Kim Young Jin's studio, Paju City, Kyunggi-Do, South Korea
p. 53: View of the waterways of Hong Kong from the Star Ferry
p. 142 center: Street in front of building designed by Zheng Guogu and Sha Yeya's Young Men construction and design firm, Yangjiang, Guangdong Province, China
p. 142 bottom: Shao Yinong and Muchen's apartment, Beijing
p. 143: Rooftop terrace of Zheng Guogu's home, designed by Young Men construction and design firm, Yangjiang
p. 184: Yiso Bahc's studio, Seoul, 2004; Photo by Jung-sik Cho; Courtesy of Mr. Daeyeol Ku and friends of Yiso Bahc

Printed in Canada by Friesens Corporation.

CONTENTS

FOREWORD 8

ACKNOWLEDGMENTS 10

CRISSCROSS: NEW TRENDS IN ART, EAST ASIA 14
Betti-Sue Hertz

PARALLEL TRAJECTORIES: SEEKING NEW IDENTITIES IN EAST ASIA 24
Zhang Zhaohui

SAME CULTURE, DIFFERENT NATURE / SAME CULTURE, SAME NATURE 30
Li Xianting

IN SEARCH OF THE INCOMMENSURABLE: JAPANESE ART IN TRANSITION 38
Midori Matsui

CONTEMPORARY ARTISTS OF SOUTH KOREA: A REFRACTED VIEW 44
Taehi Kang

PLATES 53

ARTISTS AND WORKS IN THE EXHIBITION 143
with texts by Betti-Sue Hertz, Sachiko Namba, Lucia Sanroman, and Lydia Thompson

FIGURE AND PLATE CAPTIONS 172

WRITERS' BIOGRAPHIES 182

The San Diego Museum of Art is proud to present *Past in Reverse: Contemporary Art of East Asia*, a major exhibition featuring works by twenty-two artists and artists' groups from mainland China, Taiwan, Hong Kong, Japan, and South Korea. Ranging in age from their twenties to their fifties, and working with both traditional materials and new technologies, including painting, sculpture, photography, installation, and video, the artists in *Past in Reverse* reveal the region's tremendous contemporary import and deep cultural complexity. The exhibition is designed to give audiences in the United States an overview of some relevant and dynamic artistic practices taking place throughout East Asia, focusing on the impact of the past on the experiences of artists in the increasingly globalized world.

Past in Reverse looks at the commonalities and differences among the various cultures brought together by the exhibition. This diverse art comes from a part of the world that, while too little known in the United States, continues to gain representational, commercial, and political power on the global stage. A study such as this one offers us, therefore, a regional perspective that is acutely aware of the value of cultural and artistic histories within larger geo-political conditions. It will not be surprising to see that the art from the different countries responds at some level to each one's economic position, whether visibly on the rise, as is the case with China, or emerging from a sluggish period, as with Japan. What is also revealed is that the very concepts of East and West are not self-contained, but rather each is embedded in the other, resonating as one aspect of the region's cultural hybridization. The exhibition offers a rich blend of cultural specificity on the one hand, and cross-cultural interdependencies on the other. One of the benefits of this is that we can witness the dynamic exchanges within the region, set against the backdrop of their interface with Western art systems of categorization and presentation. The consistent use of first-person pronouns by the catalogue's essayists serves to convey the sense of immediacy and vitality first conjured by the artists themselves.

The contemporary art exhibition program at the San Diego Museum of Art makes deliberate use of the resources of our Asian, European, and American historic collections to reflect on the continuities between contemporary art and that of the past. *Past in Reverse* provides an important complement to SDMA's strong Asian art collection of more than 4,000 objects, and its focus on the most compelling of contemporary artworks serves to update our knowledge of the art of East Asia, bringing it closer to our own lives. In this way, it follows another important exhibition that focused on contemporary culture and place, *Axis Mexico: Common Objects and Cosmopolitan Actions* (2002).

Past in Reverse was conceived and organized by Betti-Sue Hertz, our curator of contemporary art, who developed the project over a period of three years. Her extensive research included trips to East Asia, visiting with numerous artists and arts professionals in several cities. She has brought her deep curatorial experience with international artists to bear on the project, with the hope of bringing a better understanding of East Asia to audiences unfamiliar with the latest critical trends in the region. I seize this opportunity to express my gratitude to Betti-Sue for her many contributions to the programs at SDMA and, in particular, her unshakeable commitment to the creation of this memorable exhibition. Her intelligent essay in this handsome catalogue represents a singular contribution to the scholarship on contemporary East Asian art, and I congratulate her on that as well. This project took shape during Heath Fox's service as acting executive

director of the museum. Along with Betti-Sue, Heath deserves essential credit for stewarding *Past in Reverse* toward its final, highly successful form. So many others, listed in the Acknowledgments, contributed their talents and energy, and we are grateful to them all.

An exhibition of this scale would be impossible if not for the generous supporters who shared our vision. We would like to acknowledge the Emily Hall Tremaine Foundation for its enduring interest in this project and significant contribution to the exhibition's presentation in San Diego as well as to the tour. We are also deeply appreciative of the generous participation of Chris and Eloisa Haudenschild. In the same way, I would like to recognize the assistance of our colleagues at the various institutions to which *Past in Reverse* will travel: Rachael Blackburn Cozad, executive director, and Elizabeth Dunbar, chief curator, at the Kemper Museum of Contemporary Art, Kansas City, Missouri; and Katherine Hart, interim director and curator of academic programming, at the Hood Museum of Art at Darmouth College, Hanover, New Hampshire. It is a particular pleasure for me to collaborate with my former colleagues at the Hood Museum of Art, especially Juliette Bianco, Patrick Dunfey, Rich Gombar, John Nyberg, and Lesley Wellman.

It is a privilege to have the opportunity to consider both in the galleries and throughout the pages of this publication such a broad range of contemporary East Asian art as it is being defined by this varied group of engaging artists. I hope our audiences will feel as inspired as I do by these diverse cultural forms from such distinctly fresh perspectives. If *Past in Reverse* serves us by initiating a conversation about contemporary directions in art practice, then we can all look forward to a rich and sustaining dialogue about the many issues it raises both here in San Diego and beyond.

Derrick R. Cartwright
The Maruja Baldwin Director

ACKNOWLEDGMENTS

It is with great pleasure that I take this opportunity to thank the many individuals who participated in the success of *Past in Reverse: Contemporary Art of East Asia*. When we began work on this wholly rewarding and remarkable exhibition we knew that only with the encouragement and support of a large number of people—artists, writers, curators, gallerists, and funders—in several countries could we achieve our goals. We are truly grateful for the overwhelming response to our requests for assistance and we are honored that so many people believed in our vision for the exhibition. Without this extended community of individuals devoted to contemporary art, we would not have been able to present this work to the public and, we hope, inspire our audiences to better understand the rich contribution of so many talented artists from this dynamic region of the world.

Past in Reverse represents the successful collaboration of the San Diego Museum of Art's tireless staff. I thank Heath Fox, director of administration and former acting executive director, for his ongoing enthusiasm and support during the planning and implementation of this project, and also our new executive director, Derrick R. Cartwright, for his backing. Likewise, D. Scott Atkinson, chief curator, offered consistent support. Don Bacigalupi, former executive director, was an early advocate for our pursuit of a project of this scope. Former senior curator of Asian art Caron Smith and current Asian art curator Sonya Quintanilla shared their wide-ranging expertise on traditional art, which greatly increased our understanding of the works in the exhibition. Lucia Sanroman, project assistant for contemporary art, provided steady, comprehensive assistance and creative input throughout the development of the exhibition as well as production support and texts for this catalogue. Pamela Fong, former assistant curator of collections and exhibitions, aided in shaping the exhibition during the early planning stage. Yi-Li Kao, project assistant in Asian art, was especially helpful with the Chinese art and artists, and Kelsey Bostwick, former project assistant in Asian art, helped identify useful information about art-historical precedents. Intern Steve Rivera also provided valuable assistance. Susannah Stringham, director of marketing, developed a plan for the promotion of the project and oversaw the production of the exhibition catalogue, and Chris Zook, public relations officer, worked tirelessly to promote the exhibition in print and broadcast media to local, national, and international audiences. Director of education Maxine Gaiber and her staff, Cornelia Feye, Gwen Gomez, Leslie Powell, and Paige Satter, managed the exhibition's educational programs and organized complementary programs, and former curatorial administrator Rachel Evans and her acting successor Ramona Glickling garnered support for the touring of the exhibition. For the installation of this complex exhibition, I extend my gratitude to the expertise of the museum's design and installation department for the elegant presentation of the artworks in all their diversity: Scot Jaffe, exhibition designer, Paul Brewin, installation/construction supervisor, and Marya Villarin, exhibition graphic artist. Facilitating the transportation of artworks were registrars John Digesare and Tammie Bennett. Building superintendent Robert Kimpton attended to logistical details and security of the artworks.

For their important work in soliciting funds for the project, I thank director of development Lynda Stansbury and her staff. Special acknowledgment is due to Karen Coutts and Emily Norton for their expert and professional grant writing. I am especially grateful to the Emily Hall Tremaine Foundation for its vision in providing us with a major grant in the earliest stage of the project. Chris and Eloisa Haudenschild have graciously helped support the Yangjiang Calligraphy Group project.

I am indebted to essayists Taehi Kang, Li Xianting, Midori Matsui, and Zhang Zhaohui for sharing their insights and in-depth experience and knowledge of the contemporary art of their respective countries and the region as a whole. I am also grateful to Lydia Thompson, Sachiko Namba, and again, Lucia Sanroman for contributing entries to the catalogue. Biographical information for the artists was compiled and written by intern Maja Mamish. I thank our editor Michelle Piranio, who was indispensable in refining and shaping the texts, including some in translation, and bringing them together into a coherent collection of voices. I also want to thank Lydia Thompson and Doryun Chong for their expert translation from Chinese and Korean respectively, and Qin Liyan for additional translation and interpretation from Chinese. A special thanks is due to graphic designer Dan Meza for his creative work on this catalogue.

This exhibition would not have come to fruition without the assistance of artists and arts professionals in the United States, mainland China, Taiwan, Hong Kong, Japan, South Korea, and Europe. In particular there were individuals, many of them artists themselves, who hosted me in various cities and guided me through the local arts communities. I wish to thank the following individuals for their friendship and belief in *Past in Reverse*: Yau Ching in Hong Kong, Hongjohn Lin in Taipei, Mami Asano Hirose and Sachiko Namba in Tokyo, Toshihiro Komatsu in Kyoto, Hisako Hara in Osaka, Hyunmi Yoo in Seoul, Wang Tiande in Shanghai, Katarina Schneider and Zhang Fang in Beijing, and Eloisa Haudenschild in San Diego. It is truly because of their networks and dedication to art that we learned about many of the artists in this exhibition. The success of this exhibition has only been possible because of the scores of individuals who shared their expertise and time, as well as their generosity of spirit. In the United States: Beth Bird, Los Angeles; Lisa Bloom, independent art historian, San Diego; Jim Cheng, UC, San Diego; Ed Downum, coordinator, Miramar Air Show; Britta Erickson, independent art historian and curator, Stanford, California; Marc Foxx and Rodney Hill, Marc Foxx Gallery, Los Angeles; Brian Goldfarb, UC, San Diego; Marta Eileen Hanson, John Hopkins University, Baltimore; Andrew Leslie, Cohan and Leslie, New York; Christophe W. Mao, Chambers Fine Art, New York; Young Soon Min, UC, Irvine; Roddey Reid, UC, San Diego; Hong-Kai Wang, Jennifer Ma, and Charwai Tsai at Cai Studio, New York; Tina Yapelli, San Diego State University; Mika Yoshitake, UC, Los Angeles; and Zhang Yingjin, UC, San Diego. I would like to thank the many individuals who met with me, guided me through cities with which I was unfamiliar, and advised me in my research. In Tokyo, Asako Fujioka, Yamagata International Documentary Film Festival; Sueo Mizuma, Mizuma Art Gallery; Yukiko Shikata, Mori Art Museum; Yuji Yamashita, Meiji Gakuin University; Joni Waka (Johnnie Walker), A.R.T.; and Yoshiaki Watanabe, Tokyo National University of Fine Arts and Music. In Osaka, Kimiyoshi Kodama and Yuki Itai, Kodama Gallery. In Kanazawa, Yuko Hasegawa and Toshiya Echizen, 21st Century Museum of Contemporary Art. In Kobe, Kaori Hino, Kobe Art Village Center; Nobuhisa Shimoda, CAP House; and Tokuhiro Nakajima, Hyogo Prefectural Art Museum. In Kyoto, Kozue Abe. In Hong Kong, Henry Au-yeung, Grotto Fine Art Ltd.; Chang Tsong-zung, Hanart HZ Gallery; Choi Yan-Chi and Howard Chan, 1a Space; Grace Cheng and Connie Lam Suk, Hong Kong Arts Centre; May Fung, Hong Kong Institute of Contemporary Culture; Claire Hsu and Phoebe Wong, Asia Art Archive; Hoi-Chiu Tang and Christina Chu, Hong Kong Museum of Art; and the members of Para/Site Art Space. In Seoul, Beck Jee-Sook, Insa Art Space; Kim Hong-Hee and Hyunjin Shin, Ssamzie Space; Sunjung Kim, Artsonje Center; Seung-Wan Kang, National Museum of Contemporary Art; and Young Chul Lee, Kaywon School of Art and Design. I am especially grateful to Hunyee Jung, Hamsung University, and Daeyeol Ku for working closely with us and Yiso Bahc's family, following the artist's untimely death, to ensure Bahc's representation

in the exhibition with an important recent work. In Taipei, Rose H. K. Hsu, L'Orangerie International Art Consultant Co., Ltd.; Sunny Hsu, Jeff Hsu's Art; Ching-Tang Liu and Chen Hui-Chiao, IT Park Gallery; Margaret Shiu Tan, Bamboo Curtain Studio; and Cathy Yu. In Beijing, Feng Boyi, independent curator; Elizabeth D. Knup, Kamsky Associates, Inc.; Meg Maggio and Jeremy Wingfield, CourtYard Gallery; and Yang Qian, artist. In Shanghai, Li Xu and Jiang Mei, Shanghai Art Museum; Lorenz Helbling and Laura Zhou, ShanghART; and David Quadrio, ArtBiz. In Guangzhou, Hu Fang, Vitamin Creative Space, and Wang Huangsheng, Guangdong Museum of Art. In Paris, Hou Hanru, independent curator, and Michel Nuridsany, art critic; in Munich, Naila Kunigk and Walther Mollier, Galerie Tanit; and in Lucerne, Zsuzsa Cserhati, Urs Meile. I also want to thank the members of In-Between International Community-Initiated Art Space Network, who held two conferences, one in Hong Kong and the other in Seoul, during the research phase of the exhibition. And I want to thank the many artists with whom I met along the way. We are especially grateful to the various collectors who have generously lent works to the exhibition: Brad Davis and Janis Provisor, Carlos Mota, Ninah and Michael Lynne, Henry Au-yeung, and Matt Dillon.

Perhaps most important, I am deeply grateful to the artists whose creativity and engaged involvement has made this exhibition a vital and immensely enjoyable collaboration. They are: Ryoko Aoki, Yiso Bahc, Cai Guo-Qiang, Cao Fei, Flyingcity Urbanism Research Group (Jang Jong-kwan, Jeon Yong-seok, and Oak Jung-ho), Hiroshi Fuji, G8 Public Relations and Art Consultation Corporation (Shi Jin-hua, Wu Yue-Jiao, Yeh Yu-Nan, Lu Hao-Yuan, and Xu Huang), Hung Yi, Hee-Jeong Jang, Soun-gui Kim, Kim Young Jin, Leung Mee Ping, Michael Lin, Mitsushima Takayuki, Shao Yinong and Muchen, Wilson Shieh, Tadasu Takamine, Wang Jianwei, Wang Qingsong, Yang Fudong, Yangjiang Calligraphy Group (Zheng Guogu, Sha Yeya, Chen Zaiyan, and Sun Qinglin), and Shizuka Yokomizo.

Betti-Sue Hertz
Curator of Contemporary Art

CRISSCROSS: NEW TRENDS IN ART, EAST ASIA

Betti-Sue Hertz

Fig. 1
Catalogue for *Contemporary Art in Asia: Traditions/
Tensions*, 1996

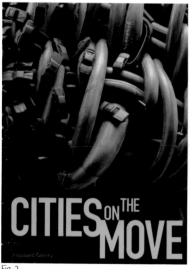

Fig. 2
Catalogue for *Cities on the Move: Urban Chaos and
Global Change—East Asian Art, Architecture and Film
Now*, 1999

Major changes are underway in the global scene. Some say that the dominance of East Asia is inevitable, especially considering China's emergent role. Others are focusing on India, on other parts of South Asia, or on the developing possibilities for Southeast Asia. Regardless of the scenario, it is an apt time for those of us living in the West to take a closer look at these shifting dynamics. *Past in Reverse: Contemporary Art of East Asia* places contemporary art in the context of some of these larger, yet related, developments. Borrowing a common practice among cultural producers in the region—namely, using the past to map the future—*Past in Reverse* looks at artistic trends throughout East Asia. The exhibition features artists from mainland China, Taiwan, Hong Kong, Japan, and South Korea, and tracks a number of significant strategies they use to incorporate cultural and artistic genealogies in their work.

One way to face the challenges of accessing the past in East Asian contemporary art is to use the long arm of art history to reach back to traditional forms such as ink painting, ceramics, or architecture as well as to ancient technologies, religious rituals, and systems of patronage. To access this connection to the past I created guidelines for selecting and interpreting the works in the exhibition: *simulation* of traditional conventions and techniques addressing issues of aura and historical objects; *adaptation* of traditional vernacular manual production to new mediums; *realignment* of traditional relationships between objects and space, including issues of function, use, and display; and *expansion* of artistic approaches incorporating traditional aesthetics and cosmologies within the context of contemporary life.

Another major focus is the region's cultural hybridization, an assertion that East and West are not separate entities but rather each is embedded in the other. Art-historical interdependencies within the region supply a dynamic framework for understanding the works of art in relationship to current systems of global connectivity. This is one way to locate the underlying commonalities in new fusion tactics that combine regional and local indigenous influences. However, in spite of this cultural proxime, the artists reveal, with an unrehearsed air of self-confidence, new views on cultural predicaments and products that show, in surprising ways, as much disconnect as common ground, placing into doubt the possibility of a regional aesthetic.

The long interdependent history of the region includes both exteriorization—cycles of contact through trade, war, invasion, colonization, and occupation—and interiorization, an enforced isolationism and denial of flows from the outside. By crisscrossing the region and sifting through its historical layers, the present's relationship to the past is exposed. Individual artists respond to this relationship by either connecting or retreating from collective memory, reclaiming or denying aesthetic influences, and building or disavowing artistic networks. A number of specific comparative factors have affected artists living in different countries of the region: the unique political histories of nation states and the borders they delineate, which constrain the social networks of artistic knowledge to which the artists have access; the uneven rate of economic development; the expansion of capitalism and its effect on individual families; the art education system and the advent of the MFA degree; and the perception of the artist as a quasi-boundary-free agent and bearer of cultural critique. The leveling of opportunities across the region, although still in formation, remains limited by a web of subtle factors, even though the desire for boundlessness plays a significant role

in the circuits of contemporary art. In the end, small dampers, time bombs, and land mines in the pathways of cultural exchange continue to derail an easy interaction among artists living in the countries that define East Asia.

■

A new trend has become apparent in recent years, which Korean film theorist Soyoung Kim calls "the new trans-Asian culturalism,"[1] referring to tenuously held alliances in the region. This rapprochement, due in large part to the narrowing of difference in the realms of economic and social modernization, has become especially evident in visual art systems. Cultural theorist Koichi Iwabuchi expresses a similar point when he states that "the experience of West-inflicted capitalist modernity has given birth to various modes of indigenized modernities, in such a way that they have become a source for the articulation of a new notion of Asian cultural commonality, difference, and asymmetry… [It is] a time-space context in which cultural similarity, developmental temporality, and different modes of negotiating with Western cultural influences are disjunctively intermingled with each other."[2] As Asia begins to participate more wholeheartedly in the globalized (and globalizing) art world, it is slowly becoming more confident in its cultural impact, which, even if not as influential as its economic one, is nevertheless shifting.

Recent Regional Perspectives

A number of important exhibitions promoting a regional perspective have been produced in East Asia (and elsewhere), and these have served to change the reception of contemporary art locally, even as the Western art system continues to be absorbed. Several survey exhibitions have set the pace for different regional approaches to presenting Asian contemporary art. In 1996 the Asia Society in New York organized a traveling exhibition of art from Thailand, India, Indonesia, South Korea, and the Philippines titled *Contemporary Art in Asia: Traditions/Tensions*, curated by Apinan Poshyananda (fig. 1). As Vishakha N. Desai stated at the time, the goal of the exhibition was "to suggest the current realities in Asia that make conventional antinomies such as 'East/West' or 'traditional/modern' somewhat outmoded."[3] *Cities on the Move: Contemporary Asian Art on the Turn of the 21st Century*, an evolving and changing exhibition organized by Hou Hanru and Hans-Ulrich Obrist, opened at the Secession in Vienna in November 1997 and traveled in various incarnations to London, Bordeaux, Humlebaek, New York, Helsinki, and Bangkok.[4] The London showing involved a change in the focus and the artist list, along with the subtitle, which became *Urban Chaos and Global Change—East Asian Art, Architecture and Film Now* (fig. 2). This open-ended curatorial strategy mirrored the nature of cities in transition and also kept the exhibition current. For the London catalogue, the curators wrote, "Now, at the end of the twentieth century, economic, political and cultural life in East Asia is undergoing rapid change. The region has witnessed a spectacular process of economic and social progress, the signs of which are most obvious in the pace of construction."[5]

Translated Acts, co-hosted by Haus der Kulturen der Welt, Berlin, and the Queens Museum of Art, New York, was organized by Yu Yeon Kim in 2001 and focused on performance art (fig. 4). She wanted "to convey two issues—the first being the articulation of cultural identity, historical legacy, and inner expression into performance—and the second the extension

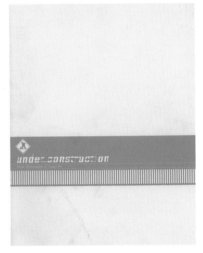

Fig. 3
Catalogue for *Under Construction: New Dimensions of Asian Art*, 2002

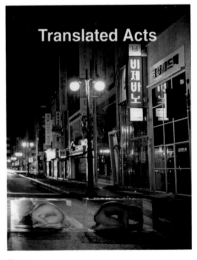

Fig. 4
Catalogue for *Translated Acts: Performance and Body Art from East Asia, 1990–2001*, 2001

of the body and performative action into other mediums, such as photography, video and digital or networked space."[6] *Under Construction: New Dimensions of Asian Art*, organized through the auspices of the Japan Foundation Asia Center, Tokyo, addressed the question: "What is Asia?" (fig. 3). This extensive project consisted of seven exhibitions in seven different countries, each organized by a local curator and presented in 2001, followed by a combined exhibition the next year at the Tokyo Opera City Art Gallery. As curator Furuichi Yasuko observed, "The economic development experienced by Asia over the last 10 to 15 years or so has culminated in Asia achieving a well established position as the growth center of the world. At the same time, this development has resulted in the further growth of the relationship of interdependence within the region, broadly and deeply influencing one another's societies and cultures."[7] *City_Net Asia* was held at the Seoul Museum of Art in 2003 and included sections devoted to specific cities organized by distinguished curators from Taipei, Seoul, Shanghai, and Tokyo.[8] One could argue that the mission of all these exhibitions was to give renewed credence to the regional approach and to promote the possibility of working across the defined geographical space of specific parts of Asia or of Asia in its entirety.

Local Affiliations

Most artists favor any other frame—individual, national, or global—than the rubric "regional" when positioning themselves in the art world, an attitude that has developed from the residue of conflicted political histories with neighboring countries. Homi K. Bhabha, in a recent *Artforum* piece on the late Edward Said, used a comparative pairing that suggests another way of coping with culture and identification. "*Worldliness* forces the location of cultural practices back into the mundane, the contextual, the historical detail of everyday life; *affiliation* is a process of dynamic articulation that draws explicit and metaphoric connections between practices, individuals, classes, and geographies."[9] Flyingcity Urbanism Research Group, based in Seoul, sees the value of honoring the layers of historical memory to be found in urban sites, and they use art to resist government- and corporate-sponsored overdevelopment in the South Korean capital. They are particularly interested in how those who are displaced by the unexpected rapid transformation of space respond, and how such displacement affects concepts of local identity on conscious and unconscious levels. The color photographs of Shao Yinong and Muchen, who have worked together since 2000, record the current state of assembly halls from China's Cultural Revolution era. Some twenty-five years after their original purpose was abandoned, these sites remain, but are now emptied of their political function. In these photographic microhistories, some of the buildings show deterioration while others have been transformed into factories or

Fig. 5 Wang Qingsong, *China Mansion*, 2003

karaoke bars or even private Buddhist temples. G8 Public Relations and Art Consultation Corporation is a group of Taiwanese artists who create conceptual and social interventions aimed at "help[ing] people who are not artists become professional artists."[10] To be effective in this goal, G8 has taken on the identity and strategies of a public relations firm. Juggling between fiction and truth, they employ the techniques of branding, marketing, and media relationships to establish their "clients" in the world of contemporary art. "Through this project," they write, "we discuss how art knowledge is used to transform *ready-being* and *ready-event* into hero/heroine and legend."[11]

As I was researching this exhibition, it became evident that the country-specific trends in art and art history education (whether one is trained in the home country or abroad), in economic mobility and resources, and in access to new technologies have had a powerful effect on individual creative activity and artistic tendencies. For example, Korea has a culture strong enough to withstand the many influences it has endured over the centuries, an ability to adopt, without swallowing them whole, the arts, religions, and philosophies brought in from China and Japan as well as from the United States, Russia, and Europe. A number of South Korean artists are exploring, albeit through a range of means, specific qualities related to their history, including an interest in the relationship between immateriality and materiality and the role of illusion as a strong counterpoint to realism in representation. This can be seen in the prevalent use of reflective materials, mirrors, and other forms of imagery that bounce off a surface or body to produce a quality of otherworldliness—a sense of floating, or of lifting off, an attempt to get to zero gravity. Alternately, presence is often referenced through absence, as things that appear may disappear, or at least escape fixing in one way or another. Kim Young Jin, for example, uses video projection to create ephemeral images of personages that appear to float between representation and ghostly memory. He often manipulates the mechanics of the camera or projector so that it more closely approximates the gestures of the human body or the imperfections of human sight as he explores gender and family lineage in a quest to understand human relationships. And in South Korea, art tends to be understood in relationship to the viewer, rather than as a thing in itself, with an emphasis on phenomena and their effect on presences. Yiso Bahc, for example, worked with common materials—wood, plaster, aluminum, paper—to create astrological maps, sun-tracking devices, and healing contraptions in an effort to capture the ineffable. Many of these artists have studied and lived in the United States or Europe and have returned to Korea with a renewed sense of artistic purpose.

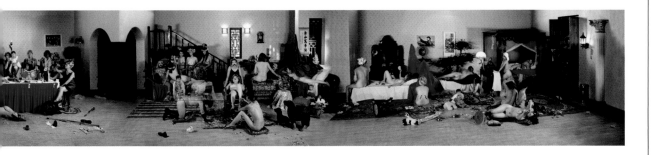

Constraints on behavior by mainstream culture in different countries have also affected the direction and practice of contemporary art. Wang Jianwei's videos are about the production of power in the context of culture and education, and how the individual negotiates authority in China. Wang Qingsong includes thirty-six nudes in his photograph *China Mansion* (2003; fig. 5), with an acute awareness that until very recently the government censored nudity in art.[12] In Japan, artists are ducking and hiding from the demands of bureaucratic society by withdrawing from larger political questions and instead building stronger bonds with local communities and personal social networks. For more than ten years, Hiroshi Fuji has worked with local groups in some seventy cities throughout Japan. He shapes a social space for craft production, using consumer plastics, and community building through environmental education. Under the guise of arts education, Fuji reinvigorates the value of creativity by teaching people how to make art—in the form of common personal and household objects from handbags to chandeliers—out of recycled materials; the artist later uses these objects as elements in his gallery installations. Ryoko Aoki uses an assembly of individual pictorial units in her drawings that collectively make up a lush assemblage of fragments—from doll-like images of girls to ornamental designs to forest landscapes. Art critic Midori Matsui observes that Aoki has "a wish to explore the internal consistency or integrity of imagination as something that gives grace to a modest and locally grounded life."[13]

The East/West Relay

Adding to the complex weave is the region's history of Imperial patronage and the tension between service and intellectual freedom stemming from these dynastic periods. In addition, aspects of Western modernism have infiltrated established visual systems, competing with the power of the cultural normatives of traditional art forms, such as ink painting and hand scrolls, and affecting even how space is ordered and narrative is constructed. All these factors reflect deep cultural histories that continue to be relevant in contemporary art.

Wilson Shieh's highly stylized figure drawings deploy the traditional *gongbi* technique to depict typical Hong Kong personality types "playing" one another as musical instruments or inhabiting ceramic vessels. Cai Guo-Qiang's

Fig. 6 Cai Guo-Qiang, *Bigfoot's Footprints: Project for Extraterrestrials No. 6*, 1991

gunpowder drawings make use of traditional landscape painting formats and the calligraphic line (fig. 6). Gunpowder was invented in ancient China, and this compelling fact is coupled with Cai's personal history of growing up in a military-based city, which is still home to gunpowder factories.[14] Yangjiang Calligraphy Group aims to create an estranged experience of the familiar form of calligraphy. They have described their projects as "calligraphy as a practice afloat on an infinitely moving surface of the ocean, remote from the land, and in a forest that has grown in an interior space."[15] Borrowing a notion of energy from the ebb and flow of ocean tides and the abundant vitality of the woods, they intend to rescue calligraphy from exile and graft it back into the avant-garde cycle. They embrace the traditional pictorial and semiotic language of calligraphy even as they create sculptures and scatter art[16] from their discarded materials of paper and ink.

While the above-mentioned artists mine their own cultural pasts, others are adapting foreign (Western) art histories and cultural trajectories to their own needs. Hee-Jeong Jang's compositional formations combine elements of Western and Eastern painting. Recalling the Korean vernacular "bird and flower" tradition of *minhwa*, Jang creates "vacuum" spaces on top of the printed images of floral patterned fabrics that serve as her source materials.[17] Shizuka Yokomizo incorporates ideas about the religious uses of directional light in European Renaissance painting into her

Fig. 7 *The Miraculous Interventions of Jizo Bosatsu*, 13th century, Japan (detail)

portraits in photography and video. Michael Lin enlarges patterns found on the Taiwanese muslin pillowcases that recall his childhood and then uses them to cover portions of specific architectural sites—whether walls or floors—to give new drama to commonplace imagery. Art critic Vivian Rehberg has noted: "Michael Lin's site-conditioned work hovers between surface and structure, ornament and architecture, motif and ground… [He] safeguards a place for the individual—differentiated by her or his corporeal, cultural, and linguistic specificity—within the collective."[18] Tadasu Takamine combines a search for quixotic personal freedoms with references to archeology and recent political histories. His installation, *Common Sense* (2004), features a landscape of dirt and junk with discreet ceramic elements, audio recordings of excerpts from Thomas Paine's *Common Sense*, and a video projection that takes on the role of a search lamp.

Connecting with Religion and Philosophy

Another deep historical commonality is the impact of religious and philosophical ideas across the region, especially Taoism, Buddhism, animism, and the teachings of such influential thinkers as Confucius. Chinese written characters were transmitted to the unrelated languages of Korean before the fourth century and Japanese in the fifth century, and Buddhist texts became the conduit for cultural exchange, opening up new avenues of communication across the region. Contemporary artists continue to forge connections to this ancient history. Hung Yi, in his very relaxed manner of mixing images from any and all sources, relies on Buddhist iconography as a central visual hook for all the other elements in the work. The literati landscape gardens of the Song Dynasty in China, designed on Taoist principles, are referenced directly in Yangjiang Calligraphy Group's installation *Calligraphy Project: In the Interior Woods* (2004) and in Yang Fudong's film *Liu Lan* (2003). Cai Guo-Qiang's explosions as well as his calligraphy works in gunpowder are Taoist in their acceptance of nature and chaos as forces of transformative creativity, especially from a cosmological point of view. Taoism is a strong influence on the work of Soun-gui Kim, evident in her exploration of momentary qualities in space/time relationships, chaos, and the relinquishing of control to natural forces.

Yiso Bahc accessed Korean animism, with its belief that natural objects have spirits, and he often imbued materials which in other contexts would be considered abject with an awe-inspiring and guardian-like aspect (fig. 8). Tadasu Takamine's recent works, based on his residency at the Tanba Manganese Memorial Museum in the Kansai region of Japan (which focuses on the history of Korean workers in the Japanese mining industry), are also animistic, relating back to auratic objects and spirits, which is contrasted with texts on common sense. Ryoko Aoki's compilations of highly detailed drawings evoke both the animist spirits of Shintoism and the Zen nature of thirteenth-century Japanese landscape paintings from the Kamakura and Kyoto schools (fig. 7). Confucianism, a system of social and ethical philosophy, or "code of conduct," has also shaped societies across the region. Artists such as Wang Qingsong, Hiroshi Fuji, and Flyingcity all critique contemporary assumptions about power and social hierarchies.

Although I am emphasizing Asian references here, I acknowledge that contemporary art relies heavily on Western philosophical traditions as well. In fact, artists Soun-gui Kim, Mitsushima Takayuki, and Shizuka Yokomizo all hold degrees in philosophy and combine Eastern and Western ideas in their work, from existentialism to semiotics to chaos theory.

Fig. 8
Yiso Bahc, *Untitled (Sky of San Antonio)*, 2000

Localized Differences

The subtle differences between an artist trained in Beijing or Hanzhou, China, and another trained in Taiwan, all sharing the same art history but with different biases, set up varying levels of confidence and doubt in the formation of the individual artist. Cities and townships, along with their histories, have different effects on artists' points of view. To generalize, artists who live in Beijing, the seat of central government, are more likely to engage large public or national questions in their work. The Guangdong (Canton) region in the south, for its part, yields works dealing with cultural marginality and the impact of global pressures on Chinese society. This can be seen in the work of Cao Fei, in which youth culture, fashion, and the advent of the white-collar worker are foregrounded. And Shanghai, with its long history as a cosmopolitan center, has become a locus for both nostalgia and hyper-individualism. Yang Fudong's films set in Shanghai and nearby pastoral locations feature attractive actors who are "finding themselves" in stylish settings reminiscent of the modern period. Taiwanese artists often balance hybrid influences to the point of forcing a mental splitting and merging of Eastern and Western references. For example, Hung Yi's eclectic postgraffiti style incorporates Taiwanese folk iconographies and Buddhist icons along with Picassoesque stylizations in his highly personal drawings and sculptures of hybrid creatures. Hong Kong's unique identity has been a central subject for many artists. Canto-pop music, fashion and style, and action movies have defined Hong Kong culture.[19] Some of these trends are referenced directly or obliquely in Wilson Shieh's drawings. In contrast, Leung Mee Ping takes advantage of the waterways and outer islands to reclaim a space of quietude for the individual. With its "special territory" status, Hong Kong poses unique challenges to its artists as they try to find viable ways to continue on their own path in the post-handover period.

If I attempt to view the work of the Japanese artists presented in *Past in Reverse* within the visual terms set up by the Chinese artists, it doesn't work or connect, and instead there is a clash. The difference between Cao Fei's fascination with advertising, commercialization, and commodity on the one hand, and the subtleties of the natural world, attention to craft, and internal dreamscapes found in Ryoko Aoki's drawings on the other exemplifies certain tensions that reflect societal disparity at this historical moment. As part of the pattern of Japanese art, trends cycle through assimilation and rejection, and the dialogue between works of art is caught in this spiraling roller coaster. The transparency of the process of making the work of art is highly valued among Japanese artists, who tacitly refuse to align themselves with the corporate model of production, branding, and media seduction. They are returning to themselves as producers with a completely different motive. This position of going back to the value of human exchange seems consistent with the collapse of the bubble economy. And this attitude of estrangement (not quite discomfort) is consistent with Japan's stagnant rate of economic mobility. Not setting out to prove something, these artists are returning to personal endeavors and the perceptual pleasures of the body in their immediate world.

Whereas the Chinese cultural establishment is just beginning to consider the value of the interdependencies of contemporary East Asian culture—including Japanese popular culture, Hong Kong fashion, and Korean ceramic traditions—Taiwan has long embraced the residue of cultural influences from the Japanese occupation in the first half of the twentieth century, influences that are now part of their own tradition. The depth of that penetration is evident in architecture, design, and fashion as well as in institutions such as teahouses, all of which have shaped, in part, contemporary aesthetic tastes. Taiwan's long colonial history—rife with European, U.S., and Japanese interventions—has left a legacy of dynamic cultural

hybridity, which in East Asia is rivaled only by Hong Kong. Although Taiwan prides itself on its Chinese, as well as non-Chinese, indigenous populations, it is increasingly affected negatively, both economically and politically, by China's growth in these arenas; Taiwan's place in the larger world order, especially its role as a gateway, is becoming less viable.

■

The works in *Past in Reverse* are collectively shaping fresh readings of contemporary society from a specific cultural point of view, whether Chinese, Korean, or Japanese. I am not ignoring prevalent ideas on the globalization of artists, as displayed by the proliferation of art biennials in many disparate localized centers. However, those artists who claim to be citizens of the world are few compared to those who engage the particular visual and philosophical languages of their home country. The extension of both traditional and modernist visual languages, or the redefinition of them, may be at the center of this exhibition. Such practices rely on the seduction of historical reference and its ability to propel folks forward. How do we incorporate the commonality of the artistic roots of all the countries included in this project into the discourse on difference and specificity? To my view the visual arts are part of the larger cultural flows within the region. There are more and more signs indicating that, for artists, staying home can yield a worthwhile support system for contemporary art practice in the global context. This emergent condition will most likely continue at an ever-increasing pace, providing platforms for the further reintegration of what the region has to offer to its artists and their audiences at home and abroad.

NOTES

[1] Soyoung Kim mentions this phrase in his course description for a class on Korean cinema. See http://filmstudies. berkeley.edu/course_archive_grad.html.

[2] Koichi Iwabuchi, *Recentering Globalization: Popular Culture and Japanese Transnationalism* (Durham: Duke University Press, 2002), 6. Iwabuchi is assistant professor of Media and Cultural Studies at International Christian University in Tokyo.

[3] Vishakha N. Desai, president of the Asia Society in New York, quoted on Asia Art Archive Web site, http://www.aaa.org. hk/media_details.asp?aid=3842&showkeyword=traditions/tensions.

[4] In Vienna the exhibition included works from Bangkok, Guangzhou, Hanoi, Hong Kong, Jakarta, Kuala Lumpur, Manila, Osaka, Beijing, Seoul, Shanghai, Shenzhen, Singapore, Tokyo, and the list continues. For each city of the exhibition tour, some artists were added, and others were dropped from the roster.

[5] Hou Hanru and Hans-Ulrich Obrist, "Cities on the Move," in *Cities on the Move: Urban Chaos and Global Change—East Asian Art, Architecture and Film Now*, exh. cat. (London: Hayward Gallery, 1999), 10.

[6] Yu Yeon Kim, *Translated Acts: Performance and Body Art from East Asia, 1990–2001,* exh. cat. (Berlin: Haus der Kulturen der Welt; New York: Queens Museum of Art, 2001), 13.

[7] Furuichi Yasuko, "Asia: The Possibility of a Collaborative Space—Under Construction Project," in *Under Construction: New Dimensions of Asian Art*, exh. cat. (Tokyo: Japan Foundation Asia Center and Tokyo Opera City Art Gallery, 2002), 13.

[8] Rhee Won-Il, chief curator at the Seoul Museum of Art, writes: "The *City_Net Asia* Project, embracing the Asian's

perspective of seeking values, is to shed light on the political, economic, and cultural issues brought about from the primary cities of a few Asian nations. After independence from the Western powers, Asian countries, in terms of history, pushed ahead with their modernization based on the systems and regulations of Western civil nations. Paying attention to the fact they sought to recover their non-occidental distinctiveness despite their heavy reliance on the West, the project, through the art language, explores the current status of Asian peoples and countries." "The Eloquent Arrangements of Disparate Time Zones and Spaces-New Asian Perspective," in *City_Net Asia*, exh. cat. (Seoul: Seoul Museum of Art, 2003), 13.

[9] Homi K. Bhabha, "Untimely Ends, Homi K. Bhabha on Edward Said," *Artforum* 42, no. 6 (February 2004): 20.

[10] From mission statement, e-mail to the author, January 4, 2004.

[11] Ibid. The group explains these concepts in an unpublished manuscript from 2004, titled *A Commentary on the Individual Exhibition of Ke Tsi-Hai versus the Birth of Ready-Made Beings*: "The discrepancy between Cai Guo-Qiang's 'ready-made event' and Duchamp's 'ready-made object' is little. As for G8, it leaps forward to create 'beings' that manifest objects and events."

[12] The constraints on nudity are weakening as laws in China are liberalizing in regard to certain personal freedoms.

[13] E-mail to the author, February 5, 2004. See also Matsui's essay in this book.

[14] "Gunpowder was invented by Chinese alchemists seeking an elixir of immortality. ... Some historians date the invention of gunpowder at 850 AD when a Taoist book warned of three specific elixir formulas as too dangerous to experiment [with]. Around 1040 AD, Tseng Kung-Liang published a true gunpowder formula for the first time in history. However, this powder was not explosive but rather burned with a sudden combustion and was used in flame-throwers." See http://www.hyperhistory.com/online_n2/connections_n2/gunpowder.html.

[15] From a description of *In the Interior Woods*, Zheng Guogu, e-mail to the author, September 25, 2003.

[16] The term "scatter art" refers to the positioning of objects or materials in spatial, often room-sized configurations. Its roots lie in process art of the 1970s, by such practitioners as Eva Hesse and Robert Morris.

[17] E-mail from Hee-Jeong Jang to Lucia Sanroman, February 17, 2004. "In Korean traditional paintings, unoccupied empty places are considered as a part of paintings. Illuminating this idea reversely, and erasing numerous kinds of images, I aim to create empty spaces in the sense of contemporary paintings. The erased images are not unnecessary parts. Rather, those are designed by my intention. Drawing the empty spaces is, ironically, the result [of] adopting the Eastern thoughts in a contemporary way. The matter of beings, or existences should be highlighted only when fake flowers or fake emptiness exist, as if the simulacra make the real conspicuous."

[18] Translation of the text is taken from Vivian Rehberg, *Michael Lin: The Language of Flowers*, exh. bro. (Paris: Palais de Tokyo, Site de création contemporaine, 2002).

[19] Unlike the situation in other parts of China, culture in Hong Kong remains independent from the central government's foray into pop entertainment.

PARALLEL TRAJECTORIES: SEEKING NEW IDENTITIES IN EAST ASIA
Zhang Zhaohui

Fig. 9
Okakura Tenshin

On July 13, 2001, it was announced that Beijing would be the host city for the 2008 Olympic Games, beating out other contenders such as Paris and Toronto. For the Chinese government, this event is emblematic of the world's recognition of China as a key player on the global stage as well as an acknowledgment of China's booming economic capabilities over the last twenty-five years. This same level of global recognition and prestige was achieved by Seoul in 1988 and Tokyo in 1964. And these parallels seem to suggest that East Asian countries have experienced a similar evolution diachronically while being located on different stages synchronically. Underneath these social-historical-cultural frameworks, and as records and reflections of social transformation, the visual arts in East Asia have been undergoing a remarkable transformation since the beginning of the twentieth century.

East Asian countries have a common cultural legacy, the so-called Far East civilization or Chinese Culture Sphere, which developed in continental Asia over thousands of years and was disseminated to peripheral areas of the region. During the Tang Dynasty (618–907), Chinese literati ink painting and calligraphy were highly valued among scholars in Korea and Japan, and Chinese ideographic block characters were appropriated by other nations who gradually developed their own written languages. Today, some Chinese characters are still used in written Korean and Japanese, even maintaining similar meanings and pronunciations. Taoism, Buddhism, and Confucianism, which were developed or localized on the mainland, were introduced in Korea and Japan in the tenth century. A Sinocentric attitude pervaded the region; both the Qing Dynasty of China (1644–1911) and the Korean Chosun Dynasty (1392–1910) adopted isolationist policies, and Koreans believed that "China was the center of the universe (realms outside China were presumed to be occupied by 'barbarians')."[1] Furthermore, Korea's initial exposure to Western culture was through envoys to the Qing government who brought back Western paintings from China.[2] All of this is to say that throughout history East Asian countries have shared a common cultural identity rooted in Chinese culture.

Beginning in the mid-nineteenth century, traditional agricultural nations in East Asia encountered a severe and powerful challenge from European industrialization and capitalism. Exposure to (and the impact of) Western civilization changed Asian people's view of the entire world and forced them to confront the rising power of the Western world. This led to widespread reform programs in Asia. With the success of the Meiji Restoration (1868), Japan placed itself on the fast track of industrialization and modernization. The Japanese government was acutely aware that the only way to stand up to and compete with the West was to study, borrow, and adapt to their own needs Western economic, military, educational, and social systems. Okakura Kakuzo (1862–1913), more commonly known as Okakura Tenshin (fig. 9), Japan's leading art critic and spokesperson for Japanese art and culture at the time, envisioned the unification of Asian culture under Japan's leadership as a vital civilization able to confront and withstand the forces of Western imperialism. In China, Western systems of education, transportation, industry, banking, and postal services were gradually launched, but the political system remained fundamentally unchanged. Intellectuals in Japan and China saw Western civilization as advanced and considered their own local and vernacular systems as being backward. Following Japan's successful modernization and Westernization, many Chinese students were sent to Japan in the first three decades of the twentieth century to study, secondhand, Western culture, including fine art, music, drama, performance, and the applied arts.[3] For many Chinese scholars and intellectuals, Japan's

reforms provided an example for China's development. In Korea and Taiwan, forty years of colonization by Japan in the early twentieth century brought those two regions into the sphere of Japan's modernization and industrialization programs. All the countries of East Asia encountered the West at roughly the same time; but this collective awareness of the West and the process of learning from its systems and cultures were germinated, in individual countries, at very different moments in their historical development.

Following the Second World War, Japan recovered quickly from the trauma of war and emerged as an economic superpower. South Korea, Taiwan, and Hong Kong, as the "Small Dragons of Asia," created their own economic miracles. In China, the open-door policy and economic development of the past twenty-six years have brought that country into the realm of a potential superpower. With the mutation of the postwar framework—the emergence of globalization in terms of interdependence of new technologies, economies, and financial markets—countries across East Asia are confronting a new global context. Intellectuals and artists in this region have gradually fostered a keen awareness of the need to establish new cultural and artistic identities to match their new status.

East Asian countries share not only cultural roots but also the experience of absorbing Western art systems. Around the turn of the twentieth century, art students from China and Japan went to Europe to study, and they brought back with them Western realist and modernist techniques and philosophies. Western art education systems were established in Japan and in China, challenging the supremacy of traditional arts such as ink painting on rice paper. Traditional ink painting (fig. 10)—called *guohua* (national painting, or literati painting) in Chinese, *nanga* (literati painting) in Japanese, and *don'yang hwa* (oriental painting) in Korea—became overshadowed by Western realist oil painting. At that time, Western art as a whole was commonly viewed by East Asians as being more advanced and progressive than their indigenous traditional systems, ideologies, and cultural production. For nearly a century, the debate surrounding the relationship between the East and the West has never ceased, and it outlines a polarized history of repeated self-discovery and a desire to catch up with the West. Only in South Korea did Western modern art meet a strong nationalist resistance, because it was brought in and promoted by Japanese colonists; as a result, traditional ink painting played a larger role in South Korea.

Nevertheless, a number of insightful Chinese and Japanese scholars believed that literati painting could be rejuvenated. In China, many artists who trained in Western oil techniques returned to the practice of traditional ink painting later in life in order to create a new art language that integrated Chinese and Western techniques and aesthetics: the so-called *ronghe dongxi* (Integration of the Oriental and Occidental) style. Traditional ideas were still crucial factors in the pursuits of many artists.[4] The resulting debate around tradition and modernity, and the exploration of a synthesis between Eastern and Western qualities in art, provide a useful outline of the development of modern Chinese and Japanese painting, which heavily integrated Western realist techniques and modernist approaches with Eastern aesthetics. Traditional ink painting practices in China, Korea, and Japan alike developed strong techniques for portraying the spectacles of social reality (fig. 11). In these ways, traditional art in East Asia has been updated and diversified in light of artistic Westernization.

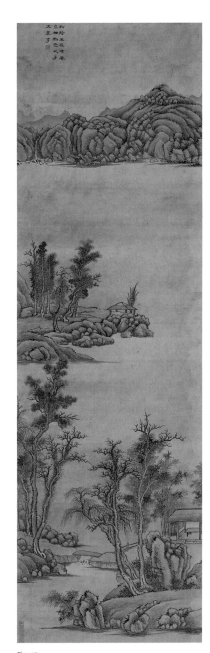

Fig. 10
Wen Zhenheng, *Picture of the Pine-Shaded Studio*, 17th century

Fig. 11
Kim Ho-Suk, *The History of Korea's Resistance Against Japanese Colonialism: Comfort Women*, 1990

Paradoxically, during China's Cultural Revolution, traditional art was abolished altogether and Western realist techniques were widely utilized for propagandistic purposes, even though in the climate of the Cold War, anti-Western sentiments were prevalent in China. Throughout the twentieth century, during the course of modernization, Eastern cultural traditions and vernacular heritages were extended to concrete art practices. Parallel to the continuous exposure to and learning from Western art was an ongoing application and re-application of traditional cultural elements.

At the same time that their economies developed, East Asian countries became increasingly attuned to the notion of cultural identity in the new global context. The Gutai Group in Japan is a good example in this regard. Founded in Osaka in 1954, the members of the Gutai Group were pioneers of performance art and unorthodox variations on action painting. During the 1950s, the avant-garde art movement in Japan was taking place simultaneously with its counterpart in New York, as an integral part of the overall currents in art. In New York in the 1950s, D. T. Suzuki's lectures on Zen Buddhism made a strong impression on the American avant-garde scene, evident, for example, in the experiments of John Cage. In the following decades, Asian avant-garde artists, including Nam June Paik (fig. 12) and Yoko Ono, were deeply involved in Euro-America art movements such as Fluxus. After the Second World War, the development of Western avant-garde art, especially in the United States, owed many debts to the traditional cultures of East Asian countries.[5] Asian artists, represented initially by Japanese practitioners, were no longer considered bit players on the Euro-American contemporary art stage. Asian artists and theorists started to reconsider their position, and their influence, in the world art scene. The Japanese group Mono-ha, for example, advocated for a contemporary Asian art that gave form and meaning to their particular worldview.[6] Emerging in Tokyo in the late 1960s, Mono-ha artists favored the use of natural materials such as stone, water, clay, and wooden logs to reveal the nature of existence, giving radically new form to a pervasive cultural ideal, which had been suppressed by rationalism and industrialization, of making the mind and nature one.

Over the last twenty years, with the reconfiguration of the global framework in the post–Cold War era, contemporary art from East Asian countries has appeared more frequently on the world art stage. International art biennials/triennials have been staged in Kwangju, Fukuoka, Taipei, Shanghai, and Guangzhou. East Asian countries have become vital sectors in the contemporary global art scene. The increased role that these countries are playing has been accompanied by a push for rethinking and re-evaluating the past. Artworks referencing traditional thought and appropriating traditional media or subject matter are popular among East Asian artists. New light is being shed on collective memories and cultural legacies through artists' reworking of traditional indigenous art forms. Not only have these types of explorations enriched the world art scene, but they have also challenged the tenets of Western modernism and of postcolonialist exoticism.

Because of its complicated cultural and historical context, the "past" in Chinese culture embodies multiple layers of meaning. First, it refers to ancient times, namely, the period before 1840, which was a historical watershed in the transition from ancient to modern China; second, it includes the revolutionary liberation period (1840–1949); and third, it encompasses

the Mao era of socialism and the Cultural Revolution. The first association is to a glorious past as a dominant power, China being one of the four great ancient civilizations in the world (along with ancient Egypt, Babylon, and India). The second association is full of sorrowful memories, of a time when war, revolution, anti-invasion, and famine were intertwined. The third meaning relates to the communist disaster when the entire nation approached "the fringe of breakdown."[7] Modern and contemporary artworks by artists from mainland China and by Chinese artists living abroad are generally based in at least one of these incarnations of the past. A number of renowned Chinese artists living abroad have expanded on the theme of China's ancient history, incorporating such elements as gunpowder, herbal medicine, acupuncture, block characters, Taihushi stones, and Fengshui. Their references to the past encompass its techniques, media, ideologies, methodologies, and philosophies. Their works can arguably be viewed as an artistic extension of ancient Chinese civilization into today's global context and a cultural harbinger of an up-and-coming superpower. In mainland China, signifiers of the Cultural Revolution were once used extensively by many artists, demonstrating an ironic and thorny critique of the once stagnate socio-political system. In this sense the "past" serves as a tool for fighting for a better and freer system.

In Japan and Korea the past has functioned as a positive model for establishing a new cultural identity, as the modernization of the economies of these two nations parallels the modernization of their socio-political systems. In China, however, the "past" remains a complicated reference and resource. Numerous social, political, cultural, and economic crises still need to be resolved. From the point of view of the socio-political system, the inertia of the past, still weighing heavy today, has yet to find an effective way of working within global democratic trends. Therefore, Chinese artists and scholars are faced with an ambiguous and paradoxical attitude toward the "past," with its references to nationalism and Chinese-ness. Many artists whose work deals with images of the past tend to be ironic and subversive in their attitudes.

In Taiwan, forty years of Japanese colonization brought in the influence of Western oil painting. The nationalist government retreated from the mainland in 1949 and promoted traditional ink painting as a means to foster Chinese identity and to preserve the past. Today a large number of artists and critics trained in Europe and America are establishing a new cultural image in the international arena, and to some degree, the past remains on equal footing with present reality. Moreover, the complicated and continuous political turmoil dramatized in Taiwan's art scene has forged a quasi-pluralism but can hardly be said to summarize an overall identity. For Hong Kong, the past means 150 years of colonization by the British, which turned Hong Kong into a capitalist, but not a culturally global, city. The handover to China has been challenging for Hong Kong artists, who now face an even more complex situation, and the uncertainty of the transition fuels them to rethink the past and their present reality.

East Asia as a whole is developing in a single historical direction, namely, toward modernization and globalization. However, because of different socio-cultural contexts, each country is situated at its own distinct point along that trajectory. The "past" as a resource and as an extension of reality serves both as a constructive power for seeking a new cultural identity in the global context and as a destructive force to the current system, which is embedded with the hope for a better future. On the other hand, rethinking the past of East Asia as a whole provides a new perspective for examining the present

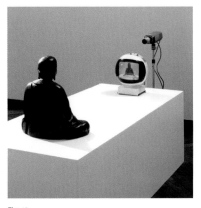

Fig. 12
Nam June Paik, *TV Buddha*, 1974

dramatic relationship between the two sides of the world—East and West—even as globalization is continually reconfiguring the cultural map.

NOTES

[1] Jae-Ryung Roe, "Encountering the World: The Past and the Present," in *Contemporary Art in Asia: Traditions/Tensions*, exh. cat. (New York: Asia Society and Harry N. Abrams, 1996), 94.

[2] Ibid.

[3] Chinese students in Japan studied not Japanese cultures, but Western cultures. Eighty percent of all art students studied oil painting in Japan; others studied sculpture, ceramics, lacquer art, design, and art history, while only a few students specialized in Japanese painting. See Liu Xiaolu, "Gependongxi: Jinian Liuxue Dongyang He Xiyang de Zhongguo Jindai Meishu Xianqumen" (To the East and West: In memory of the Chinese art pioneers who studied in Europe and Japan), in *Shijie meishu zhong de zhongguo he riben meishu* (The art of China and Japan in world art) (Nanning: Guangxi Fine Art Press, 2001), 220.

[4] In fact, many established Chinese artists enjoy a reputation for combining Western techniques and Chinese tradition.

[5] See Gail Gelburd and Geri De Paoli, *The Transparent Thread: Asian Philosophy in Recent American Art*, exh. cat. (Hempstead, N.Y.: Hofstra University; Annandale-on-Hudson, N.Y.: Bard College, 1990), 11.

[6] See Alexandra Munroe, "The Laws of Situation: Mono-ha and Beyond the Sculptural Paradigm," in *Scream Against the Sky: Japanese Art after 1945* (New York: Harry N. Abrams, 1994), 257.

[7] This phrase is used commonly to comment on the consequences of the Cultural Revolution; it was initially applied by Hua Guofeng, the premier of China in the late 1970s, when he delivered the Governmental Report to the Fifth National People's Congress on February 26, 1978, addressing issues of the national economy.

SAME CULTURE, DIFFERENT NATURE / SAME CULTURE, SAME NATURE
Li Xianting

Same culture, different nature. By "same culture" I refer to how Chinese artists from different regions make use of a common language and cultural tradition, and to varying degrees, draw upon their cultural heritage. What I mean by "different nature" is that even within a same culture, artists express disparate feelings and their works convey different implications. Although artists from Hong Kong, Taiwan, mainland China, and the Chinese diaspora have a common language and cultural tradition, and work within the discourse and mode of contemporary art, their practices are driven by individual feelings and perspectives. The diversity and dissimilarity among them emerge, in part, from the artists' different political realities, values, standards, and backgrounds. And yet sometimes their feelings about the plight of humankind and human existence converge. When artists share fundamental ideas about human existence, then it can be said that their work develops out of both same culture and same nature. The Chinese artists represented in *Past in Reverse* reflect a variety of convergences and divergences, sameness and difference.

◾

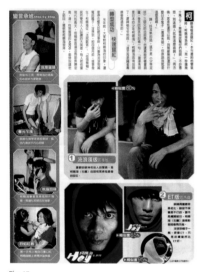

Fig. 13
"Ke Tsi-Hai Makeover as Zhou Jie lun," *Yishukan Weekly Magazine*, June 6, 2002

In her installation *In Search of Insomnious Sheep* (2004; pp. 134–35), Leung Mee Ping invites viewers onto a mirrored boat drifting in the ocean, giving us an opportunity to see ourselves as solitary beings. New York City, Tokyo, and Hong Kong are all similarly large cities. Each time I go to these cities, I am involuntarily pushed, shoved, and rushed by the hustle and bustle of the crowds, and I unconsciously quicken my step. Day after day, my back aches, my feet hurt, and my head is muddled. Whenever I am in the midst of this busy-ness, I am reminded of ants. Shouldn't we take a little time for self-reflection? As Leung has stated: "In the confined, fast-paced city of Hong Kong, is it possible to stop oneself and just reflect? Through the mirrored boat one can experience this feeling of solitude, of being one small island in a vast heavenly sea (during the day), of being a beacon in complete darkness (at night). It provides an inverted reflection of oneself (because of the reflection of the mirrored boat) as well as an opportunity to learn from the ebb and flow of one's life experiences."[1] Even though Leung lives in Hong Kong, she is able to achieve this profound experience. In fact, when a person is carried along by the hustle and bustle of the crowd, it is a lonely experience, much like being in the middle of a great ocean. There is an old saying in China: "The sea of people is boundless." The individual and the crowd are like the viewer and the mirrored boat, between which there is a kind of mutually reflecting relationship. The individual in a vast sea of people, an individual passing through the crowd, is comparable to looking at one's reflection and lamenting one's isolation. The mirrored boat on a vast ocean is one of Leung's most poignant ideas. It encourages us (the audience) to reflect on ourselves; it is also a parable of modern culture and life. In terms of its discourse and expression of a universal human condition, Leung's work can be said to belong to international culture.

Another Hong Kong artist, Wilson Shieh, produces work more in keeping with the language of Chinese traditional art. He has described how he came to his particular brand of figurative art: "My work originates from Chinese *gongbi* (fine-brush) figure painting … First, it was the meticulous process of its execution that suited my personality and working style. Secondly, as this style is considered to be a marginal art form in modern Chinese art discourse, especially when compared with the literati expressive style, it leaves much room for exploration and development. Finally, it is the languages of figure painting that attract

me to the larger extent. The research in the descriptive and narrative functions of this painting style formed the foundation of my work."[2] Citing the profound effect on his work of the sensory overload of images and information that is characteristic of popular culture, Shieh continues: "[Because] I live in an era filled with various images of different artistic currents and popular culture, my paintings cannot be considered an authentic inheritance from the old tradition. They should be seen as contemporary representations. Although I work in a classical painting style, I prefer different and diverse interpretations of my works." This theoretical position is similar to that of many mainland Chinese artists who utilize the medium of traditional painting. They stand poised between the traditional and the modern, looking for a meeting point. This is especially true of those whom numerous critics call the "Painting Is Dead" artists. At a time when many artists are passionately involved in experimental new media art, others use their modern sensibility to revive traditional techniques. Within contemporary art practice, this is very new and very significant; it represents the formation of a new approach.

As an example, during the last several years Shieh has taken his work in a new direction, producing a series of naked angular figures whose "bodies symbolize human beings ... but they have no identity, especially those associated with real life such as class, profession or historical significance. They act as signs in the painting."[3] In Shieh's *Musical Instruments Series* (1999/2004; pp. 58–59), we can see the influence of both Man Ray and Nam June Paik. Moreover, in creating figures whose gender is ambiguous, Shieh is able to achieve a more universal and deeper exploration of the individual's relationship to others. In addition to working in the style of traditional Chinese fine-line painting, he also lays out the images in the manner of traditional book illustrations, thereby imbuing his work with the look and feel of ancient Chinese scroll-books while instilling the images with modern humor.

G8 Public Relations and Art Consultation Corporation is a small creative group established in 2002 by four Taiwanese artists and a critic. When you combine the English pronunciation of the letter G (gee) with the Chinese word for 8 (ba), it is homophonous with a slang word in Chinese for penis (*jiba*). When you add the rest of the name, it takes on an air of parodying the current art system. Expanding on Duchamp's concept of the readymade to encompass what they call "ready-beings" (the concept of Taiwanese art critic Ni Zaixin), G8 appropriated the identity of a famous personage in Taiwan, Ke Tsi-Hai, known for his work on behalf of stray dogs. An activist and entrepreneur, Ke is a product of Taiwan's democratic society, and is even more well known than Taiwan's leading singers and television celebrities (fig. 13). However, unlike the celebrities who are used by the media, becoming figures of consumerism, Ke manipulates the power of the media to protest social injustice, and his escapades and run-ins with the authorities have been highly publicized. Fascinated by Ke's strategies, and without the participation or even the knowledge of the activist, G8 appropriated his identity and promotes him as a "conceptual artist."

G8's "reproductions" of Ke Tsi-Hai's activism reach beyond the art world to transform society. In the guise of Ke, G8 participates directly in live social events, turning them into works of art to further strengthen their effect on and intervention in society. "Life is art" is contemporary art's most lasting and profoundly useful concept. Often when we look at things in our lives, events in society, and their effect on human spirit and tendencies, it makes us feel like art is powerless. However,

Ke's interventions (the real ones and the re-created ones) do have an impact on the human spirit and tendencies, at least within Taiwan. Moreover, in terms of its effect on future events, Ke's work, thanks to G8, has to a large extent gone beyond the utilitarian to become an enviable work of avant-garde art. Of course, one could argue that the real Ke's intentions stem from a "non-art" objective and have an inherent goal of usefulness in society, and that when this persona and these events become works of art, then Ke's activities take on a purely aesthetic objective. Implicit in this dilemma is the question of art's limitations. When I lecture on performance art at universities in mainland China, I often run into students who say that, in terms of having an impact on and shocking society, Mao Tse-tung and Osama Bin Laden are the greatest performance artists. I reply to them that a work of art doesn't have a utilitarian objective beyond expressing the artist's own feelings, and that Mao and Bin Laden had completely utilitarian objectives for society. Furthermore, a politically correct work of art ought to include within its objective an investigative scope. In this way, at the very least, G8's artistic practice is indeed experimental, avant-garde, and wading in very valuable theoretical issues and concerns.

Also expanding on Duchamp's model, Cai Guo-Qiang takes the readymade object into the arena of the readymade event. For the 1999 Asia-Pacific Triennial of Contemporary Art in Brisbane, Australia, he created a live tableau based on the use of nude models in traditional realist painting techniques. For an exhibition in Canada, he created an installation of a Chinese garden and then invited Chinese ink painters to paint bird and flowers and mountains and rocks within it. And for a solo show in Shanghai, Cai mounted an exhibition of his collection of Konstantin Maksimov paintings to memorialize the Soviet artist's great influence on the Chinese art world in the 1950s. The events chosen by Cai are ones that had a major influence on art production in China over the past fifty years. The reproductions of these particular events and artworks had a significant impact as vehicles of cultural memory, nostalgia, self-examination, and satire. This is especially true of his partial replication, for the 1999 Venice Biennale, of the famous Cultural Revolution–era *Rent Collection Courtyard,* which featured more than one hundred life-size clay figure created by a group of artists from the Sichuan Institute of Fine Arts. Cai's version (figs. 14, 15) won him the Golden Lion Prize, thanks in part to the endorsement of curator Harald Szeemann. In the 1970s, Szeemann had wanted to include *Rent Collection Courtyard* in an exhibition he was organizing in Bucharest, but was unsuccessful. Cai's re-creation of the piece, therefore, created many different associations, and was successful on a variety of levels, not only for the artist but also for Szeemann, for the Western art world, and for China's art world.

The works of Taiwanese artists Hung Yi and Michael Lin have many similarities to mainland China's Gaudy Art of the mid-1990s—an aesthetic that borrows from American-style consumer culture and combines it with regional vulgar culture, especially that associated with the taste and mentality of the peasantry or common folk. Images such as the Laughing Buddha, for example, in light of Chinese Buddhist pragmatism toward the world, become objects of secular amusement. Hung Yi uses the signs and colors of popular culture to satirize our constant pursuit of worldly desires. His *Happy Buddha* (2001; p. 127) does not instruct us in spiritual lessons about "the superficiality of reality"; instead, it is the guardian of pleasure-seeking and self-gratification.

Fig. 14
Cai Guo-Qiang, *Venice Rent Collection Courtyard*, 1999

Fig. 15
Detail of *Venice Rent Collection Courtyard*

Hung's pictorial language is derived from the figural style and colors of Chinese folk painting, and is full of irony and humor. Although Michael Lin also draws inspiration from a folk pictorial tradition—he uses flower patterns from folk textiles of his grandmother's era—for him, it resonates with a more personal childhood memory of home. Lin was born in Japan, has lived in America and Taiwan, and his art projects are spread throughout the world. This childhood memory is represented as a hazy homesickness, a dissipated trace that follows him around the world, making it all the more prominent for its persistence. Its identity is known, established, and self-reflexive. In every exhibition, throughout the world, Lin places his flower patterns in gigantic spaces where they become huge carpets or sofas, in the process transporting his "home" from place to place so that audiences from different cultures and backgrounds can, along with him, casually enjoy themselves and partake in the mood of a different culture. Especially in today's globalized culture, with the emergence of a new type of urban, transnational, nomadic class of people, the "homes" of such a person's various cultures have become portable, forever accompanying him or her across the globe. Lin's work asserts that home is in the heart, and, like a childhood dream, we can carry it with us forever.

Figs. 16–17
Stills from Cao Fei, Ou Ning, and U-Thèque Organization, *San Yuan Li*, 2003

Artists from mainland China, including Wang Qingsong, Zheng Guogu and the Yangjiang Calligraphy Group, Ou Ning, and Cao Fei, are concerned primarily with issues related to China under the assault of the world's consumer culture. For example, *San Yuan Li* (2003; figs. 16, 17), an experimental video by Cao Fei, Ou Ning, and U-Thèque Organization, documents the particular case of San Yuan Li, a village on the outskirts of Guangzhou that is coming under increasing pressure of the larger city's encroaching culture. The artists sensitively capture the process by which China's urban culture becomes the epitome of advancing modernization. This is China's special circumstance in East Asia, and there are several scholars who feel that this is a postmodern phenomenon.[4] However, I would argue that the process of globalization and modernization is leading to the destruction of the original values of Third World Culture. After satisfying short-term utilitarian needs and choices, every shattered piece of culture is heaped together in the same place and time, making China into a big garbage bin: clumsy knock-offs of European amusements and vestiges of China's traditions; Coca-Cola, literati tea ceremony accoutrements, and medicine cure-alls—secret remedies passed down through generations. Sinking into the dregs or rising above the scum, the new, the old, the good, the bad—it all surges chaotically toward us. But there is nothing of value in them. We are left only with insatiable, ever-expanding individual desires. Daily life in every city is seething with crime, drugs, sex, and violence, creating a debauched human farce. All of this is ironically implied in *San Yuan Li*, which is set in a village that was once the site of spontaneous mass resistance to the importation of drugs (opium) from England.

Wang Qingsong is one of the most important artists of the Gaudy Art movement that emerged in the mid-1990s and continues to be influential and prominent in an art world still focused on mass consumer culture. To penetrate this language structure, Wang exaggeratedly imitates the gaudiness and vulgarity of mass culture and, mocking the superficiality of consumer culture, humorously satirizes that culture's ostentatious peasant taste. His *Knickknack Peddler* photograph (2002; pp. 54–55) portrays a street peddler who, in an earlier time, sold mostly items for daily use. Such peddlers still exist today, especially in the countryside. However, it seems that the wares have undergone a transformation, reflective of the effects of China's modernization. Though some commodities still harken back to traditional channels and forms, the rest of the goods being

sold from his pack are cheap market items, propagandistic souvenirs, and imitations of American consumer goods. This is modern-day China: a grab bag of the most traditional to the most trendy. The artist himself plays the role of the peddler, perhaps commenting on the self-aggrandizing era in which we live.

The image of the peddler carries numerous associations in Chinese consciousness (fig. 18). In the past, especially in remote villages, the arrival of the peddler was cause for celebration among the local people, and something of this festive atmosphere is conveyed in *Knickknack Peddler*. During the Cultural Revolution, in revolutionary operas, sometimes the character of the peddler was a model worker carrying forth the goals of the revolution, and at other times, he was presented as an enemy of the revolutionary cause, perpetrating destructive acts. In our education and history, therefore, the peddler played many different roles, providing a barometer of cultural and economic changes over time.

Wang's recent *Red Peony* and *White Peony* series (2003; pp. 56–57) evoke the perceived refinement of Chinese literati bird and flower paintings. However, in Wang's photographs, the flower petals are made of meat, which, as becomes evident if one looks closely, is dripping blood and rotting. Lu Xun, a renowned twentieth-century writer, satirized Chinese literati in a poem with the following words: "The place that is rotten is seductive like plum and pear [blossoms]." There is another saying in China: "Outside is gold and jade, inside is decay." Wang Qingsong's photographs of flowers express his sense of "the superficiality of a prosperous age" in China today.

Compared to artists from Hong Kong and Taiwan, the work of artists from mainland China is more concerned with social and ideological pressures, with the predicaments of human existence. Wang Jianwei's video *Theater* (2003; pp. 114–17) is about a highly popular subject in Chinese theater from the 1940s to the 1970s: the story of the White-Haired Girl. Wang's video provides a layered history of how different versions of this story evolved from the prototype. The original story of the White-Haired Girl is about the relationship between a poor peasant girl and a rich farmer. Later it became a tale of abandonment. In the early 1940s, as part of the Yan'an Art and Literature movement, this story was made into an opera about class struggle, reflecting an important strain in Communist ideology espousing that retaliation against the wealthy is necessary for the poor to become the leaders of society. Moreover, it provided a justification for the incitement of violence. According to records from Yan'an from that period, local soldiers indignantly opened fire on the actor who played the landlord on stage. The story continued to be popular in the 1960s and 1970s and was made into both a movie and a ballet. The story's content and characters underwent incessant change, driven by the evolving ideology. Wang's video is not concerned with revisiting history but rather in examining his personal educational experience, which he does using the style of historical narrative. As Wang has stated: "The most familiar standards and norms are perhaps the most unworthy of our trust." In fact, Chinese theater from ancient times to the present has always played both a ceremonial and an educational role in Chinese society. Officially sponsored operas disseminated moral standards and ideology to the common people—something that is clearly evident in the ancient operas still being performed today.

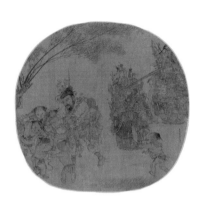

Fig. 18
Li Song, *The Knickknack Peddler*, Song Dynasty, 1212

A counterpart to this is Shao Yinong and Muchen's photographs of former assembly halls (pp. 90–93), either abandoned or put to new use, which also provided a kind of theater. In addition to being performance spaces, these halls served an important function as meeting places for the Chinese Communist Party (CCP). For fifty years, a popular joke in China has been: "Under the Guomindang there were many taxes, under the CCP there are many meetings." I know of no other political party that relies on meetings at every level, big and small, from the metropolises down to every tiny village. Within these halls, political struggles raged, people feasted, and tired meeting attendees fell asleep. Of the officially organized mandatory meetings, those dedicated to shaping the thoughts of the masses were the most required.

The assembly halls were sites for meetings of every kind and at every level, and were mostly a product of Communist ideology. Even today, with China's economic openness, ideology still dictates culture. With the development of television media, the Chinese government has found an even better means for conveying its ideology. The assembly halls are going by the wayside, and many of them have been abandoned or are being used for other purposes. But they remain testimonies to a bygone era and are deeply rooted in people's hearts. They now serve as memorials to important historic events, such as the first meeting of the Shanghai communist party and the historic Zunyi meeting, held in January 1935, establishing Mao as chairman of the CCP.

Yang Fudong's work concerns itself with another type of ideological pressure, reflecting a certain nostalgia for China's literati past. The fourth-century literati Tao Yuanming's (ca. 365–427) prose-poem "Peach Blossom Shangri-la" symbolizes the Chinese literati's escape from social and political pressures in their homeland. Yang's film *Liu Lan* (2003; pp. 66–69) is redolent of the lyrical, painterly ambience of the Jiangnan countryside and evokes the world portrayed in "Peach Blossom Shangri-la." There is a common saying in China: "Above is heaven, below is Su-Hang [Suzhou and Hangzhou]." Yang is a northerner who attended college in Hangzhou and has a special feeling for the Jiangnan countryside and parks. When he made his 2001 film *Su Xiaoxiao*, about a female poet and prostitute living at the turn of the sixth century, Yang stated:

> Historically there have been two Su Xiaoxiaos, one in the Southern Dynasties [317–589], the other from the Northern Song period [960–1127]. They are both sad tales. With such a long history, later generations of people look at her, having no regard for her grief but associating her with a kind of savage longing and beauty. It is not a completely fond remembrance. I rather prefer the feeling of the Southern Dynasties' Su Xiaoxiao. Although *Su Xiaoxiao* was shot in Suzhou, it is related to the kind of landscape I saw when I attended university at Hangzhou. For example, during the dark days of a Jiangnan winter, when you sit and look at the surrounding landscape, an indescribable sensation can come over you.[5]

Yang has also described a certain feeling, when spending restful time in nature and parks, of "not knowing what was real and what was imaginary, a kind of illusion, a kind of waking dream." In *Liu Lan*, some of the scenes filmed in the Jiangnan countryside are real and others are fantasy.

Lines from two well-known Song Dynasty (960–1279) Chinese poems are quoted in *Liu Lan*: "The gleam on the water as it ripples is best on clear days. / The appearance of the mountains, empty and hazy, is also remarkable in the rain," from "Drinking on the Lake" by Su Shi (1037–1101)[6]; and "The fishermen's songs echo each other. How marvelous is this music!" from "Record of Yueyang Tower" by Fan Zhongyan (989–1052). This is the realm pursued by classical Chinese poetry, literati painting, and gardens. It reflects how Chinese literati, at odds with the baser intentions of officialdom, adopted and yearned for the pristine landscape and idealized life of the countryside. In today's fast-paced culture, with its all-consuming human desires, Chinese intellectuals especially yearn for a place that is redolent of "poetic feeling and painterly idea" and a kind of illusory waking dreamworld.

To close out this essay, I would like to discuss Cai Guo-Qiang in the context of the Western art world. Many Western art critics attribute Cai's success to his transformation of indigenous resources, such as fireworks, into new art forms. I would argue that, in addition to his talent, Cai's success in the West results from his particular charm, wisdom, courage, and enthusiasm, as well as his ability to respond to the world around him. Cai is a great joker, in the tradition of Duchamp. After Duchamp, works of art became less important than the artists themselves—their ideas, concepts, and wisdom. Cai's importance lies exactly here: in taking Duchamp and pushing it to this place. "Strategy" is the key aspect of Cai's work. He uses elements of Western conceptual art, such as environmental art, and many other art modes, and connects them not only to various types of Chinese traditions and resources but also to historic events, art theory, and works of art that were considered important when he was growing up. His appeal lies in his ability to grasp every kind of connection—societal, art historical, environmental. Cai is also very good at gamesmanship, playing with authority, money, systems, concepts. And by playing his conceptual games, he compels us, the viewers, to investigate the life experience behind the art, its cultural traditions and art historical lineages in all their complexity.

Translated from the Chinese by Lydia Thompson

NOTES

[1] Leung Mee Ping, correspondence with the author, March 2004.

[2] Wilson Shieh, "Artist Statement," in *Hyphenation: Contemporary Hong Kong Art*, exh. cat. (Hong Kong: Grotto Fine Art Ltd., 2001), 23.

[3] Ibid.

[4] Postmodernist theory became very fashionable in China beginning in the mid-1990s, when Fredric Jameson visited mainland China frequently to give lectures. Many Chinese theorists and critics regard the phenomenon of mixing traditional and modern forms as a postmodern practice.

[5] Yang Fudong, interview by Li Xianting, "Searching for a Kind of Beauty," *Xin Chao* (New Wave), no. 12 (2002).

[6] The translation is from Michael A. Fuller, *The Road to East Slope: The Development of Su Shi's Poetic Voice* (Stanford, Calif.: Stanford University Press, 1990), 167.

IN SEARCH OF THE INCOMMENSURABLE: JAPANESE ART IN TRANSITION
Midori Matsui

I. From Emergence to Reintegration: Three Stages of Japanese Contemporary Art

The new Japanese art that emerged internationally at the end of the 1980s and spread its influence throughout the 1990s responded powerfully to the effects of globalizing modernity. Reflecting the changes in social behavior and perception of reality that were the consequences of modernity, while suggesting the means for transforming them, the new Japanese art became truly postmodern.[1] Its mutations can be mapped in three stages.

Between 1989 and 1992, Yasumasa Morimura (fig. 19), Dumb Type, Takashi Murakami, and Kenji Yanobe actively incorporated technological mediums and methods as well as icons of Japanese popular culture to critically reflect on problematic conditions of their postmodern world. These concerns included commodity fetishism, the cultural deployment of infantilism as a means of political control, and the phantasmagoric transformation of cityscapes into images out of science fiction films. Representing a generation whose identity was shaped by the enjoyment of consumerist and anime cultures of the 1980s, these artists formed the first wave of Japanese postmodern art, reinventing the idea and style of Pop as New Pop. They embodied a subversive aesthetic of a "minor" culture that transforms the influences of the dominant (Western) culture through the deliberately aberrant and playful usage of "modern" knowledge and technology.[2]

The empowered strategy of New Pop resembled the simulation of contemporary kitsch by American appropriationist photography and Neo-Geo. This tactic was opposed by a contemporaneous generation of younger artists, led by Tsuyoshi Ozawa and Makoto Aida, who deliberately sought out marginalized elements within the systems of modernization. Between

Fig. 19 Yasumasa Morimura, *Blinded by the Light*, 1991

1988 and 1992, Ozawa traveled to various parts of Asia. At key stops such as Tiananmen Square and the border between North and South Korea, he would leave *jizo*, effigies of the Japanese deity-protector of travelers. These took such ephemeral forms as drawings or human-shaped shadows, metonymical signs which the artist then photographed to mark his contact. In 1993, at a fashionable corner of Ginza known for its expensive commercial galleries, Ozawa set up a wooden milk crate as a temporary gallery, where he displayed his own and his friends' artworks (fig. 20). Aida resurfaced the memory of "war paintings," done by Japanese artists during the Second World War but excluded from postwar Japanese art history, in his parodic series *War Painting Returns* (1995–99; fig. 21), satirizing the postwar Japanese inability to historicize the consequences of blindly embracing institutions derived from the West.[3]

Embodying the return of the repressed against the modern rationalization of life, Ozawa and Aida reasserted the indeterminable nature of human activities, which they saw as elements affecting the course of history. Their incongruities or incommensurability constitute a "difference" within legitimized social structures. Such difference enables one to reinterpret history or to claim one's unique position within its interstices.[4] Both Aida's representation of a precise revisionist moment in Japanese art history and Ozawa's intervention in the public sphere suggest ways of existing that are different from those imposed by the many social constraints.

Japanese art today is in a period of transition, with many artists pursuing very diversified interests. Those who designate this "third wave" combine the impetuses of the first- and second-wave artists with changes suggestive of their responses to their own time. Like the first generation, current artists are interested in reflecting on the nature of the contemporary world, including its increased contingency and uncertainty. While refusing, like the second generation, to apply an empowered theoretical analysis to mundane reality, they turn away from subversive irony; they find greater significance in private experience, which is frequently nurtured by small groups of friends, and in sensory experiences triggered by everyday encounters. They seek to reconstruct their unique relationship with reality through their private contact with or physical perception of contemporary circumstances, frequently showing that the personal is inevitably intertwined with the political.

The five Japanese artists selected for *Past in Reverse*—Ryoko Aoki, Hiroshi Fuji, Mitsushima Takayuki, Tadasu Takamine, and Shizuka Yokomizo—belong to this third wave of postmodern art, which falls roughly into two groupings of dominant tendencies. The first extends the associative possibilities of drawing, and is apparent in the work of Kaoru Arima (fig. 22), Zon Ito, Tam Ochiai, Hiroshi Sugito, and Ryoko Aoki. These artists are characterized by an antimonumental tendency, producing bodies of work that convey an aesthetic attitude rather than creating individual masterpieces. Favoring ephemeral lines, vacant areas, and fluid interaction between the center and the periphery, their work projects a spiritual milieu through a combination of fragmented images, words, and subtle painterly signs. It evokes the process whereby images come into being out of memory fragments, activating viewers' own perceptions. Like classical Japanese design, which uses figurative form to explore abstraction, their work mediates the perception of reality as fluid, unformed, and full of the possibilities of refiguration.

Fig. 20
Tsuyoshi Ozawa, *Nasubi Gallery–Takashi Murakami exhibition [Little Aperto]*, 1995

Fig. 21
Makoto Aida, *Beautiful Flag (War Picture Returns)*, 1995

Related to this tendency toward fluidity are the tactile paintings of Mitsushima Takayuki, made with the unusual mediums of adhesive tape and tactile copy machines, which leave Braille-like retraceable markings on the surface of his works. Created from the free transcription of impressions acquired mostly through touch (the artist is blind), Mitsushima's tableaux present an even stronger performativity than that of standard gestural drawing; his boldly articulated lines mark the points and trajectories of the artist's contact with a phenomenal world. Broken, curving, or composing color fields, they transmit the intensities of his perception, while tracing its transformation in the imaginative integration of sensory data.

The second group of third-wave artists, including Hiroshi Fuji and Tadasu Takamine, inherits the interventionist or revisionist tendency of their second-wave predecessors. They attempt to recapitulate contemporary reality through the personal reintegration of public experience. Fuji does this by cultivating human networks beyond fixed social functions, creating a temporary space of collaboration through his recycling projects, which include the remanufacturing of domestic waste into usable objects or the refurbishing of an abandoned poultry farm into an art gallery. Takamine, for his part, pursues his tenuous sense of reality beyond legitimized systems of language. In his site-specific project *A Lover from Korea* (2003), for example, Takamine took an extremely personal approach toward the sensitive issue of the underprivileged conditions of Koreans living in Japan. The work is installed at the site of the Tanba Manganese Memorial Museum, which preserves the defunct manganese mine as a record of the history of forced relocation and labor of Korean workers during the Second World War and the Korean War. During his two-month residency at the site, Takamine made an installation in one of its caves, using gigantic vines collected from the surrounding woods and broken pieces of pottery made from local clay. The work is a synthetic allegory consisting of many paths to truth, and Takamine's diary records his contacts with the Korean director of this privately run museum—working together to build a hut, installing the piece—and receiving a letter from his Korean girlfriend, who was living in Seoul. Takamine's minute description of his own physical reaction to the dark and cold interior of the cave, and his emotional responses to the words both of the museum director and of his girlfriend, reconstruct his gradual comprehension of the history and reality of Korean residents in Japan. This process resembles a documentary film, conveying the weight of lived moments through a patient accumulation of details.

Fuji's and Takamine's interest in things abandoned by official plans of progress and in senses lying outside of functionally defined activities indicates their perception of reality as incommensurable. This attitude is shared not only by the first group of the third-wave artists, who celebrate the formlessness that underlies figuration, but also by photographer and filmmaker Shizuka Yokomizo, who has formed her artistic sensibility and conceptual strategy outside of Japan.

Yokomizo records states of abandon or suspension from habitual social interactions. The reality of the human body when it exists as mere being, in the interstices of meaning, is vividly captured in her film *When You Wake* (2002; pp. 132–33), which portrays elderly people in various stages of waking from their sleep. The film recapitulates their process of "growing human" from a deep state of primordial subconscious, to borrow Marcel Proust's comparison of the states of awakening to the stages of a cave man becoming a civilized man. Yokomizo's photographic series *Strangers*, shot between 1998 and 2000, also records moments and gestures suspended from the habitual frames of meaning. In it, individuals (strangers to the

artist), responding to her written requests, are captured standing at a window, looking out into the invisible camera lens of the unseen photographer. Their unfocused expressions and postures, revealing anxiety about and anticipation for a tryst that remains in the realm of pure possibility, attest to the incommensurability of the human body held between self-consciousness and an opening toward others.

II. Figuring Reality from the Basics: Embodying the Incommensurable in New Art

Whereas Yokomizo's artistic methods demonstrate a neutrality that reflects her freedom from national boundaries, those of Takamine, Mitsushima, Aoki, and Fuji ground their investigation of the incommensurable in their specific contacts with Japanese life. Takamine's distrust of stereotypes leads him to explore the situations in which his own senses and those of his audience are deprived of commonly expected facility. Yet his sensitive use of alienating factors paradoxically enables viewers to embrace the aberrant as strangely beautiful.

The perception of reality as incommensurable is explicitly rendered through the interactive devices of *Common Sense* (2004). In this installation, the audience is led into a dark room with sand covering the floor and paint splashed on the wall, furnished with pieces of old furniture and an artificial rock, from the top of which viewers can observe the ruinlike setting and the statements revealed by intermittent video projections. Announcing how human beings perceive the world in completely private manners, and how perception cannot be compared from one individual to the next, the statements incite a certain anxiety; yet the alienation also urges us to reconstruct our own sense of reality by going down to the basics of perception.

Common Sense exemplifies Takamine's indebtedness to an "allegorical" tendency of the first-wave postmodern artists. The word *allegory* here signifies an artistic device for evoking a larger socio-cultural context through a critical arrangement of mundane fragments. The characteristics of a postmodern allegory, described by critic Craig Owens as deploying "appropriation, site specificity, impermanence, accumulation, discursivity, hybridization,"[5] can also be applied to Takamine's work. Arranged as if part of a theatrical set, his objects urge the audience to act as both performer and interpreter of a hidden narrative. This multimedia theatrical strategy reveals the legacy of the performance style of Dumb Type who, in the early 1990s, attempted to project an allegorical picture of the global spread of capitalism and the effects of this spread, and specifically of the AIDS epidemic, on the body through a complex mixture of dance, music, texts, and film projections (fig. 23).

The increased ambiguity and the devices used to induce physical impairment indicate Takamine's departure from the precise discursivity of Dumb Type. Probing into the hidden and the obscure, seeking out the abject, Takamine's work reflects Japanese youth's desire to explore otherness within themselves, while making a tentative effort to account for the incongruities of contemporary life.

The drawings of Ryoko Aoki embody a contact with the phenomenal world by reenacting the unconscious process of integrating disparate images. The irrational accumulation of images, regardless of perspective, transcribes the swift unfolding

Fig. 22
Kaoru Arima, *Untitled ("Cold")*, March 15, 1998

Fig. 23
Dumb Type, *PH*, 1990–93

of dream scenes, while such recurrent images as multifarious flowers, dancing girls, and forests translate an internal landscape of adolescent desire. Tracing images through a carbon sheet from such secondary sources as advertisements, magazine pictures, and encyclopedia entries, Aoki compiles a direct projection of her purely personal feelings or memories; the flat juxtaposition of elliptically drawn figures evokes images conjured up by the waking brain. Presented in an installation, frequently accompanying objects or hand-drawn animations, her drawings incite an optical or perceptual play within viewers, lifting their senses above the commonsensical.

Mitsushima's tactile artworks, literally the products of a reconstruction of reality through his immediate contact with external things and the cultivation of sensorial stimuli, constitute an effective means for making viewers recapitulate the primary processes of perception and imagination. Through his public workshops teaching tactile painting, in which participants are encouraged to express one sensory stimulus through another, Mitsushima shares a way to perceive reality beyond the rationalizing functions of the eye. Whereas Takamine devises an instrument for limiting vision in order to emphasize the relativity of perception, Mitsushima uses the loss of vision to explore the possibilities of forming a common ground of communication.

While the works of the other four artists situate the audience as an agent of perceptual contact with reality, Fuji's art aims at creating actual public interstices, encouraging new relations beyond conventional local ties and attempting a wider dissemination of his recycling ideas. *Vinyl Plastics Connection* (1999–2003; pp. 112–13) extended the recycling of domestic waste to numerous sites throughout Japan; in its branch activity, *Kaekko Bazaar* (p. 111), children evaluated and exchanged their used toys, running a market and a game arcade that required no money. Fuji's idea of "public art" as the creation of an interactive space that encourages the emergence of alternative systems of living was nurtured by a two-year sojourn teaching art in Papua New Guinea. The experience of moving outside the systems and the history of modern art, loaded with its images of authority, made Fuji reconsider his artistic goal "from the primordial level of expression"; it urged him toward the appreciation of values outside of modern institutions. The open-ended and collective nature of his public projects extends life's incommensurability beyond the reification of values found in authoritative forms.

III. Conclusion: The Commonality of a Tentative Search

Insisting on the differentiable nature of perception, the new Japanese art, as demonstrated by these five artists, nevertheless provides hints for achieving a shared sense of reality. This work involves viewers as active agents, making them retrace the tentative paths toward truth taken by the artists themselves. Their art can be called quintessentially postmodern in that it recognizes the uncertainty of every epistemological framework and yet attempts to move beyond the modern belief in the rational control of human behavior or emotion, or the idea of history as having a logical design or goal, by reevaluating the ephemeral, the abandoned, or the repressed. Reworking the legacies of earlier Japanese postmodern explorers, the new art indicates a move beyond their critical harshness, modestly grounding its practice in the actual world, cultivating basic perception or "primitive" social relation as a resource for the recovery of wholeness, and amending the ravaging effects of modernity.

NOTES

[1] I use the word *postmodern* to indicate the expression that admits one's living in the world maintained by modern institutions, as well as the necessity of moving beyond it; in this I follow Anthony Giddens's definitions. He explains postmodernism as "aspects of aesthetic reflection on the nature of modernity," and "post-modernity" as the consciousness of the unreliability or relativity of all the epistemological foundations, the anti-teleological nature of history, and an awareness of the necessity of a new political agenda that seriously considers ecological concerns. My idea of postmodern art combines Giddens's definitions of postmodernism and post-modernity; see Anthony Giddens, *The Consequences of Modernity* (Stanford: Stanford University Press, 1990), 45–46.

[2] For the idea of "minor" cultural production as a radical subversion of a major culture by a "minority" group using the language or the artistic methods of a dominant culture, see Gilles Deleuze and Felix Guattari, *Kafka: Toward a Minor Literature* (1975), trans. Dana Polan (Minneapolis: University of Minnesota Press, 1986), 16.

[3] See Midori Matsui, "The Place of Marginal Positionality: Legacies of Japanese Anti-Modernity," in *Consuming Bodies: Sex and Contemporary Art*, ed. Fran Lloyd (London: Reaktion Books, 2003), 142–65.

[4] For the argument for the subversive nature of cultural difference, see Homi K. Bhabha, *The Location of Culture* (London: Routledge, 1994), 162–63: "Cultural difference, as a form of intervention, participates in a logic of supplementary subversion similar to the strategies of minority discourse" (p. 162).

[5] Craig Owens, "The Allegorical Impulse: Toward a Theory of Postmodernism" (1980), in *Beyond Recognition: Representation, Power, and Culture*, ed. Scott Bryson, Barbara Kruger, et al. (Berkeley: University of California Press, 1992), 58.

CONTEMPORARY ARTISTS OF SOUTH KOREA: A REFRACTED VIEW
Taehi Kang

The premise of this essay lies in the discussion of the South Korean artists in *Past in Reverse*, selected from the perspective of an "Other," within the framework of an "insider's" view, that of a South Korean critic. In other words, the artists handpicked by the Western gaze that has exercised so much influence on the formation of contemporary art in East Asia are introduced from the position of an author who shares their nationality and cultural referents. The hope is that the reader, then, will gain information about and interpretation of this exhibition through a kind of "dual lens" that combines an American curator's perspective and my own, providing a more diverse and refracted overview.

Four cultures are represented in *Past in Reverse: Contemporary Art of East Asia*. If we include Hong Kong and Taiwan under the larger umbrella of Chinese culture, the list comprises China, Japan, and South Korea, plus the United States, where this exhibition is being held. However, while the three Asian countries are relatively well versed in American culture and history, American knowledge of East Asia is not commensurate. China, Japan, and South Korea are, furthermore, informed less about the art of their own Asian neighbors than they are about American contemporary art. Such a relationship of differences and imbalances is precisely the basis of the current exhibition and also serves as the point of departure from which East Asian art may be understood in new and rewarding ways.

Recently, interest in contemporary art in East Asia has grown within the region as well as from outside. The viewpoint that casts doubt on the Eurocentrism inherent in the geographic designation of "East Asia" itself has already been raised. And among the people in this region, which has undergone the confusion of modernity and still suffers from the repercussions of modernization (deemed synonymous with Westernization), one witnesses visible efforts to view themselves through their own eyes rather than through the gaze of others. Within the currents of globalization, discourses originating from the West—such as identity and autonomy, tradition and modernity, globalization and locality, and center and periphery—have paradoxically brought about internal alliances within East Asia. Against this backdrop, there are several layers of meaning one can unearth in exhibiting the art of East Asia—long relegated to the artistic margins—in the United States, the "center" of Western art and a prime suspect of cultural imperialism and domination.

Furthermore, unlike Chinese art, which has only recently emerged as a "new mainstream" at international biennials after many years of alienation from the Western art world, the histories of modern art in Japan and Korea cannot be discussed in isolation from Western modern art history. In addition, compared to Japan, the source of orientalism in art, or even China, Korea is mostly an unknown factor for American audiences.

After the Second World War, South Korean modern art history began to be shaped under the heavy influence of Western art history, starting with Abstract Expressionism and Art Informel. From that point on, tensions arose between the international and the national, the global and the local, in terms of artistic trends and aesthetics. Most Korean artists had neither the time nor the access to information to digest all these new art forms and make them their own, though there were a few successful "translations" of foreign idioms into a genuinely Korean art. However, only in the 1970s was a collective effort made among artists to reinterpret traditional Korean art within the context of Western idioms and to make works of "Korean" modern

Fig. 24
Yoon Oh, *Song of Sword*, 1983

art. Whether or not this movement was successful, it did spark reaction, and one of the most unique concepts in modern art history–*Minjoong Misul* (People's art)–swept the culture (fig. 24). In the 1990s, postmodernism changed the scene profoundly, and many artists found it difficult to find their place, and their own identity, within it. This was due in large part to the fact that Korean artists did not have a solid foundation of modernism–an art establishment, like that in the West–against which to react. Therefore, the pervasive attitude was one of anything goes.

Befitting a country with the highest per-capita Internet connection and mobile phone use, South Korea is a dynamic society that responds quickly and sensitively to stimuli from the outside. Ever since the entire population was mobilized a couple of years ago on the occasion of the World Cup soccer tournament–a mobilization that astounded the rest of the world–there has been a visible coalescing of popular perceptions of culture, shepherded to a large extent by the Internet. This dynamism of society and its attendant confusions are closely linked to the export-heavy economic structure–an unavoidable situation for a small, divided country with few natural resources–and to the socio-political situation in which the very conditions that move society forward and accomplish rapid economic growth leave perennial social problems such as corruption and an overly competitive education system unresolved. Moreover, in the midst of the secularization accompanying South Korea's break-neck modernization, value systems are disintegrating and materialism has oversaturated the entire fabric of society. The gap between haves and have-nots is widening, without the safety net of a well-functioning welfare system. Meanwhile, Korean youths have assumed the agency of cultural transformation, quickly forgetting traditional Confucian philosophy and culture. Adhering to the fundamental right to pursue happiness, today's youth culture has placed individualism above everything else. And yet, on a societal level, the populace's demand for political reform is stronger than ever, and its desire for integrity and transparency is transforming the South Korean political and cultural landscape in vital ways.

In the arena of contemporary art, the South Korean art market, like that in many other countries, lacks vigor due to economic recession. Also lacking is a system that can properly supply art to potential buyers. Internet-based art sites and online auctions have debuted, but due to an underdeveloped collector base, many art galleries are not able to survive for long. Relative to the past, the number of exhibition spaces has greatly increased, and the role of the professional curator has grown sound. Nevertheless, widespread slapdash job performance still persists and there is a dearth of opportunity for ongoing discourse around curatorial practice. Exhibition philosophies and concepts tend to be developed on very short notice and are promptly forgotten. In the midst of this are a number of notable changes, including the emergence of highly visible young artists in their twenties and thirties; the active role played by alternative spaces; and the frequent mounting of international-scale exhibitions. The Kwangju Biennial, the Busan Biennial, and Media City Seoul, which all have by now found their footings, served to forge the basic infrastructures necessary in today's art world. The majority of South Korean artists, while still working in poor exhibition environments and with impoverished conditions for art-making, are learning how to survive in that art world. Given the opportunity, most artists would aspire to find their place in the international arena rather than remain in the small Korean field. Considering that the potential of Korean society, as we have seen, lies in its dynamism and "creative confusion," art is no exception.

The four artists and one artists' collective selected for *Past in Reverse* range in age from late twenties to late fifties. They all attended art schools in Korea and most have had experience studying or living abroad. This has afforded them exposure to new ways of thinking and to the international art scene, even while trying to maintain their identity and traditional values. As a result, these artists make a kind of "bilingual" art, which can speak both Korean and "international." However, it is often only after returning to Korea that they find their individual voices. The experience of such cultural bilingualism is both a challenge and a blessing, a double-edged sword.

Hee-Jeong Jang, who is in her mid-thirties, studied painting at New York University after attending college in Seoul. Since art school, Jang has been painting dolls and mannequins, and her subject matter has moved through a host of "feminine" topics, including Barbie dolls that she has torn apart to create "petals," taxidermied cosmetics bottled in formaldehyde, mirrors, and most recently, flowers. The latter was prompted by the artist's encounter with the Dutch tradition of *vanitas*, especially flowers painted against a black backdrop. In her own work, however, unrelated to the idea of the *vanitas*, Jang paints flowers on fabrics already printed with flowers, causing the painted and printed versions to become indistinguishable from each other. Using printed fabrics she has collected from all over the world, Jang cuts and sews patterns of flowers and insects into collages, daubs paint on them, and creates backdrops to transform them into completely new pictorial spaces. In the process, the artist uses Korean folk painting (*minhwa*) as a reference; this traditional artistic precedent brilliantly portrays natural subjects such as grass, butterflies, and birds, and finds new resonance in Jang's collaged screens.

Jang's flower paintings (pp. 86–89) address the problematic nature of representation. Her confusing of reality and representation, which surfaced in her earlier works with dolls, is explored further through such binaries as realism and hyper-realism, mass production and handicrafts, fine art and commercial art, readymade and adapted readymade, and Pop art and folk art. Her practice of painting on collaged images to create confusion between the real and the fictional is distantly reminiscent of Marcel Duchamp's *Tu m'* (1918; fig. 25), and the pictures layered on top of flower-pattern fabrics bring to mind the proto-postmodern works of the American Pattern and Decoration group of the mid to late 1970s. But whereas P and D artists utilized Pop patterns and decorations to undercut the boundaries of high art, focusing on the unique historical

Fig. 25 Marcel Duchamp, *Tu m'*, 1918

values and roles of decoration, Jang is concerned with the more fundamental problematic of representation, and its ongoing relevance. Her labor-intensive work may give the impression that she is stubbornly adhering to the power of image and representation, which is currently being challenged yet again. On the other hand, her work may also serve as a good example of an artist questioning whether her chosen medium—painting—is still an effective one in our digital era.

Yiso Bahc returned to Korea after living in New York for more than a decade. The period of his overseas sojourn coincided with the introduction of the theories of postmodernism and the rise of debates around identity, cultural adaptation and hybridity, and the "Other." Bahc was initially drawn to making artworks within those contexts and at one point even ran his own alternative space. After he returned home in the mid-1990s, however, he showed little interest in ideological topics and instead turned his attention toward more existentialist examinations of human efforts and the limitations thereof, as well as the fatigue and meaninglessness of life in general. Bahc felt the impossibility of expression so profoundly that he even characterized his own art as futile, vacant, and remote. Rather than striving for perfection or authenticity, he focused on the gaps or coincidences, interpreting them through paradox and humor. Seeking to confound the existing structures that determine value, he expressed these "gaps" in the form of unfinished objects or unsound structures made from cheap Styrofoam, wood beams, cement, and plywood. His work, then, appears highly un-artistic and anti-spectacle on the surface.

In works such as *Untitled (Drift)* (2000), in which the artist pitched a bottle equipped with a GPS (Global Positioning System) into the Gulf of Mexico as a commentary on the image of humankind exerting all kinds of effort to attain needless knowledge, as well as *Venice Biennale* and *World's Top Ten Tallest Structures in 2010* (fig. 26), which he exhibited at the Korean Pavilion for the 2003 Venice Biennale, Bahc dealt with the pointlessness of competition and the human drive for accomplishment. His painting *Wide World Wide* (2003; p. 82), a parody of the World Wide Web, consists of a map of the world that comes into form through the accumulation of names, clumsily handwritten by the artist, of real cities one has never heard of, set against a pale blue canvas and with candle-like dim lighting on the floor. It addresses the gap between the infinitely wide actual world made up of numerous obscure, unknown cities and the Web we constantly access through the Internet. What Bahc did in his practice was to contend with human limitations and ineptitudes, desires and failures, expressing an awareness of and empathy for our ultimate idiocies, while standing one step removed from them through his unique brand of humor.

Kim Young Jin, who has participated in artist-in-residency programs in New York and in Fukuoka, Japan, commands some recognition in the international art world, where he is usually classified as a video installation artist. However, it is difficult to call him a bona fide video artist as his work relies on simple and humble, rather than high-tech, techniques, and he utilizes these techniques more for the message than for any medium-specific qualities. Kim's "trademark" work, the *Fluids* series (1993–2002)—in which the artist sprays water and glycerin on a glass pane and projects the resulting images of droplets running and stopping on the glass—is an unexpectedly "simple" work, but its "scenery" is highly surprising and alluring. Such visual allure, however, seems to have obscured the more important question of why the artist is showing us the movement of fluids in the first place. As to the identity of the fluids, which are reminiscent of the blood flowing in our vessels or other

Fig. 26
Yiso Bahc, *World's Top Ten Tallest Structures in 2010*, 2003

bodily fluids, the artist states that the water drops are a metaphor for the vital constitutive element of all living beings and its circulation. This reading invites comparison with Bill Viola's work, which also uses water as a main motif. In Viola's *Nantes Triptych* (1992) or *Five Angels for the Millennium* (2001; fig. 27), for instance, water is a grand mass whose flow envelops and subsumes individual human beings. In contrast, the ebbs and flows in Kim's work create a grand epic poem on birth, death, and rebirth; the biological phenomena of the organic being that is the human body; and the circulation of nature and humankind.

In *Globe: The Passage of Anima* (2002), shot in a documentary-style format, Kim moves about with a camera attached to his body that uses 360-degree perspective to capture the images all around him. The optically seized images trace the movements of a man (the artist), who wanders through remote and expansive places until he finally reaches the ocean (p. 121), and of a woman, who drifts around in a complex interior space, which was shot separately. In this video, the parallel journeys of the man returning to the sea and the woman arriving at her bathtub are united by their conclusion in water. All distinctions between existence and nonexistence vanish, leaving only what the artist describes as "the universe's journey and the energy of movement." By this he means the transcendent state in which an individual is wholly one with the universe.

Soun-gui Kim moved to France after finishing graduate school in Korea and is currently teaching art in Dijon. From an early age, she studied the *I Ching* and Eastern philosophy and was deeply engrossed in Buddhist and Taoist thought; her scholarship and knowledge base spans both Eastern and Western traditions, of which she has acquired the wisdom to acknowledge and respect the differences and divergences. Furthermore, grasping early on the illusion of globalization, Kim draws from her distinctive heritage to create works in which her beliefs and life experiences are incorporated naturally. For her, a work of art is less about making something tangible than it is about a process of unfolding her thoughts, as in a conversation. And rather than imposing herself in the work, she prefers to let things flow like a stream of water.

Lunes (2003; pp. 76 right, 77) is a series of photographs depicting the movement of the moon, taken in long exposures (15 to 60 minutes) using a fixed pinhole camera the artist made. This "dumb" camera, which indiscriminately records whatever is exposed to its eye, does its job dispassionately and remembers all coincidental details that may be missed by the impatient human eye. These photographic images, reminiscent of a minimalist painting or Dan Flavin's fluorescent light work, may be compared to *TV Clock* (1963–81) by Kim's predecessor in video art Nam June Paik. Kim's photography "abuses" the very language of photography to destabilize its phenomenological notion of time. In the process, she dismantles, at its foundation, the distinction between making and taking a photograph, between straight photography and documentary photography.

In *Pap-gré* (2001; p. 76 left), an image of a frolicking pair is projected onto the surface of a Korean moon-shaped jar. Also called "The dance of two frogs and butterflies" or "The dance of emptiness," the video features two yellow butterflies, an insect that appears elsewhere in the artist's work as a reference to the famous dream of Chuang-tzu of which Kim is fond,[1] and two frogs, perhaps symbolizing, in their awakening from a long hibernation, the Buddha's Sudden Awakening.

Fig. 27
Bill Viola, *Five Angels for the Millennium,* 2001, i. "Departing Angel"

Though meticulous in its use of video and computer manipulation, Kim's work produces results that are low-tech and slow-paced. As in her photographs of the moon, she shows the viewer a generous and restful dimension of enlightenment. The story of Chuang-tzu's dream is one of confusion between sleeping and waking states, and the consequent realization that everything is empty and meaningless. In *Pap-gré*, the ancient dream and modern technology are happily joined.

Flyingcity Urbanism Research Group, founded in 2000 by theorist Jeon Yong-seok and two young artists, Jang Jong-kwan and Gi-soo Kim (the current core members are Jeon, Jang, and Oak Jung-ho), is a small artists' group that collaborates frequently with other artists and nonart organizations. Flyingcity is interested in the lives and circumstances of socially disenfranchised groups, such as the urban poor, the dislocated and homeless, and illegal migrant workers. Emerging with other artists' groups during the recent boom of new alternative spaces, Flyingcity locates its mission in research and criticism of the urban geographic reality of contemporary culture.

Flyingcity's *Drifting Producers: Cheonggyecheon Project* (2004; pp. 102–5) concerns a massive urban redevelopment project currently under way in Seoul. In the 1960s, it was decided, rather suddenly, to pave over the Cheonggyecheon (literally "Blue Stream"), which flows from north to south in the heart of the city, and to build an urban highway overpass. The recently elected mayor of Seoul, following through on a campaign promise, made an equally rash decision to pursue an immense project that reverses the previous plan—knocking down the highway, restoring the stream, and gentrifying the surrounding areas. From the beginning, there were clearly divided supporters of and opponents to the project; but with the rapid and successful reconstruction of the site, the public has mostly embraced the project. What Flyingcity accomplishes is to focus attention on the disruption to the shops, factories, street vendors, tool sellers, and others who have lost their homes in the process.

Cheonggyecheon was originally the location of an urban slum, and three or four decades ago its inhabitants were forcibly relocated to satellite cities having little of the necessary infrastructure. This urban history provides a potent context for *Drifting Producers: Cheonggyecheon Project*. Under the now-demolished overpass, there were once massive malls packed with small shops. There, one could find all sorts of steel and metal wares, tools, electronics and parts, used and new merchandise, and knock-offs and illegal goods. It was often said that in this unique place one could buy anything except nuclear weapons. Based on their research and encounters with merchants of Cheonggyecheon, Flyingcity discovered that the hardware stores co-residing there with seemingly no order were in fact highly organized networks resembling production assembly lines, and the group criticizes the government's policy, based solely on the logic of late capitalism, of relocating these merchants to the outskirts of the city. Flyingcity also made a *Talk Show Tent* in which it sought to highlight the shop owners' personal stories, presenting them on the street in the format of a TV talk show. The members of the group continue their efforts in this area in collaboration with other organizations, such as Consortium for Urban Environment and Urban Architecture Network. At this moment, the accomplishments of this small artists' collective are ripe for evaluation. In terms of both theory and practice, their work warrants a more sensitive contextualization that puts it in relation to trends in contemporary art while also making distinctions from such a context. By bringing into focus,

in such a lively manner, issues previously abandoned or neglected by contemporary art, Flyingcity makes an undeniable contribution to the field, and their work has deservedly garnered interest from within the country and without.

Although I proposed at the outset of this essay the possibility of differences between the "Other's" gaze and that of the native, it appears that with the exception of Flyingcity's projects, most of the works discussed here do not require knowledge about the particular circumstances and specificities of South Korean art. This is partly because so many of these artists have studied in the United States or in Europe, but it also has to do with the fact that art has gained a common ground as a global language. Without doubt, there are many other notable artists in South Korea, and they could very well present different pictures of Korean art than the one portrayed here. However, just as the picture of a whole is always composed of various distinct parts, the premise of this exhibition—that past and present, East and West, are intertwined—could very well highlight any aspect of contemporary Korean art. For these constitutive features are like an open weaving whose warp and woof meet with and depart from one another endlessly. As different perspectives, including this exhibition, cross one another and accumulate over time, we will gain ever-more complete and complex portrayals of Korean art, Asian art, and global art.

Translated from the Korean by Doryun Chong

NOTES

[1] Chuang-tzu, a fourth-century BCE Chinese philosopher, was an influential teacher and an important interpreter of Taoism.

PLATES

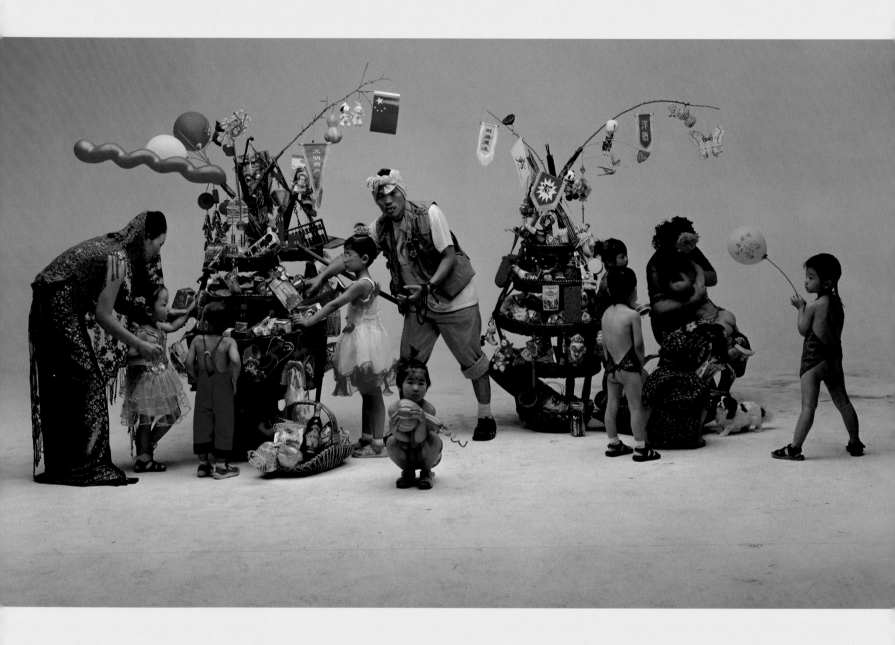

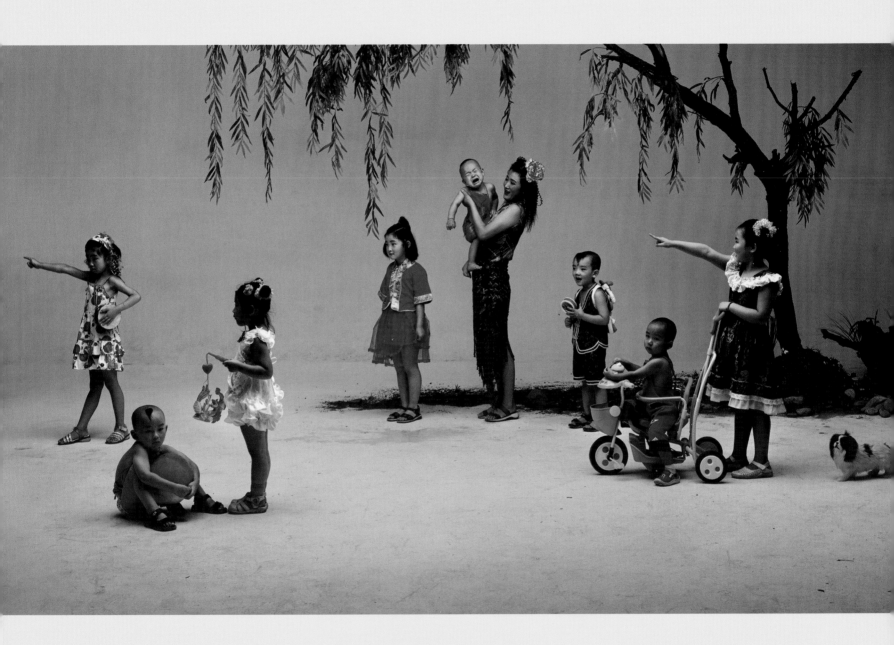

WILSON SHIEH

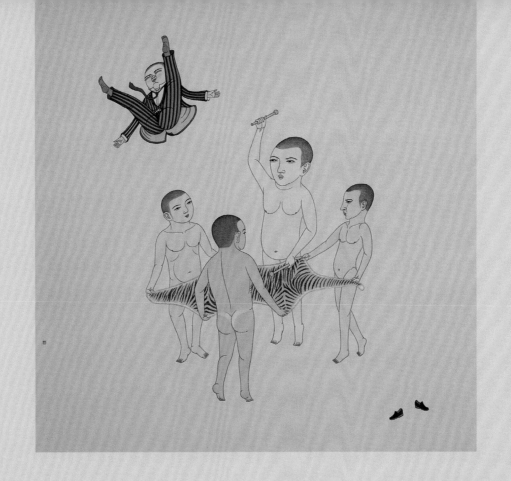

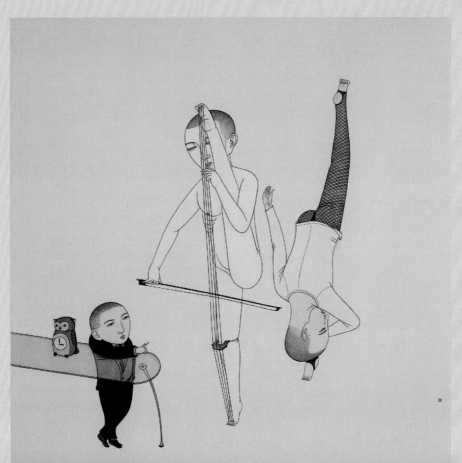

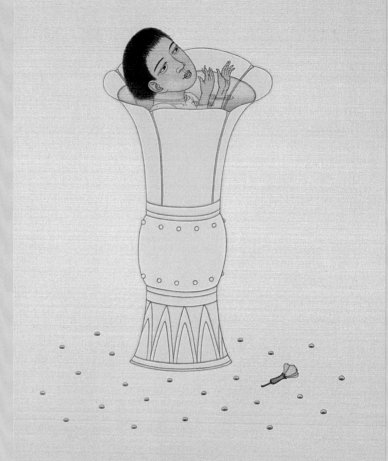

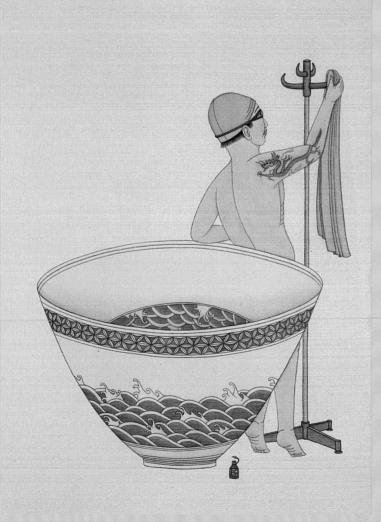

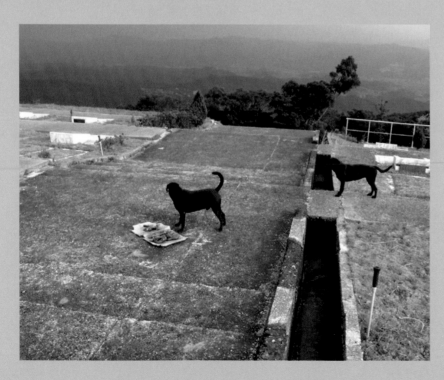

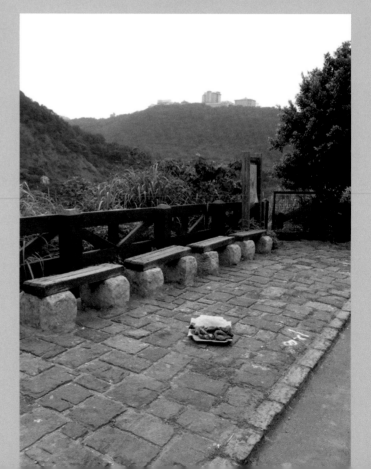

63

YANG FUDONG

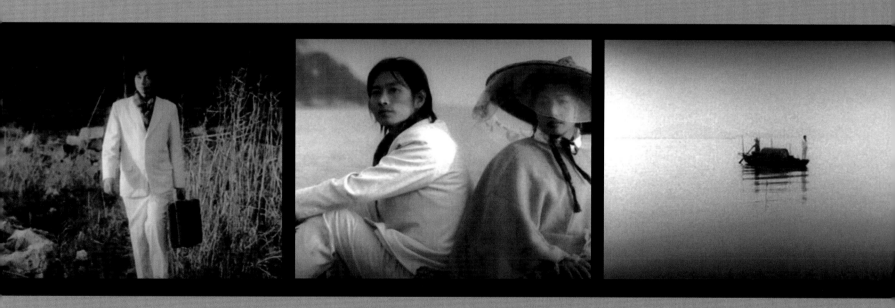

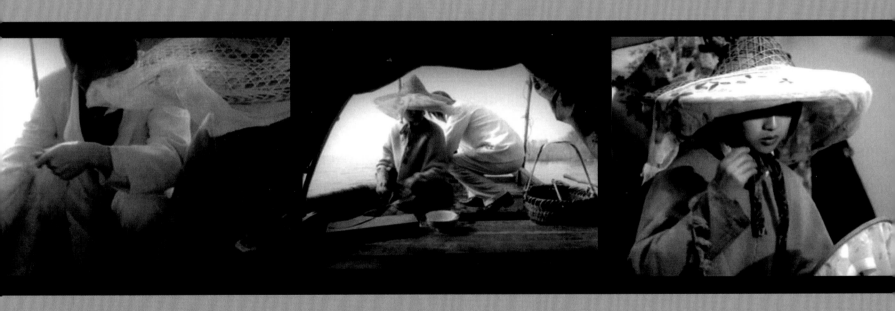

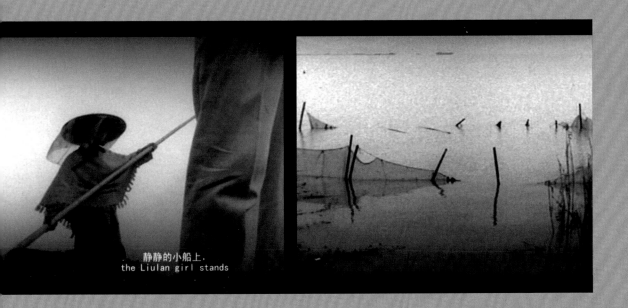

静静的小船上·
the Liulan girl stands

TADASU TAKAMINE

SOUN-GUI KIM

YISO BAHC

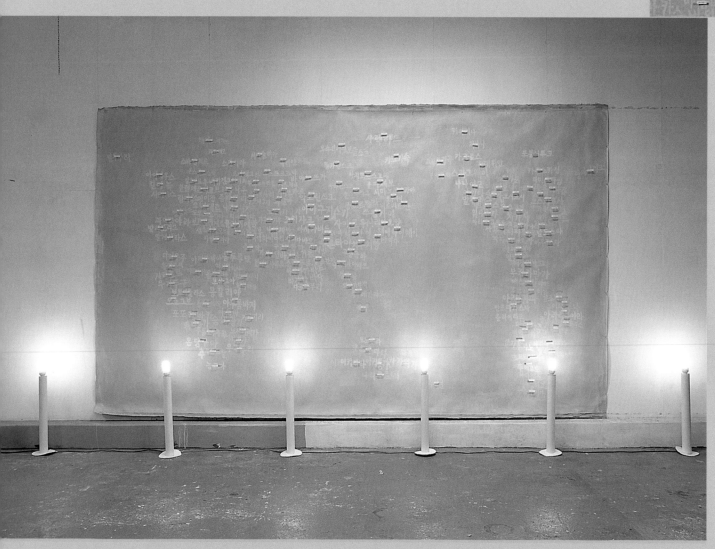

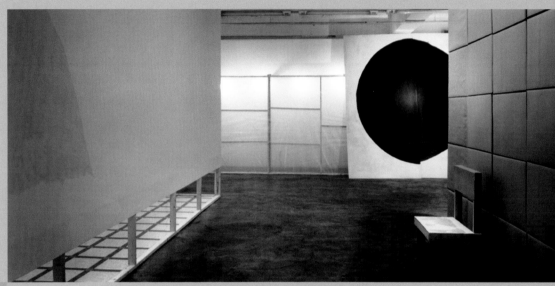

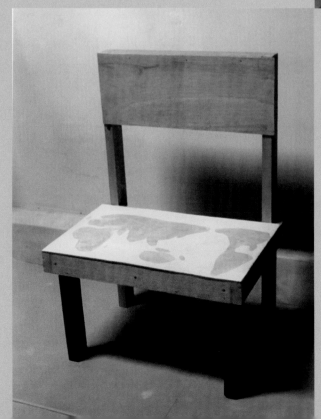

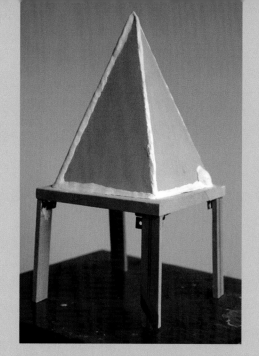

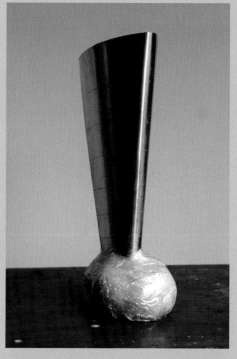

2004 년 열두달

〈열두달 =열두 조각〉

Nothing Sculptures + Calender

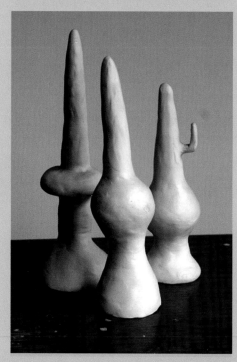

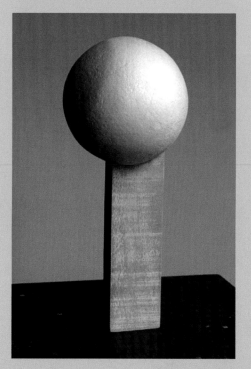

84

HEE-JEONG JANG

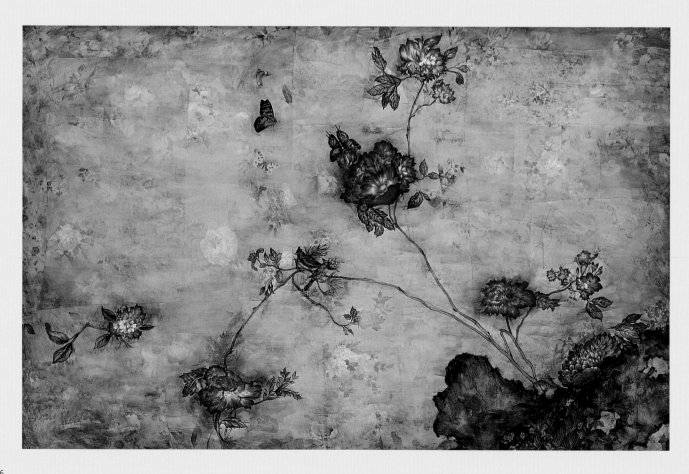

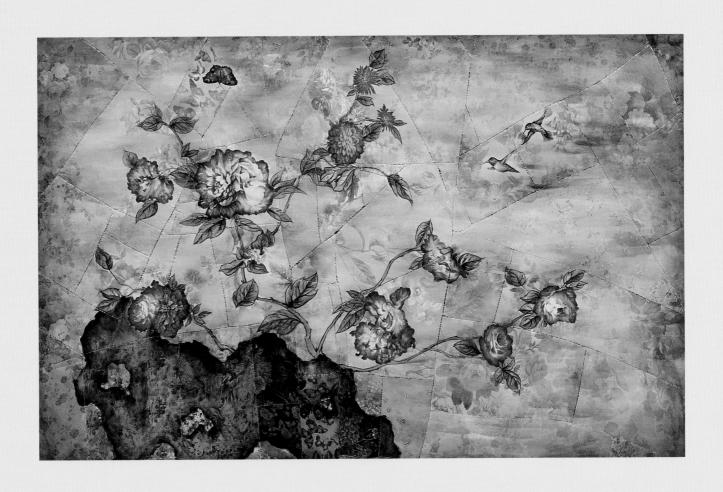

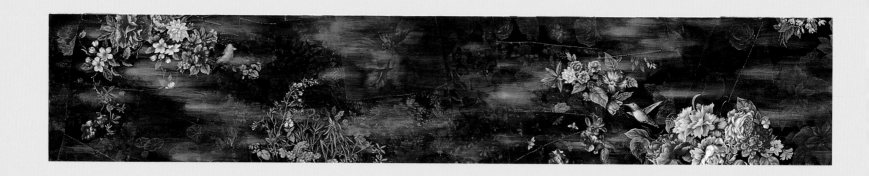

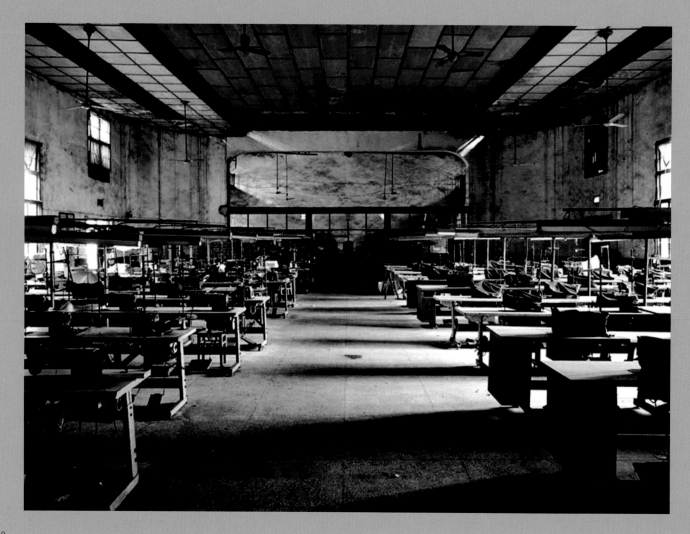

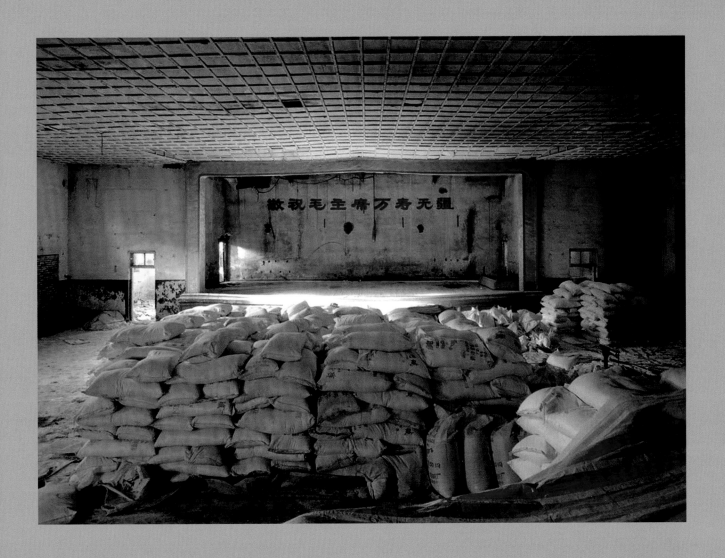

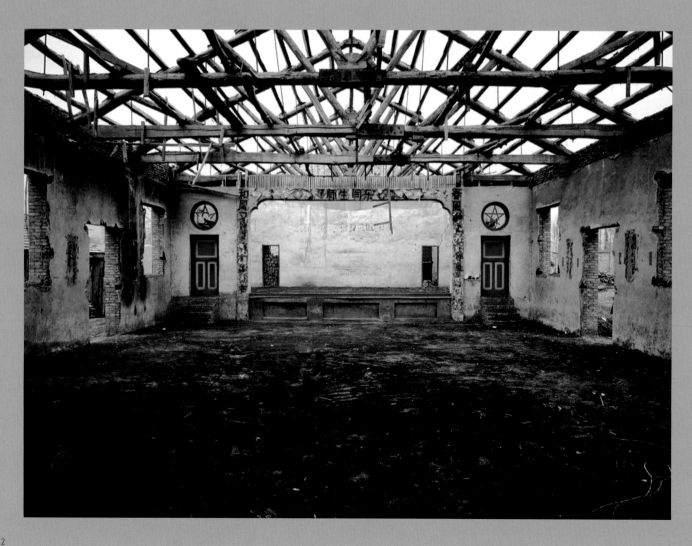

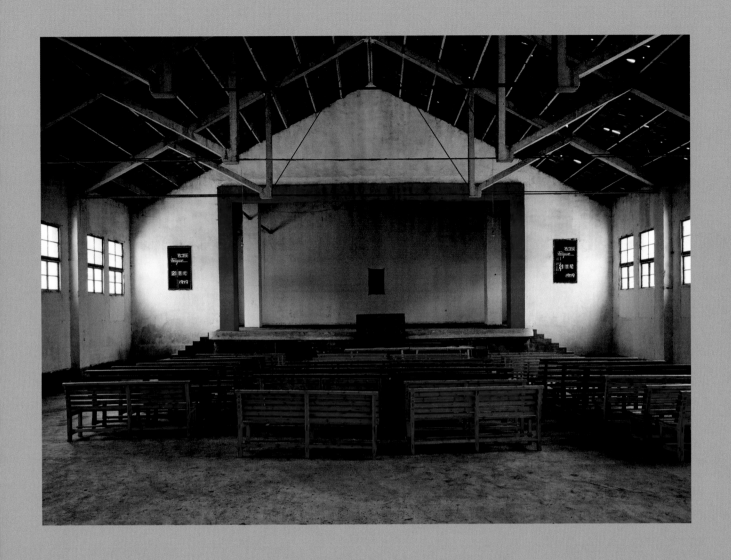

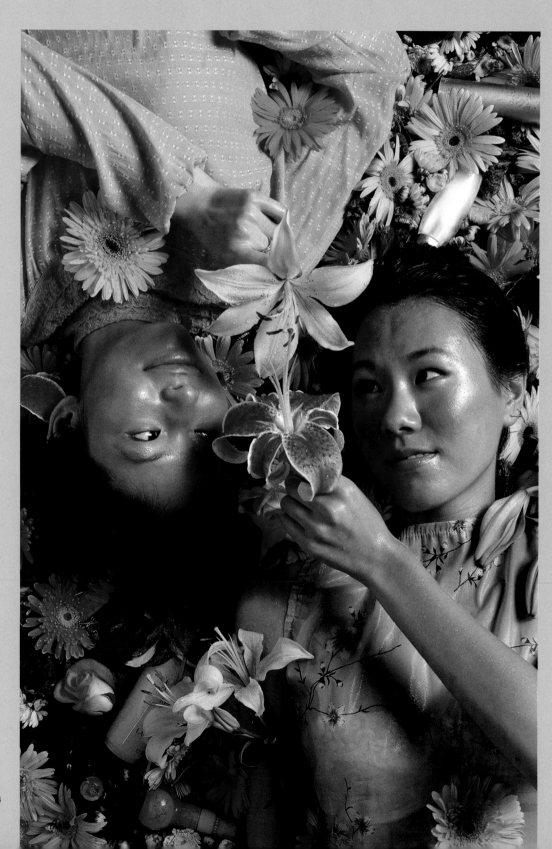

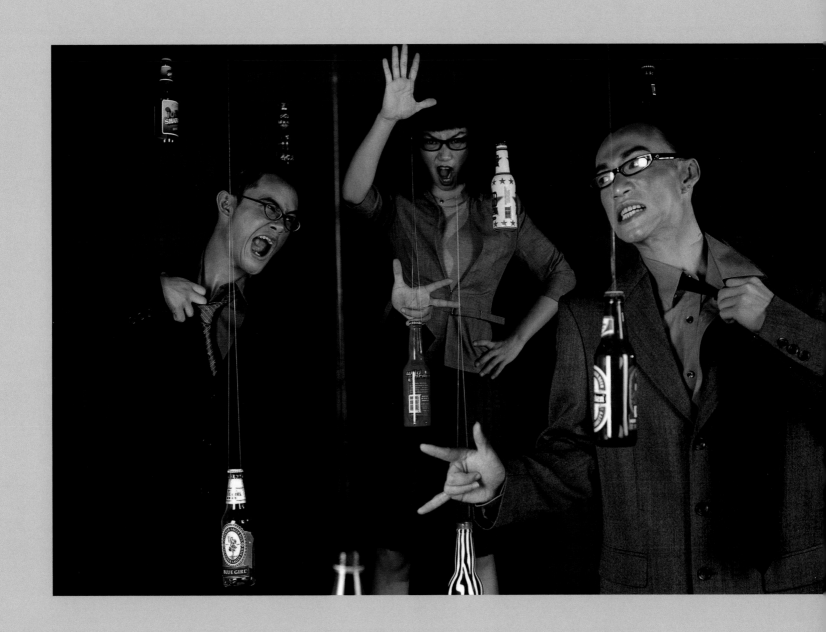

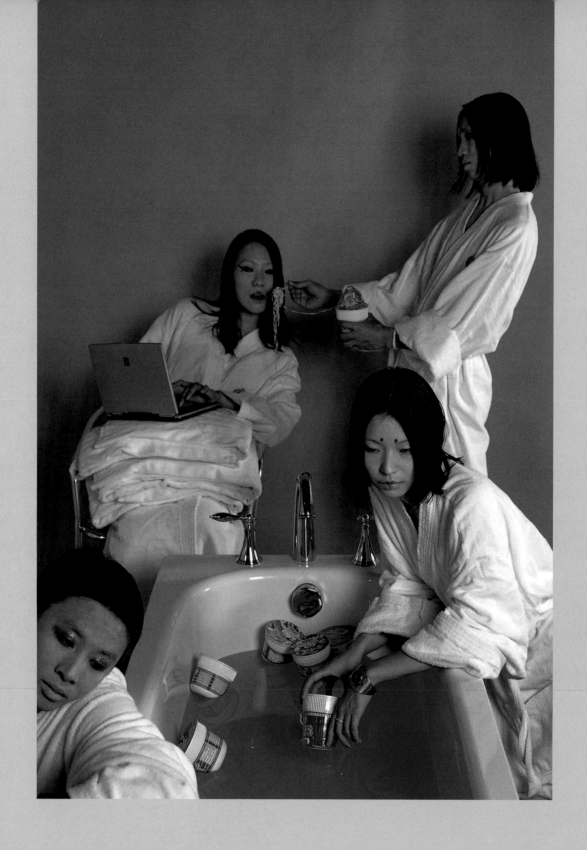

MICHAEL LIN

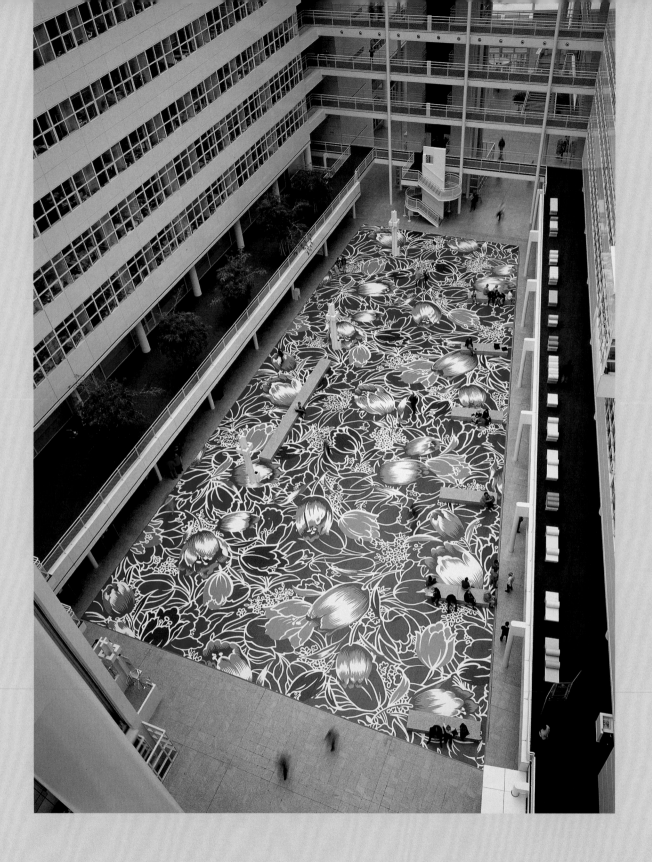

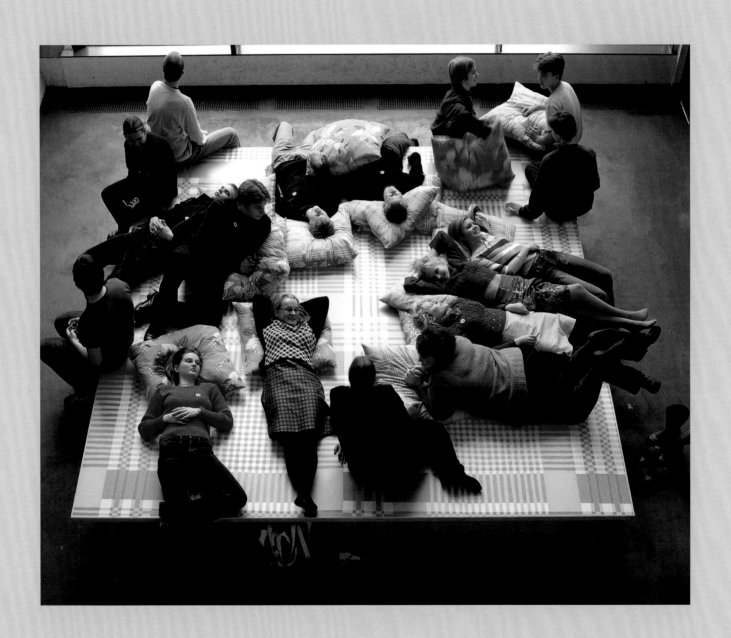

FLYINGCITY URBANISM RESEARCH GROUP

플라잉시티의 청계천 프로젝트 중 하나인 '이야기 천막'은 노점상들의 이야기를 잘 들어보자는 의도를 가지고 있다.

청계천을 취재하면서 우리는 수많은 '이야기'들을 접할 수 있었는데, 이러한 일상들은 많은 경우 주목 받지 못하고 허공으로 증발해버리거나 현재 문제가 되고 있는 생존권 투쟁과 같은 이슈에 가려 보이지 않게 된다. 현재 청계천로에는 열 한 개의 노점상 천막이 생존의 현장을 지키려는 목적으로 서있는데 그들의 풍부한 이야기가 집단 이익의 차원으로 단순화되는 것 역시 바람직하지 않은 것 같다.

우리는 집회에서의 목소리가 아닌 낮은 톤으로 말하되 사람들의 주의 집중을 받을 수 있는 어떤 형식을 상상했고, 이것은 파라솔의 색을 이용하여 디자인한 깃발, 천막 등을 거리에 설치하고 그곳에서 토크쇼 형태의 이벤트를 진행하는 것으로 이어졌다.

공구상가 네트워

청계천 금속 공구 상가를 답사하면서 놀란 것은 가게들 상호 연관 관계가 견고하고 유연했다는 것이다.
겉으로 보기에 무질서하게 얽힌 채 무감각하게 일이나 하는 것으로 보이는 이 공간은 나름대로 일종의 카오
스적인 질서를 갖춘 채 움직이고 있었다. 이 카오스적인 질서의 하나는 공구상가 내에서 만들어지는 상호 거
래 관계였다. 원자재와 설계, 가공, 판매의 과정은 각각 독립적으로 존재하면서도 일관된 생산라인을 형성하
고 있으며, 동시에 최종 수요자의 요구에 따라 유연하게 재편성될 수 있다. 가령, 을지금속-영광주물-부광분
체칠공업사-월드특수조명 으로 이어지는 라인과 같은 것이 존재한다는 것이 일단 새삼스러웠고, 한편 이 생
산라인은 그렇게 하나로만 이어지는 것이 아니라 물량과 물건의 특성에 따라 신축적으로 운영되고 있었다.
안정적인 생산라인의 존재는 경쟁력 유지에 필수적이다. 생산라인이 흐트러지면(한 가게라도 빠져나가면) 단
가가 높아져서 다른 곳하고 경쟁이 안 된다고 한다.

이와 같이 잘 드러나지 않는 금속, 공구상가의 결합관계는 쉽게 보이지 않는 경제의 비공식적 부문과 겹쳐있
고 이 때문에 상당히 부풀려진 측면도 있다. 총 부품을 만들어 주었다느니, 어느 날 조폭이 와서 대검을 만
들어 갔다느니 하는 이야기들을 주워들을 수 있었지만 사실인지는 알 수 없다. 어쨌든 그 비가시적이지만 확
고한 네트워크가 탱크도 만들어 낼 수 있다는 청계천에 대한 루머의 원천인 것은 분명해 보인다.

다이어그램은 가게들의 결합관계를 표시하되 선형적으로만 존재하는 것이 아니라는 점과 물류 동선의 물리적
인 복잡함(골목길)을 고려하려 그린 것이다.

They tell that it is entangled

and chaotic as labyrinths

Raw metal

a Fa
scin
atio
n.

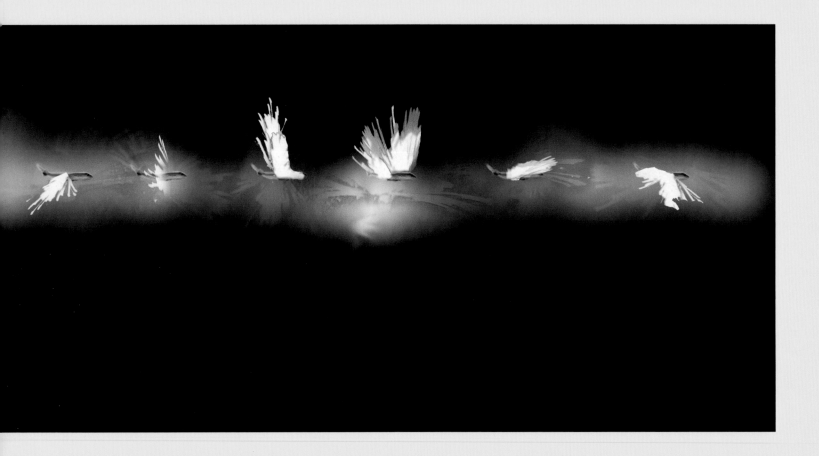

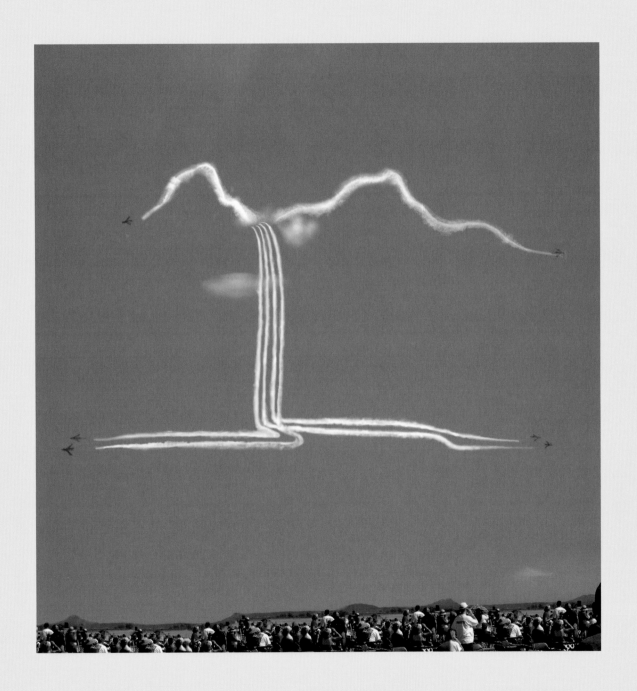

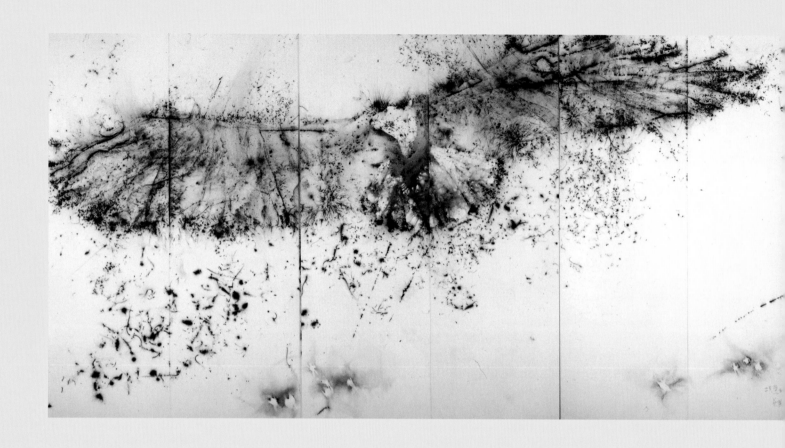

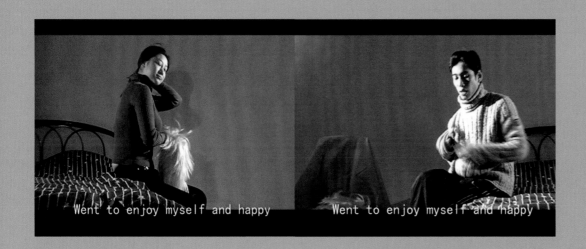

Went to enjoy myself and happy Went to enjoy myself and happy

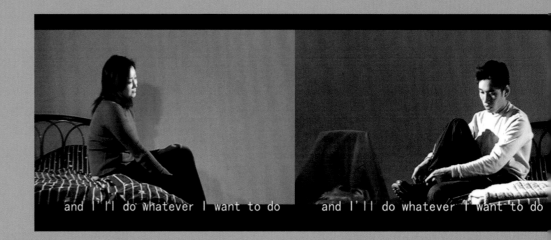

and I'll do whatever I want to do and I'll do whatever I want to do

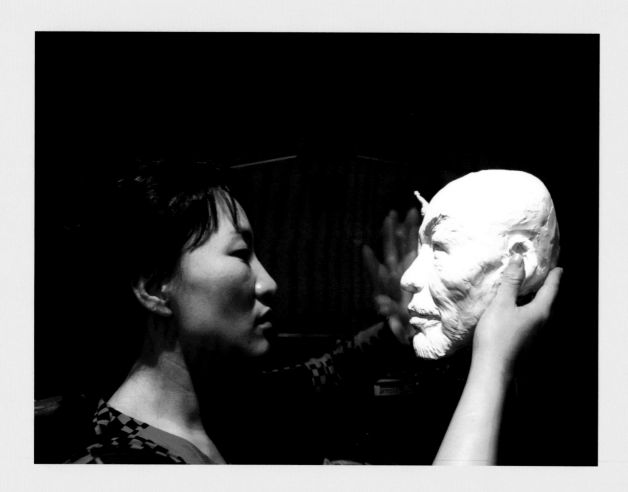

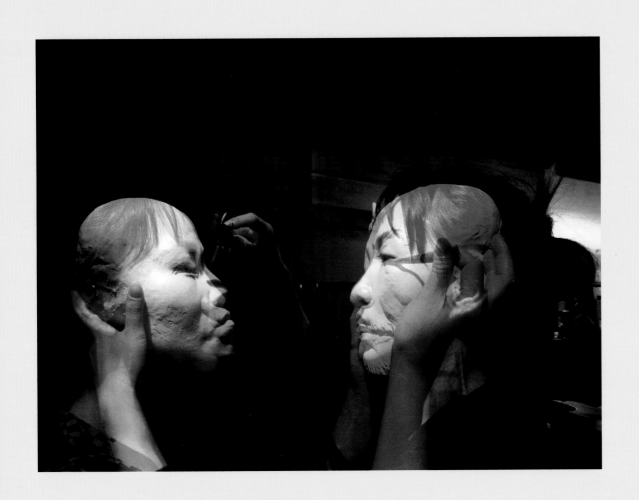

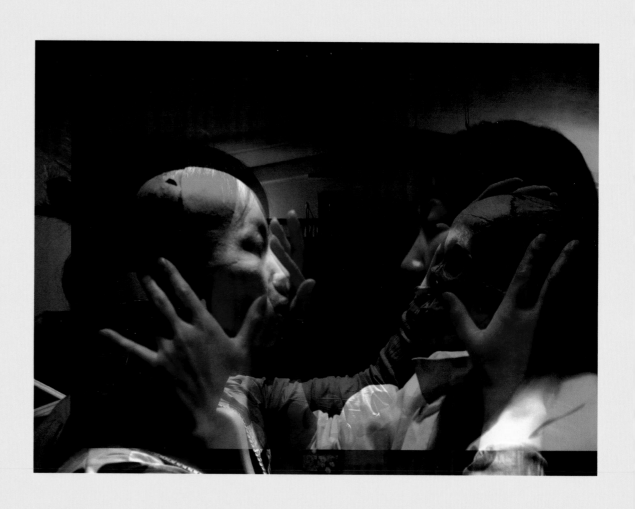

搞怪秀創意 藝術總統人人當

心國、美之國、迷猴國 還有屎國 九藝術創作競選

【記者周美惠／台北報導】總統大選引發的爭端尚未落幕，又有人搶著競逐總統大位。一群藝術家昨天發起「藝術總統人人當」行動藝術，他們裝扮成各式造型、高舉競選口號，遊走台北街頭，所到之處只見民眾交頭接耳。

一九九一年參加國大選舉，並籍「蒙娜麗莎杜象村」造型，在選舉台上大肆宣揚藝術理念的藝術家張永村，曾在對選舉懷抱高度熱情的藝術家張永村，走台北街頭。上兩屆總統大選期間，張永村更先後策動「心靈總統大展」，將自己虛擬為「體制外總統候選人」加入選戰。

今年的總統大選，張永村也不甘寂寞，號召八位藝術同好「競選」，在選戰最炙熱的二、三月間，他們先後在高雄、台中、台北舉行「藝術總統展」觀念藝術展，現在更將靜態展覽化為行動藝術。宣稱他們「不定時、不定點」隨時可能「出現在你身邊」。

張永村認為，以國家為單位的政治領袖，只能制；藝術的世界裡，可從個人的總統仍得受內外在箝有一位總統，而政治上的總統仍得受內外在制；藝術的世界裡，可從個人的內在出發，以外在的藝術形式表達無窮盡的創意，因此人人可以當總統。

九位競選藝術總統的藝術家，張永村將佛陀、聖母與耶穌及蒙娜麗莎的影像化為輸出圖檔穿在身上，號稱是「靈藝牛神人」；劉實生以謎樣南洋少女的裝扮，主持「心靈光國」；施工忠吳提出非統非獨的「無國度宣言」；洪易化身巨鴨造型，提倡「鴨霸國」的「三大共識九大宣言」；吳鈺珊的「心國」強調「在這心裡住著許多心」；許景淳的「美之國」宣稱「人人是總統，世界真美好」；李俊陽「台灣迷猴國」諷刺不知該選誰當總統的現象；Rebeca「心靈之國」的宣言是「協助人類尋求純粹昇華的進化」；阿庚「屎國」提倡「認真放屎做自己」。

93.3/25 聯合報

民生報　　中華民國九十一年七月二十八日/星期日

李立群的鄉愁在舞台劇

在大陸演電視劇 一檔接一檔 回台灣演舞台劇'練功、磨戲'

記者紀慧邦/專訪

開過泡沫紅茶店、餐廳、pub 看見人生百態

洪易 生猛彩繪普羅眾生

【記者黃寶萍/報導】

兵器 武功秘笈 不藏私

百年武術史料展秀出來

【本報訊】

1993年　藝術新樂園複合式餐飲

1993 - "New Art Paradise" Food & Drink Place

In an old warehouse from the Japanese era with a mosaic pillar outside and a theatrical stage for a bar, colorful lanterns with rotating shadows,trendy men and women all set the scene for a chaotic time.

An impossible possibility and an unpredictable predictability sum up the spirit of this new paradise.

People come and go, eating, drinking, chatting, having fun,

but no one actually understands what my new paradise is all about.

我愛子的吧枱，日本時代的舊倉庫，時髦的男女女，馬賽克的柱柱，以及五彩繽紛的走馬燈，
訴說著渾沌時代的來臨，一種不可能的可能，一種未知的預知，一切訴說著新樂園的心樂園。
來來往往的人，吃飯、喝茶的人，聊天、禱義的人，其實不懂我的 心 樂 園 。

1998年　RABBIT【兔子】複合式餐飲

I'm used to observing the different moods of people in pubs. In such places, loneliness, laughter and lamenting can break out like fire, I know. And I always have a lonely flower in my hand, ready for someone willing to awaken it.

我習慣了觀察PUB的人生百態，
在那種地方，
也如道寂寞，歡樂、夢問，
竟然都可以燃燒的。
而我也往往在這個時候，
手捧著一朵寂寞的花，
守候著有人願意讓它想燃起來。

1998 - "Bunny" Food & Drink Place

2000年　第一屆20號倉庫駐站藝術家．駐站的夢．——

2000 - The First Artist to Exhibit in Railway Warehouse 20 - "Happy Buddha"

When you're happy as Buddha, Buddha is happy. Everything starts from your heart. You reap what you sow. Be happy everyday. You see everyone has carnal, material and emotional needs, and if you get what you want by fair means, then you're happy. When you ask for things at the altar, the words tell the people of Taiwan that here in this spiritual realm of invisible wishes we are silently led astray. We breathe in the illusions, hallucinations and desires that are in the air all around us. Without knowing it, they seduce us and there is no happiness any more...

駐站期間，想像自己是凡人，是聖起是修行者，塵世間的俗世，每天都隨著自己的心情而轉換。
時而喜悅、時而憂愁、時而重瘀、時而盛衰。一直想完成一幅大畫，幻想著它的出生。
所以給自己一個進駐20號倉庫的夢。2000號大畫的夢，2000多萬台灣人的夢……為這夢祈福……
希望這塊土地……國泰民安。

129

SHIZUKA YOKOMIZO

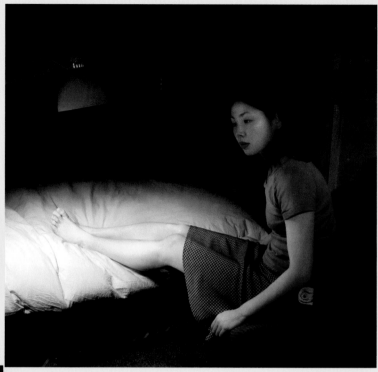

LEUNG MEE PING

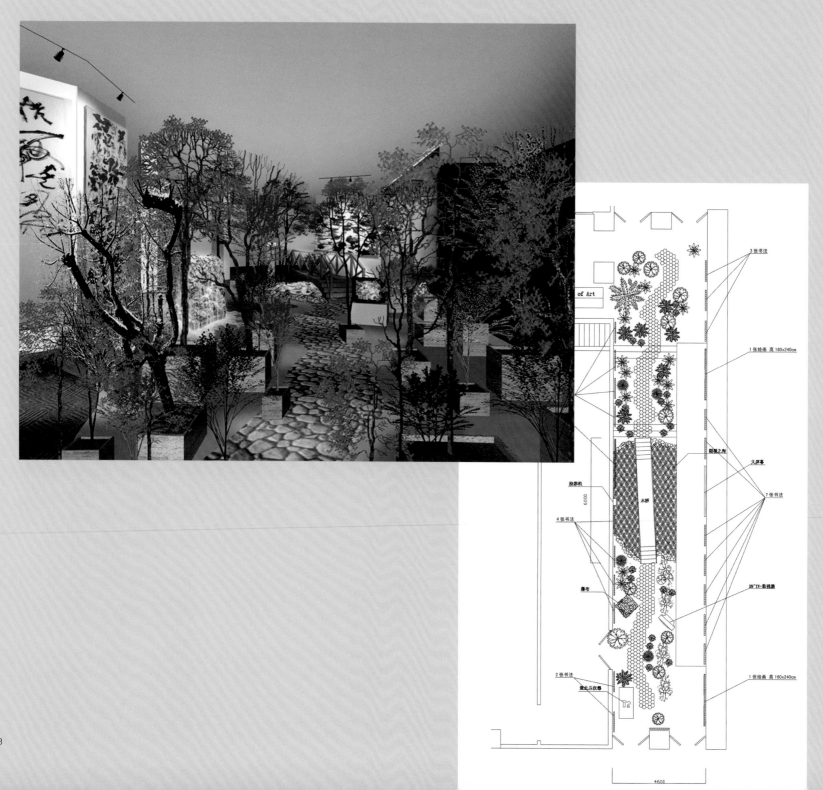

ARTISTS AND WORKS IN THE EXHIBITION

RYOKO AOKI

Born 1973, Hyougo, Japan; lives in Kyoto, Japan

Training Room
2004
Installation with small drawings of varying sizes
10 x 12 x 10 ft. (3 x 3.65 x 3 m) overall
Courtesy of the artist
Page 122–25 (details)

In her highly associative compositions, Ryoko Aoki gathers an assembly of individual elements into small, tight groupings of image types ranging from floral patterns to the drawing styles of adolescent girls. She works magic with common drawing materials—pens, pencils, and colored markers—and makes use of the color of paper itself. Aoki draws close in to the body, and the movement of arm, wrist, and fingers can be tracked through her intricate and deliberate markings. Influences culled from traditional calligraphic drawing and ink painting share space in the artist's storage-and-retrieval system with such popular-culture sources as graphic novels and animation. Aoki is working with an approach counter to Takashi Murakami's Superflat aesthetic, while also engaging, like him and his followers, the popular arts of the past as well as their contemporary counterparts, such as anime, manga, and pop dolls. Aoki returns them to the local and the personal, and to feminine space.

A historical reference for the construction of space in Aoki's drawings is the Kyoto-based e-maki pictorial handscrolls of the late Heian and Kamakura period, such as *Saigyo E-Kotoba Monogatari* (Illustrated biography of the monk Saigyo) from the second half of the thirteenth century. This painting is filled with refined details and "space cells," distinct areas of pictorial activity that define freely drawn areas of landscape—cherry blossoms, a view of Chisato beach, an arc of rough pines.

In a similar way, Aoki's drawings give us access to the discreet, secret places that end up on her small pages. She invites us into her private world as onlookers. The curator Kenji Kubota has written that Aoki's "realm is in no way a promised land of paradise where there is permanent happiness, but it is a very delicate and fragile world which could disappear at a single noise or sound." Aoki's natural world, fertile and verdant and seemingly innocent, is peppered with dark and shadowy imagery—skulls, menacing eyes, bad witches, and dark holes. She seduces us into this imaginary world in part by awakening our unconscious recall of how young girls draw and by evoking the stirring desires of youth, whose vulnerability cannot be disguised. Though the artist uses spatial constructions specific to Japanese aesthetics, she also utilizes methods of transformation not available in traditional Japanese art.

Aoki often displays individual works in room-size installations, in an effect similar to wallpaper or in seemingly random clusters. Their organizing principle is derived from how girls decorate their own room, prioritizing items that on their own may seem insignificant or impersonal, but through placement and organization come to be identified as highly personal and even idiosyncratic. The pictorial resonance of childlike imagery is coupled with celebratory decorations associated with Japanese national festivals such as Tanabata, which takes place on July 7. The visual elements surrounding this festival include woven streamers, origami, small hanging strips of colored paper with wishes written on them, and paper kimonos, all of which transform the city streets into a kaleidoscopic swirl of moving color. The festival was brought to Japan from China during the Nara period (710–84), and it later evolved into a celebration for children and young girls wishing to improve their skills in sewing, weaving, calligraphy, and other handicrafts. By aligning her imagery with these types of cultural festivals, Aoki embraces the cheap ornament as a truly valuable source for her semi-conscious spatial wanderings.

Ryoko Aoki completed her MFA at Kyoto University of Fine Art (1999) and that same year had her first solo exhibition, *Aokigahara, Sea of Trees*, at Gallery Blue Nile, Osaka (1999). Other solo exhibitions include *Sliding Circle*, Marc Foxx, Los Angeles (2004); *gluesights*, Kodama Gallery, Osaka (2002); *criterium 51*, Art Tower Mito, Japan (2002); and *Patterns*, Kodama Gallery, Osaka (2000). Group exhibitions include *Slow Painting*, Daiwa Radiator Factory Viewing Room, Hiroshima (2003); *Dark Shadows*, Marc Foxx, Los Angeles (2003); Watari-um Museum, Tokyo (2003) (in collaboration with Zon Ito); Kyoto Biennial (2003); *Beautiful Life?*, Art Tower Mito, Japan (2002); Yokohama Triennial (2001) (both in collaboration with Zon Ito); and *Music Video Festival 2000, The Video Bar*, Northern Photographic Center, Oulu, Finland (2000).

—BSH

Wide World Wide
2003
Acylic and oil on canvas, paper labels, and light fixtures
Painting: 95 1/4 x 163 3/8 in. (242 x 415 cm)
Installation: 104 3/8 x 200 5/8 x 9 7/8 in. (265 x 510 x 25 cm)
Courtesy of Mr. Daeyeol Ku and friends of Yiso Bahc
Page 82

In looking across Yiso Bahc's artistic practice, it is almost impossible to pin down precisely what he was meaning to do. This may be due in part to the artist's own uncertainty or indecision about how to complete the communication between artist and audience. But it is probably driven more by Bahc's interest in the ephemeral and his attraction to the conception of time in ancient cosmologies as in some ways unknowable. The making of artwork about that which cannot be known or cannot be seen has been part of the Korean artistic psyche for a long time. In recent history, it was evident in the monochromatic painting movement of the mid-1960s, which continues to influence many younger artists. These paintings took advantage of the void, an East Asian concept that is aligned with the nonartificiality of Taoism and the desire to follow nature by harmonizing with it. Bahc's references to the paradoxical nature of time, along with the only marginal successes of material form at representing the ephemeral—the not quite there, the quixotic—show how he struggled to find a path through the interstices of this maze of "thereness" and "not thereness."

In recent years, Bahc had embarked on a series of elegant works using informal materials such as processed wood, plaster, clay, paper, sheetrock, glass, and abject found objects from the streets of Seoul. All these materials were brought into service of a construction/deconstruction modus operandi, as in *Today (at Yokohama)* (2001), which included taking apart sections of wall and placing them on the floor, where a live video feed of the sun beamed across it. He sought to disorient viewers by displacing normal codes of spatial comfort—vertical becomes horizontal, outside moves its way into the space of the gallery. In another example, *Untitled (Drift)* (2000), Bahc floated a plastic container equipped with a Global Positioning System off the Gulf of Mexico. Whether depicting the almost imperceptible or the lonely drift, Bahc's work evinced a bit of sadness as well as social remove.

The mural-size painting *Wide World Wide* reflects Bahc's discomfort with the ubiquitous obsession with notions of the global. By arranging the names, written in Korean letters with a diluted white wash on a sky-blue background, of 184 little-known cities from around the globe into an image of the world map, Bahc created an alternative concept of inclusion, one that is virtually invisible to the macro lens. The artist wrote: "The emptiness of the phonetic sounds of names of the cities—Araraquara, Fakfak, Unachuak, Quezaltenango, etc.—are floating signifiers reflecting on the meaning of the (un)real, [in]

the world, communication, place and experience." Six electric candle-shaped lamps line the floor below the painting, commemorating the things we do not know.

Bahc created a number of unrealized installation proposals. One of them, *FALLAYAVADA* (2001), features a film shown on the floor of a thirteen-foot-long and four-foot-high coliseum-shaped structure. The film features images captured when the camera was thrown from a plane, rapidly falling to the ground from the sky and producing the sensation of downward motion against the horizontality of the landscape in a vertical flow of time and space. This action is repeated several times, representing the endless repetition of life and death, birth and rebirth. In contrast, the place where one views the film—from atop the stable and serene symmetrical structure—provides a meditative environment. Here, as in many of his works, Bahc uses disorientation and the realignment of known and unknown relationships to reflect on the fragility of our experience of reality.

After completing his BFA at Hong-ik University in South Korea (1981), Yiso Bahc moved to the United States in 1982, pursuing an MFA at the Pratt Institute in New York. He was known then as Mo Bahc, and his early conceptual work was produced at a time when multiculturalism was gaining credence in the art world. However, this positioning as the "Other" led to a frustrating cycle of artistic critique and eventual fashionable co-optation on the part of the art world, prompting an exasperated Bahc to return to Seoul in 1995. His later work was motivated by a desire for an intentional absence of positioning. Solo exhibitions include alternative space POOL, Seoul, 2001. He represented South Korea at the 50th Venice Biennale (2003) in a three-person exhibition, *Landscape of Differences*. Group exhibitions include the Busan Biennial, South Korea (2004); Yokohama Triennial (2001); Taipei Biennial (1998); and *Defrost*, Sonje Museum of Contemporary Art, Kyongju, South Korea (1998). In 2001 he was selected for ArtPace's International Artist-in-Residence Program, San Antonio, Texas.

—BSH

CAI GUO-QIANG

Born 1957, Quanzhou, China; lives in New York, New York

Painting Chinese Landscape Painting
2004
Gunpowder drawing
12 x 18 ft. (4 x 6 m)
Courtesy of the artist

Painting Chinese Landscape Painting, Miramar Air Show,
and *Making Drawing for Painting Chinese Landscape Painting,*
San Diego Museum of Art
2004
DVD
Courtesy of the artist

Cai-Guo Qiang Explosion Projects (1990–2003)
DVD
17 min. approx.
Courtesy of the artist

Combining the latest computer technology, practices of spectacle and appropriation derived from Western contemporary art, and gunpowder, with its ancient reputation as an alchemical mixture, Cai Guo-Qiang skillfully incorporates into a single vision achievements that mark different historical moments. His work resonates with the history of his home city Quanzhou, in the southern province of Fujian. It is here that several battles were fought with the Taiwanese during the artist's youth, and the city still has a large gunpowder manufacturing sector, an industry with a very long history in the region. Cai's father was an ink painter, a calligrapher, and an author of books on Chinese art, and his interest in ancient Chinese thought, Taoism in particular, greatly influenced the artist's approach to art. For Cai, art is an ephemeral experience that temporarily provides a new extension to time/space relationships, which in Taoism are viewed as being constantly in motion and ever-changing.

Cai lived in Japan from 1987 to 1995, where he studied with Kawaguchi Tatsuo, a veteran of the 1960s experimental art scene. His influence, and that of American land artists such as Walter De Maria and Michael Heizer, who create large-scale works designed to be seen from above, in the physical and metaphorical sense, as well as from the ground, are evident in Cai's large-scale "events." He has long used gunpowder for his explosion projects in the landscape or on architectural structures. One recent project, *Explosion Event: Light Cycle over Central Park* (2003; p. 109), rises into the sky with monumentally scaled spectacles of fireworks and is intended, on one level, to serve as a protective amulet over one hub of the city in reference to September 11.

San Diego is home to a large military community, and for *Past in Reverse* Cai chose to pursue a project in conjunction with the annual air show at the Miramar Marine Corps Air Station. The air show features specially choreographed flight demonstrations by military and civilian acts as well as a range of ground demonstrations of military equipment and firearms, including a wall of fire. This overdetermined context provides the artist an opportunity to present his work at a location that embodies the source of many of his ideas about violence and beauty, construction and destruction, for an audience with presumably little experience of Asian contemporary art. With airplanes as his medium, Cai uses the sky as a site for image-making in a whole new way. Adding his act to the regular line up is ambitious, and the success of the project lies in its artistic and aesthetic difference, its visual poetics, and the introduction of another sense of time and purpose to the three days of entertainments that often draw as many as half a million people.

Cai realized his project for the day show; *Painting Chinese Landscape Painting* involved six T-34 skywriting planes trailing white vapors to create a landscape image that appears and disappears within minutes (p. 107). The painting in motion begins with a silhouette of two mountains, then a waterfall appears in the valley of the two mountains and eventually parts ways into opposite streams. *Bird of Light*, his project for the night show (unrealized), envisions one airplane that is turned into the image of a bird with fiery flapping wings made of roman candles, illuminating the night sky (p. 106). As proposed, this work would unfold as if the viewer, in a dream state, were watching an imaginary flight—a flight that represents a desire for unrestrained freedom. *Painting Chinese Landscape Painting* is the basis for the gunpowder drawing created for the exhibition, which is accompanied by two videos: one of the performative process of making the drawing, and the other a compilation of explosion projects from 1990 to 2003.

Cai Guo-Qiang completed his schooling at the Shanghai Drama Institute in the Department of Stage Design (1985), thus avoiding Chinese academic art training. The following year he left for Japan, where contemporary artists were confronting a discussion on what balance was to be found between national pride and the cult of the West. In 1995, he began a residency at P.S. 1 Contemporary Art Center in Long Island City, New York, and was a finalist for the first Hugo Boss Prize in 1996. Solo exhibitions and projects include *Explosion Event: Light Cycle over Central Park,* Asia Society and Museum, New York (2003); *Cai Guo-Qiang*, Shanghai Art Museum (2002); *Transient Rainbow*, Museum of Modern Art, New York (2002); *An Arbitrary History*, Musée d'art contemporain, Lyon, France (2001); *Project for Projects*, Fondation Cartier pour l'art contemporain, Paris (2000); and *No Construction, No Destruction: Bombing the Taiwan Museum of Art*, Taiwan Museum of Art, Taichung (1998). Group exhibitions include *The Snow Show*, Rovaniemi, Finland (2004); *Exposing Cinema*, International Film Festival, Rotteram (2004); *Locus/Focus*, Sonsbeek 9, Arnhem, Netherlands (2001); Yokohama Triennial (2001); *Over the Edges*, SMAK/Stedelijk Museum voor Actuele Kunst, Ghent, Belgium (2000); *The Quiet in the Land*, Museu de Arte Moderna de Bahia, Salvador, Brazil (2000); Media City Seoul (2000); Shanghai Biennial (2000); *Beyond the Future*, Third Asia-Pacific Triennial of Contemporary Art, Brisbane, Australia (1999); Venice Biennale (1999), where he was awarded the International Golden Lion Prize; Taipei Biennial (1998); and *Issey Miyake Making Things*, Fondation Cartier pour l'art contemporain, Paris (1998).

—BSH

CAO FEI

Born 1978, Guangzhou, China; lives in Guangzhou

Game Series: Finger-Guessing Game
2000
Chromogenic print
47 1/4 x 70 7/8 in. (120 x 180 cm)
Courtesy of the artist
Page 95

Game Series: Plant Contest
2000
Chromogenic print
70 7/8 x 47 1/4 in. (180 x 120 cm)
Courtesy of the artist
Page 94

Game Series: Football
2000
Chromogenic print
70 7/8 x 47 1/4 in. (180 x 120 cm)
Courtesy of the artist
Page 97

Game Series: Wine Vessels Floating in the Meandering River
2000
Chromogenic print
70 7/8 x 47 1/4 in. (180 x 120)
Courtesy of the artist
Page 96

Cao Fei utilizes the slick language and imagery of Hong Kong advertising and pop culture to evoke the feelings of desire, loss, and dislocation associated with an era of hyper-consumerism. In her photographs and videos, Cao casts a cynical eye on romantic relationships, savagely parodies competition and conformity in the corporate workplace, and unearths the unconscious anxiety of a generation that has grown up on a steady diet of video games, MTV-Asia, and international fashion trends.

Social and cultural dislocation is the subject of her theatrically staged *Games Series* (2000). Created originally for a glossy magazine, *Modern Weekly, Guangzhou*, her photographs elide the boundaries between art and advertising. Cao incorporates intense colors, dramatic gestures, and theatrical makeup to create scenarios that are both visually seductive and psychologically disturbing. In *Finger-Guessing Game*, the players are fashionably dressed in the clothes of the corporate workplace. The bottles of beer suspended from the ceiling and hand gestures of the actors indicate that these people are engaged in the popular drinking game *caiquan*. In this game, the drinkers' out-stretched fingers represent a number between one and twenty. As the players throw down their hands, they shout out a number. The person who calls out the number matching the sum total when the fingers are added up is the winner; the losers have to drink. Ostensibly a scene of corporate workers cutting loose, Cao's depiction has an aggressive overtone. The men yank at their ties as if constricted by them, their faces violently contorted.

Wine Vessels Floating in the Meandering River references another drinking game, though one with a venerable cultural history. This game was first recorded by China's most celebrated calligrapher, Wang Xizhi (303–361) in one of his most famous works, *Preface to the Gathering at the Orchid Pavilion*. At this party, Wang Xizhi and a group of friends sat beside a meandering river as jade wine cups floated downstream. When a wine cup stopped in front of one of the guests, he had to improvise a poem and drink the wine. It is a story redolent with the refined sensibility of traditional China's literati class, whose leisure activities were as much about cultivating one's character as about creating pleasant diversions. In Cao's version of the scene, the stream is replaced with a bathtub, the jade wine cup with instant noodles in a Styrofoam cup, and the spontaneous penning of a poem with a laptop computer. The expressions of the men and women, who are dressed in spa robes, convey the ennui and disconnection that accompanies an urbanized, fast-paced life made even faster by the trappings of a postindustrial world.

In *Plant Contest*, Cao again uses the refined sensibility of traditional Chinese society as a foil. In this case, she invokes the elegant pastimes of ladies in the spring, when they would stroll in gardens improvising poems about the flowers they had picked. Cao's scene resembles a cosmetics ad. Two young, attractive women lie head to head on a bed of brightly colored chrysanthemums and lilies. Scattered among the flowers are beauty products. The garish colors and bright lighting enhance the artificiality of the scene. The young women each hold a flower and, like the flowers, are on display to be appreciated for their freshness and beauty. Yet there is an underlying psychological tension between them. Though smiling, the expression of the young woman at the bottom of the photograph is tense. Her lips are parted, showing her teeth in an expression that lies somewhere between a smile and a snarl. The flowers they hold up are suggestive of sexual competition between the two.

In *Football*, three men dressed in silk pajamas engage in a pillow fight, a game typically associated with the innocence of child's play. However, there is a sinister overtone to Cao's image. Two of the men wear masks—one a mud-mask used for facials, the other a simple

silk one—that are suggestive of two psychological states. The silk pajamas, pillows, and masks allude to comforts and irresponsibility in modern life. Yet, like the actors in *Finger-Guessing Game*, their expressions are distorted into exaggerated excitement, giving us the uncomfortable feeling of a game on the verge of becoming a violent confrontation.

Cao Fei graduated from the Affiliated Middle School of Guangzhou Academy of Fine Arts (1997), continuing on at the Guangzhou Academy and graduating four years later (2001). Her video and photography work, which examines ironically a new era of Chinese cosmopolitan life, has been exhibited throughout Asia and the West in numerous group exhibitions, including *Zooming into Focus: Contemporary Chinese Photography from the Haudenschild Collection*, University Art Gallery, San Diego State University, California (2004); *Between Past and Future: New Photography and Video from China*, International Center of Photography and Asia Society and Museum, New York (2004); *Feverish Unconscious: The Digital Culture in Contemporary China*, Chambers Fine Art, New York (2004); *Alors, la Chine?*, Musée national d'art moderne, Centre Georges Pompidou, Paris (2003); 50th Venice Biennale (2003); 1st Guangzhou Triennial (2002); *China on Screen*, Tate Modern, London (2002); Kwangju Biennial, South Korea (2002); *Making China*, Ethan Cohen Fine Art, New York (2002); *Living in Time*, Hamburger Bahnhof, Museum für Gegenwart, Berlin (2001); *FUCK OFF*, Eastlink Gallery, Shanghai (2000); and Galerie Büro Friedrich, Berlin (1999).

—LT

FLYINGCITY URBANISM RESEARCH GROUP

Formed 2000 in Seoul, South Korea; live in Seoul

Drifting Producers: Cheonggyecheon Project
2004
Photographs, monitors, video, PowerPoint™ presentation, drawings, architectural models, maps, and digital prints
Dimensions variable
Courtesy of the artists
Pages 102–5

The artist collective Flyingcity Urbanism Research Group was formed by Jang Jong-kwan, Jeon Yong-seok, and Gi-soo Kim (the current core members are Jeon, Jang, and Oak Jung-ho) to explore the city of Seoul not as a series of urban objects but as a historical entity. As they have written in their mission statement: "We are finding alternative ways of thinking about the city's ongoing growth conditioned by overdensity and overaccumulation. In the meantime, we have tried to delineate the process of the natural growth of the city." By natural growth they mean a process of development that would respect the cultural values of those usually left behind by rapid growth. They are particularly interested in residents' responses to the unexpected transformation of space, its effect on concepts of local identity (on both conscious and subconscious levels), and social geology—that is, how the layers of cultural intervention on the land accumulate into an ever-changing series of urban relations. Flyingcity's methodology closely follows the terms and concepts developed by the European Situationist International group (1957–72), including "psychogeography" (the study of the effects of geographical settings, consciously managed or not, acting directly on the mood and behavior of the individual), and *dérive* (drifting—opening one's consciousness to the unconsciousness of urban space).

For *Drifting Producers: Cheonggyecheon Project*, Flyingcity documented the vestiges of a community of small commercial businesses along the Cheonnggye rivulet in Seoul, which was about to be turned over to developers to be made into block apartment buildings. Jeon Yong-seok describes his opinion of the government's attitude: "Certain social groups around Cheonggyecheon serve as a social sewage, just like the rivulet itself served." The community's unique style of economic recycling evolved from the residual influence of the Japanese occupiers with their technical know-how in making non–mass produced specialty metal products. Jeon continues, "They are working with a sense of faktura (a concept important to artists of the Russian avant-garde), from their way of producing, to their way of organizing space and their ordinary everyday life." Flyingcity looked at the patterns of production and resistance exhibited by the small businesses, especially the metal workshops, and mapped the flow of productivity and exchange among the businesses. They created an archive of photographic evidence showing the transition from old economic forms to the new urbanism, and a series of diagrammatic images, using Russian Constructivist pictorial

codes, that were based on the shapes and patterns used by these small manufacturers. Flyingcity also set up a *Talk Show Tent* in the middle of the road while the street vendors were demonstrating against their removal by the city, to provide a space for community members to tell their stories. Flyingcity's social activism drives their art practice; they are establishing a new social function for art that affects the environment not through political positioning but through performative intervention.

Flyingcity Urbanism Research Group was formed in 2000 after members met at a seminar on avant-garde art at the Ilju Art House in Seoul. Their conceptual, experimental critiques and research into the urban environment have been shown at such international platforms as "An International Symposium on Alternative Space: The Remembrance of a City, the History of a Space," Japan Foundation Seoul Cultural Center (2003); *Montevideo*, Media Arts Institute, Amsterdam (2003); "2nd Community and Art International Workshop: *Fixing the Bridge*," Jogyakarta, Indonesia (2003); Kwangju Biennial, South Korea (2002); *Asian Comments*, Copenhagen (2002); and *Public Dream-Jongro*, alternative space POOL, Seoul (2002).

—BSH

HIROSHI FUJI

Born 1960, Kyoto, Japan; lives in Fukuoka, Japan

Kaekko Bazaar
2004
Used toys and mixed media
Dimensions variable
Courtesy of the artist
Page 111

Vinyl Plastics Connection
2004
Recycled plastic materials
Dimensions variable
Courtesy of the artist
Page 113

■ ■ ■ ■ ■ ◻ ■ ■ ■ ■ ■ ■ ■ ■ ■ ■ ■ ■ ■ ■ ■ ■ ■ ■

Used plastic bottles, polyethylene bags, and food trays made of polystyrene foam—these familiar waste objects from daily life are all key items for Hiroshi Fuji's *Vinyl Plastics Connection*, a series of practices developed by the artist in an attempt to create a new type of network through the recycling of materials. In the mid-1980s, Fuji escaped from Japan's mass-consumption society, which was then riding the wave of the bubble economy, and went to Papua New Guinea to teach art. There, he was amazed at the creative and widespread use of plastic products by the local people amid their unspoiled natural environment. This experience set the basic direction of his artistic practice, founded on the keywords "area," "appropriate technology," and "cooperation."

On returning to Japan, Fuji began collecting used plastic bags and bottles, transforming them into various artworks now known collectively as *Vinyl Plastics Connection*. The work as a whole comprises installations of furniture and sculpture, fashion shows featuring clothes made from vinyl packaging, and shops that sell recycled products. The concept of *kaekko* (swapping) is the activity in *Vinyl Plastics Connection* that best illustrates the three key principles of Fuji's project. Children bring their old toys to the Kaekko Bank and get points, which they can exchange for toys or use in auctions and other activities. This is not simply a place for exchange, but one where a new kind of trading system is actively constructed through organic interaction of the participants. It is run by "bankers," played by children, who get additional points for assessing the value of the toys brought in by other children. Although the basic template is provided by the artist, the actual operations are in the hands of the participants and are open to various interpretations.

Vinyl Plastics Connection is not a political statement or gesture, though it does raise awareness of environmental issues. How it is interpreted and made to function varies with the individual needs of those involved. It is a platform for exchange, cooperation, education, and local revitalization, propelling the search for a new lifestyle by transforming overlooked objects into art—all within a spirit of playfulness and fun.

Hiroshi Fuji completed his postgraduate studies at Kyoto City University of Arts (1985). He has been conducting community workshops throughout Japan and other Asian countries for more than ten years. His solo exhibitions include *Tracks of the Skinny Dogs*, MOMA Contemporary, Fukuoka, Japan (2001), and *Fuji Hiroshi, Vinyl Plastics Collection*, Hakone Open-Air Museum, Kanagawa, Japan (1999). Group exhibitions include *Beautiful Life?*, Art Tower Mito, Japan (2002); *Labyrinth of Pleasure*, Museum of Contemporary Art, Taipei (2001); *Art Day for Kids*, Watari-um Museum, Tokyo (2001); *Pusan International Contemporary Art Festival*, South Korea (2000); and *Art Scene '90–'96*, Art Tower Mito, Japan (1997).

—SN

G8 PUBLIC RELATIONS AND ART CONSULTATION CORPORATION

Formed 2002, Taipei, Taiwan; live in Taipei

Jamming Communication Project
2002
Nine black-and-white photographs and one text
Photographs: 23 3/8 x 23 3/8 in. (60 x 60 cm) each
Text: 23 3/8 x 23 3/8 in. (60 x 60 cm)
Courtesy of the artists
Page 64–65

Messaging Project
2002
Fifteen black-and-white photographs and three texts
Photographs: 23 3/8 x 23 3/8 in. (60 x 60 cm) each
Texts: 23 3/8 x 23 3/8 in. (60 x 60 cm) each
Courtesy of the artists
Page 63

Stray Dogs Project
2002
Thirty-three black-and-white photographs, one text, and two maps
Photographs: 23 3/8 x 23 3/8 in. (60 x 60 cm) each
Text: 23 3/8 x 23 3/8 in. (60 x 60 cm)
Maps: 35 3/8 x 35 3/8 (90 x 90 cm) each
Courtesy of the artists
Page 62

In the summer of 2002, artists Shi Jin-hua, Wu Yue-Jiao, Yeh Yu-Nan, and Lu Hao-Yuan, along with critic Xu Huang, formed G8 Public Relations and Art Consultation Corporation to offer services as image consultants to potential conceptual artists. Poising their "corporation" between fact and fiction, G8's first "client" was the criminal tycoon Ke Tsi-Hai (sometimes transliterated as Ko Szu-hai). Ke was already a public figure in celebrity-obsessed Taiwan long before G8 made over his image, unbeknownst to him, from self-styled protester and oddball advocate for stray dogs to cerebral avant-garde artist in the venerable tradition of Joseph Beuys's social activism.

G8 maintains that in the carnival atmosphere of Taiwan's public debate and political forums, all that matters is image and media exposure. They thoroughly researched their client's personal habits and political views to formulate a comprehensive marketing campaign and to publicize Ke's new avant-garde persona. *Stray Dogs Project* is a pseudo-documentation of Ke's daily feeding of stray dogs, which are routinely put down by government decree, with barbecue ribs left over from his meals at local restaurants. Reproducing these actions in a quasi-imaginary production, G8 transported dogs and food to significant locations around Taipei. The resulting photographic "documentation" of interventions credited to (the fictional) Ke shows street dogs feasting with the government palace in the background, in front of former president Lee Teung-hui's mansions, or at Five Finger mountain, a popular tourist attraction.

Critical of how economics drive the contemporary art world—which they see as reliant on its own system of sophisticated biennials and international exhibitions to disseminate product—G8 observes that while the objects of exchange in this economy are both the artwork and the artist, it is the communication of knowledge that sets the rate of exchange as it is passed from artist to dealer, to curator, to collector, to art administrator, and finally to the general public. Mimicking another of Ke Tsi-Hai's criminal invasions—this time of Taiwan's communications system, by jamming phone and fax lines using a computer modem—G8's *Messaging Project* records the effects of information overload. As part of a PR campaign on behalf of Ke, they synchronized the sending of cell phone text-messages to artists, curators, media personalities, and politicians during the opening of the 2002 Taipei Biennial. Bombarded by statements such as "None of you can deprive me of my privilege of being an artist" and "I am definitely a conceptual artist / Don't even doubt it," Taipei's art intelligentsia was forced to acknowledge Ke's guerrilla conceptualism.

G8 reformulates the strategies of Hans Haacke, including his use of quotation and stark serial photography, which he formulated in the 1970s to protest the politics of art and capital. By borrowing the commercial tactics of mass media and corporate life, G8 accepts the commodification of individuals that is so engrained in today's celebrity culture, and updates the Duchampian concept of the readymade to include what they call the "ready-being": a potentially profitable conglomerate of publicly traded personas whose fact is fiction and whose value is set by advertising.

Shi Jin-hua completed his BFA at the National Taiwan Normal University in Taipei (1990) and an MFA at the University of California at Irvine (1996). Wu Yue-Jiao, Yeh Yu-Nan, and Lu Hao-Yuan hold BFAs from the Taipei National University of the Arts (2004). Xu Huang completed a BS (1994) and an MS (1996) in physics from the National Chiao Tung University, Hsinchu, as well as an MFA from Fo Guang University, Ilan, Taiwan. G8 Public Relations and Art Consultation Corporation's first project (and the first solo exhibition of the fictitious Ke Tsi-Hai), *Once upon a Time in Taiwan*, was presented at the Huashann Arts District, Taipei, in 2002–3.

—LS

The Incense Burner of Bei-Gang: The Flying President of the Assembly A-Zhoo-Wu-Yi
2001
Ink jet enlargement of original ballpoint pen drawing, papier-mâché sculpture
Sculpture: 39 3/8 x 39 3/8 x 42 1/4 in. (100 x 100 x 120 cm)
Drawing: 72 7/8 x 48 3/8 in. (185x 123 cm)
Courtesy of the artist
Page 127

1998, "Bunny" Food and Drink Place
2001
Ballpoint pen on paper
11 5/8 x 8 1/4 in. (29.7 x 21 cm)
Courtesy of the artist
Page 129

2000, Still a Bee Retro Art-Restaurant
2001
Ballpoint pen on paper
11 5/8 x 8 1/4 in. (29.7 x 21 cm)
Courtesy of the artist

2000, The First Artist to Exhibit in Railway Warehouse 20, "The Dream"
2001
Pen and ink on paper
11 5/8 x 8 1/4 in. (29.7 x 21 cm)
Courtesy of the artist

2001, River Art Golden Boy Dances with a Lion
2001
Ballpoint pen on paper
11 5/8 x 8 1/4 in. (29.7 x 21 cm)
Courtesy of Li Zhen, Taichung

■ ■ ■ ■ ■ ■ ■ □ ■ ■ ■ ■ ■ ■ ■ ■ ■ ■ ■ ■ ■

Hung Yi's work reflects the hybridity that characterizes contemporary Taiwan, the result of centuries of colonialist influence from both East and West. His paintings, drawings, and sculptures as well as installations and performances fuse styles and attitudes derived from modern masters of the Western art pantheon, such as Van Gogh and Picasso, with typical forms and colors of Taiwanese folk arts and religious iconography. Humorous and irreverent, his sculptural installation *The Incense Burner of Bei-Gang: The Flying President of the Assembly A-Zhoo-Wu-Yi* refers to the Cahutian Temple in the city of Beigang, a popular pilgrimage site always teeming with worshipers. The anthropomorphic xianglu (incense burner) is half traditional Taiwanese mud doll, half futuristic cartoon character, of which we see only the vast expanse of a voluptuous rump perched precariously on three wobbly legs, or more accurately, two legs and a penis. This auspicious object is paired with Hung's self-portrait as an ironic guardian angel of the National Assembly. Taiwan's frenzied "election festivals" have been held every four years since 1996, when the presidential election was opened to popular vote. Prior to that time, the president of the Assembly was elected by the National Assembly for a term of six years. Hung's satirical yet melancholic angel calls out for political transparency: "I want to fly into the clouds and eavesdrop on people's secrets," Hung writes, adding, "I live in ignorance and want to fly into the future and understand what this land has been through."

Using a style that blends surrealist a-temporal composition and forceful line—recalling the work of Hung Tung, the outsider artist who influenced a whole generation of Taiwanese contemporary artists in the 1980s and 1990s—Hung Yi draws on dual associations: the common view in Taiwan of folk traditions as embodying an essential local culture, separate from the traditions identified with mainland China; and Western modernist or avant-garde models that often define the artistic discourse in the region. Working outside this kind of dualistic and necessarily reductive view of what constitutes culture in Taiwan, Hung's guttural emotional approach links him to a worldwide grass-roots street aesthetic of post-graffiti artists who oppose the academic, theoretically driven art intelligentsia and the exclusivity of their audience. These artists see their role in society as that of the individualistic observer of the absurdities stemming from globalizing mass culture. Suspicious of the Taiwanese government's monopoly on contemporary art through its control of exhibition venues and publications, Hung uses drawing and painting, sometimes on his own body, to narrate the trials and tribulations of his daily life. He carves out a space where his flamboyant work is both a reflection on and a reaction against the contradictions of urban life in Taiwan.

After leaving the military, Hung Yi opened several bars/alternative galleries and then began making drawings of what he saw there. His solo exhibitions include *Number 20 Barnhouse*, Taichung, and Taiman Art Center, Taipei (2001). Group exhibitions, at diverse types of venues, include *10+10+21*, National Art Gallery, Taipei (2002); *Good Place: Taichung Cityscape Arts Festival Canadian Series* (2001); *The Dream*, Railway Warehouse 20, Taichung (2000); *Still a Bee*, Retro-Art Restaurant, Taichung (2000); The Golden Church Pub, Taichung (1999); and Bunny Food and Drink Place, Taichung (1998).

—LS

HEE-JEONG JANG

Born 1969, Seoul, South Korea; lives in Seoul

Flower Painting with Bird
2004
Acrylic and gloss medium on floral fabric
39 1/4 x 74 7/8 in. (100 x 190 cm)
Courtesy of the artist

Flower Painting with Bird
2004
Acrylic and gloss medium on floral fabric
12 1/2 x 69 5/8 in. (32 x 177 cm)
Courtesy of the artist
Page 88

Flower Painting with Bird and Butterfly
2004
Acrylic and gloss medium on floral fabric
40 1/2 x 63 3/4 in. (102.9 x 161.8 cm)
Courtesy of the artist
Page 86

Flower Painting with Bird and Butterfly
2004
Acrylic and gloss medium on floral fabric
40 1/2 x 63 3/4 in. (102.9 x 161.8 cm)
Courtesy of the artist
Page 87

Grass Painting with Butterfly and Insect
2004
Acrylic and gloss medium on floral fabric
24 in. (61 cm) diam.
Courtesy of the artist
Page 89

In Hee-Jeong Jang's most recent work, the processes of deconstruction, re-construction, repetition, and erasure create the ground for easel-size paintings made with patches of Western decorative cloth, acquired by the artist locally and through the Internet. By cutting different floral fabrics into swatches, rearranging them, and then stitching them together over round oval, and rectangular stretchers, Jang dislocates the symbolic associations inherent in the banal, yet culturally significant, textiles.

An accomplished realist painter trained in South Korea and New York, Jang's preoccupation with Western pictorial traditions led her to reflect on the seductive fakery of representation; she does this by exploring the primacy of certain culturally specific image types, particularly those associated with the construction of femininity. In her current patchwork series of flower paintings (2004), she obscures the expected relationship between signifier and signified in representational painting by covering over, with acrylic paint, the artificiality of both the "painterly" factory-made textile motifs and the ground's patchwork construction. The viewer becomes aware that some of the lush flowers and birds are not painted on the collaged canvas, but are themselves patterned copies, only after looking through the hazy *sfumato* on the picture plane. Yet a sedimental image remains, and in just the kind of reverse turn Jang enjoys, the saccharin motifs allude to opposing cultures: Dutch *vanitas* still-life painting and the Korean folk adaptation, *minhwa* (folk painting), of traditional East Asian "flower and bird" subjects, which often hung in women's and children's quarters of Korean homes. Women's work and domesticity are evoked especially by the flower motifs of *minhwa* painting, traditionally meant as an amulet to bring prosperity, happiness, and benediction to the home, while paired birds represent the happy couple.

By revising the fixed grammar of both traditions, Jang is able to escape their rigid typologies. The collages humorously create what she calls an "irony of relations" on the surface, which is itself smudged over and erased by washes of pale acrylic paint, symbolically blurring such categories as real and fake, masculine and feminine, illusionism and abstraction, and East and West. The underlying admonitions of the *vanitas* and their Western pictorial conventions are blotted out, leaving an alternative space, a void, what Jang calls "a space for Asian-style painting." This "empty space," or *yaeobaek*, so important to Korean pictorial traditions both past and present, represents a nothingness—created from the balancing of antagonistic forces—in which the domestic evocations of "bird and flower" *minhwa* are but memories.

Hee-Jeong Jang completed her BFA at Ewha Woman's University in Seoul (1992) and went on to pursue an MA at New York University (1995). Solo exhibitions include *Repeatable*, Ssamzie Space, Seoul (2001), and Insa Gallery, Seoul (1997). Group exhibitions include *Absence*, Korean Cultural Service, New York (2002); *Taking Nine Colors: In Search of the Genesis of Phenomena*, Youngeun Museum, Kwangju, South Korea (2002); *Eyes of One Thousand, Stones of One Thousand*, Kwon Hoon Gallery, Seoul (2002); *Reading the Two Extremes of Contemporary Art*, Dong-Duk Art Gallery, Seoul (2001); and *A Frame Is Better than Painting Work*, Kumho Museum of Art, Seoul (1999).

—LS

Aléa
1997
Video projector, small speakers, DVD player, and wood cart
24 x 36 x 24 in. (60.9 x 91.4 x 60.9 cm) approx.
Courtesy of the artist
Pages 74–75

Pap-gré
2001
Video projection, ceramic vase, and pedestal
23 5/8 x 23 5/8 in. (60 x 60 cm)
Courtesy of the artist
Page 76 left

Twelve works from the *Lunes* series
2003
Gelatin silver prints
32 5/8 x 23 5/8 in. (83 x 60 cm) each
Courtesy of the artist
Pages 76 right, 77

■ ■ ■ ■ ■ ■ ■ ■ ■ ■ □ ■ ■ ■ ■ ■ ■ ■ ■ ■

Soun-gui Kim's wide-ranging art practice—from videos to calligraphy novels—is informed by her equally expansive philosophical interests, from the word play of Ludwig Wittgenstein to the sixth-century Taoist Zhuang Zi's concept of "fundamental liberty" (chaos) whereby one can be reborn again and again, every instant, in all imaginable forms or nonforms. Also implicit in the work is a uniquely feminine approach to these philosophies.

Kim's video installations use contemporary game theory to structure the repetition of slightly different images, adding and subtracting sections of footage of daily-life routines. In *Aléa*, a clip from a Korean vegetable market in Paris shows an elderly woman purchasing vegetables from an older man, in a repeating loop. The image is projected from a cart which the audience is free to move around in the gallery. The stability of realism is dematerialized as the scene slowly converts into vertical color bars with each stripe originating from a color element in the documentary footage. This deconstructive move (an accidental effect resulting from a damaged computer hard drive) points out the illusionistic nature of video as a medium. Kim first used this motif in 1980 and then again in 1984, when video artist Nam June Paik asked her to create a painting representing a video test bar (she has also adapted it to architectural ornamentation, ceremonial cake decoration, and textiles). The striped pattern can also be likened to a motif from the Buddhist *sekdong* mandala as well as the five colors in the cosmology of the *I Ching*. Kim has stated, "The triviality and ordinariness of our everyday gestures, no matter how small and insignificant they may appear, are endowed with meaning as 'forms of life' and take part in a 'language game.'" The French philosopher Jean-Luc Nancy focuses on another aspect of the work when he writes, "Each time, her time is one of dissolution, disappearance, evading or erasing."

Pap-gré incorporates important forms from Korea's cultural patrimony into Kim's feminine poststructuralist relationship with metaphysical questions. A video projected on a vase features two frogs and two butterflies who perform a "dance of emptiness," alluding to the sudden understanding of the Buddha, which was none other than the discovery of reality. The moon vase form, from the Choson Dynasty (sixteenth to eighteenth centuries), takes the shape of a near perfect moon, but is a little bit deformed. These vases were created purely for their aesthetic beauty, having no practical function. Kim has also produced a body of atmospheric photographs using a pinhole camera; taken with long exposure times, the image depends on the artist's lack of control over the aesthetic outcome. *Lunes* is a series of twelve photographs, each featuring a rod of light on a black field that references moon cycles in reduced visual terms. Kim actively engages new and old technologies and iconographies in an attempt to erase periodization, and even linear time itself.

Soun-gui Kim received an MA at Seoul National University (1971) and moved to France the same year to pursue studies in semiology at the University of Provence (1984) and later, aesthetics at the University of Nice (1994). Although she has lived in France for more than thirty years, she returns often to Korea. She divides her time between art-making, philosophical writing, and university teaching. Solo exhibitions include presentations of her video installation *Stock Exchange* at La Maison de l'art et de la communication, Sallaumines, France (2001), and Maison du livre d'artist contemporain, Domart-en-Ponthieu, France (1999); *Stock Exchange II*, Artsonje Center, Seoul (2000); and *PAP installation, vidéo, photographies*, Galerie Lara Vincy, Paris (2000). Group exhibitions include *Sarajevo 2000*, Palais Lichtenstein, Vienna (1998); Lyon Festival of Video and Film, France (1998); and *Quality-Quality-Sensation*, National Museum of Contemporary Art of Kyua-tchon, South Korea (1995).

—BSH

KIM YOUNG JIN

Born 1961, Busan, South Korea; lives in Seoul, South Korea

I, My, Me
2004
Two-channel synchronized video projection, pleated screen, two DVD players, and two projectors
Dimensions variable
Courtesy of the artist
Pages 118–20

In Kim Young Jin's videos and projection installations, a postindustrial, hybrid body negotiates the self's relationship to memory, the present, and a presumed future. His homemade mechanical devices extend the body's functions with the help of prosthetics that fuse technology with nature through performance. Reflecting an East Asian belief in the continuity between nature and culture, Kim's work proposes that perception alone—whether by the artist as observer or by the audience—is what forms stable ontological categories and identity.

Perception and the self are central themes in *Globe* (2001; p. 121). This twelve-minute, single-channel video loops the mechanics of the "eye" of the camera to the "I" of consciousness as Kim wanders, accompanied only by a small dog, through a barren landscape in ritualized re-creation of memorable childhood experiences. Recorded using a camera rigged to the artist's body, the video gives a 360-degree perspective that contains the entirety of the world in its gaze. But the cosmos we see has not been observed through sensory perception; rather, it is a camera with a mirrored sphere—like a fish-eye or an oculus—in front of the lens that observes, echoes, and mediates phenomena. *Globe* reflects an internalized environment where, rejecting the social sphere, the formative narratives lie in the body itself, emerging only through the filter of memory. Memories are re-enacted and then recorded, just seconds after being performed, in a time lapse that exposes Kim's belief in reality as a time/space construct, in which present existence and the self emerge from the tension between the past and evolving events and phenomena.

I, My, Me furthers these themes but exposes the processes of observation per se as the factors that create selfhood. Meditative and philosophical, this two-channel video has a theme-and-variation structure as two videos with similar imagery are projected onto the same screen. One set of images shows a woman carefully studying a skull, which she holds in her hands. Examining it and recording details like an anthropologist, the woman seeks certainty of the present moment by claiming the objectivity of the scientist's analytical tools to study the past. As she observes, measures, and maps the skull's topography with detachment, the apparent distance and supposed objectivity of the anthropologist's methodology slowly dissolve until it is no longer clear who is observing, and therefore creating, what: Is this woman decoding and re-creating the information contained on the skull, or is she becoming her "self" by restructuring the past? Problematizing this interpretation, a parallel process of observation is layered on top of this narrative as a second set of images of the same woman, now in the role of introspective sculptor, looks keenly over the surface of a mask bearing her own features. As Kim has written, this woman, acting now as an artist, "is in the process of discovering a certain human facial form as she retraces her own consciousness." The impetus here, at once solipsistic and tender, is of self-discovery by self-observation. But as both sets of video footage overlap, the composite image projected on the screen reminds viewers of the impossibility of stable identity in the ebb and flow of shifting viewpoints through time.

Kim Young Jin completed both his BFA (1989) and MFA (1992) in sculpture at Hong-ik University in Seoul. He is part of a generation of artists in South Korea who emerged during the latter half of the 1980s and distanced themselves from what had become ideological tensions in Korea between modernism and *Minjoong Misul* (People's art). Solo exhibitions include Artsonje Center, Seoul (2002); *Fluids*, Korean Culture and Arts Foundation, Seoul (1996); and *Asian Arts Today, Fukuoka Annual IX: Kim Young Jin*, Fukuoka Asian Art Museum, Japan (1995). Group shows include *Happiness, A Survival Guide for Art and Life*, Mori Art Museum, Tokyo, (2003); *Leaning Forward, Looking Back*, Asian Art Museum, San Francisco (2003); *Beautiful Life?*, Art Tower Mito, Japan (2002); *Hands Touch Water* (collaboration with Butoh dancer Toru Iwahsita), Capio Hall, Tsukuba, Japan (2002); Sonsbeek 9, Arnhem, Netherlands (2001); International Istanbul Biennial (2001); *Translated Acts*, Queens Museum of Art, New York, and Haus der Kulturen der Welt, Berlin (2001); *The Song of the Earth*, Museum Fridericianum, Kassel, Germany (2000); Media City Seoul (2000); Asia-Pacific Triennial of Contemporary Art, Brisbane, Australia (1999), and *In the Year of the Tiger*, Ludwig Forum, Aachen, Germany, and Haus der Kulturen der Welt, Berlin (1998).

—LS

In Search of Insomnious Sheep
2004
Mirrored boat, video projection, and sound recording
84 x 42 x 36 in. (213 x 106 x 91 cm)
Courtesy of the artist
Pages 134–35

A conceptual and installation artist, Leung Mee Ping uses ready-made objects and hand-crafted elements to stage events in which the audience is as instrumental to the work as the components that make it up. Leung often explores existential questions about individuation and the self, particularly in relation to mass identity—a constant preoccupation throughout her career. In *So Near Yet So Far—Mongkok Version* (2001), everyday objects are repositories for individual memories that, by their diversity and range, give rise to a grand historical, yet nonhierarchical, narrative about place. Attempting to still the effects of the 1997 unification of Hong Kong with mainland China on the lives of residents in the neighborhood of Mongkok, where the artist grew up, Leung collected more than one hundred mailboxes and also recorded local sounds ranging from ambient noise to personal conversations. Each mailbox has an audio component set to low volume that whispers narratives about site and community that are both lyrical and cacophonous, private and public.

In Search of Insomnious Sheep also asks the audience to witness someone else's daily existence. To create this interactive public art installation, staged in the busy waterways of Hong Kong off the Sai Kung coast, Leung set up conditions for a collective and willful act of seeing and listening to someone else, and of metaphysically reaching out to that person so as to better understand oneself and one's own place in the world. A small dinghy, mirrored on all sides, drifts in the water and carries a single passenger, whose image is reflected back to him/her from the boat's surface. The passenger holds a microphone and as he or she thinks out loud, the words are transmitted to an audience in a larger boat, some distance away, that is connected to the dinghy by a rope—an umbilical cord of sorts that is the physical parallel to the wireless signal.

Leung asked her Hong Kongese audience to take a few minutes out of their relentlessly fast-paced lives. "I wish to construct a kind of 'formless,' reflective space for existence," she has written. By mirroring everything around it, the small boat disappears in a sense, becoming at once present and absent. The "empty" space is then filled by acts of reflection itself: physical reflection, as the boat casts back the images of water and sky around it, and philosophical reflection on the nature of being itself.

By documenting *In Search of Insomnious Sheep* and presenting it in a gallery setting, the original definition of that performance, contingent on the openness and transformability of individual experience within a shifting, yet familiar cultural context, is re-created as something more stable and defined. Educated in Hong Kong, Paris, and California, Leung is acutely aware of the relationship between selfhood and locality, and of what is lost and what remains in translating that self to another situation. She is interested in what occurs when a certain type of space, with its cultural and physical specificity, disappears, leaving behind a conceptual trace that exists unequivocally as it frames the present. In the gallery, viewers encounter the evidence of that day—a mirrored boat, a projection on a wall, and the sound of someone thinking out loud. Though the Cantonese monologue emitted through the installation's speakers may not be understood by all, the installation induces the audience to participate symbolically in that original performance, setting up a similar epistemological ambiguity and contradictory experience of connection and disconnection.

Leung Mee Ping received a BA from L'École Nationale Superieure des Beaux-Arts in Paris (1991) and completed her MFA at the California Institute for the Arts in Valencia (2000). Solo exhibitions include *Water Tone: Leung Mee Ping, 1992–2003*, Kaoshsiung Fine Art Museum, Taiwan (2003), and *A Poem Without a Title*, Para/Site Art Space, Hong Kong (1998). Group exhibitions include Sharjah International Biennial, United Arab Emirates (2003); *Return Nature*, Shenghua Arts Center, Nanjing, China (2003); *City_Net Asia*, Seoul Museum of Art (2003); Hong Kong Biennial (2002–3); *Wo Man-Feminine Art*, Old Ladies' House, Macao (2001); *Text and Subtext*, Lasalle-SIA College of the Arts, Singapore (traveled 2000–2003); and Para/Site Art Space, Hong Kong (1998). Leung received the Hong Kong Biennial Award in 2002, and in 2003 was awarded the Starr Foundation Fellowship by the Asian Cultural Council, USA.

—LS

MICHAEL LIN

Born 1964, Tokyo, Japan; lives in Paris, France

Untitled
2002
Emulsion on wood
29.5 x 19.7 ft. (900 x 600 cm)
Courtesy of the artist and Galerie Tanit, Munich
Page 99

■ ■ ■ ■ ■ ■ ■ ■ ■ ■ ■ ■ ■ ■ ■ □ ■ ■ ■ ■ ■ ■ ■ ■ ■

Michael Lin's installations challenge established architectural order and transform viewers into performers in events where issues of identity and tradition in Taiwanese domestic arts come face to come face with Western notions of artistic value and contemplation. Lin paints onto floors and walls extremely oversize textile patterns found on items of daily household use and special-occasion objects, such as honeymoon bed covers and pillows. In this way, iconographic traditions, made invisible by familiarity in their original context, become charged with exotic appeal to the Western eye. The sheer size and resolute flatness of the hand-painted designs link them in style to decorative painting and in scale to mural painting and the monumental aspirations of the Abstract Expressionists. Yet the motifs are symbols of home and homemaking for Lin; he began using them, upon returning to Taiwan after years of living and studying in the United States, as a way to explore his immediate environment through cultural and formal quotation. The shift in scale and the distanced, parodic, almost mechanical style act as foils to the viewer's desire to either orientalize or translate the symbolic allusions to weddings and folk celebrations encoded in these designs.

The floor piece for the atrium at The Hague's municipal hall, made as a site-specific installation in 2002 (p. 100), forces the audience to focus on space as such, rather than on the artwork's pictorial composition or its sculptural presence. Lin's painting disappears as an object of distanced contemplation and becomes ambiguously support and surface, emphasizing the existing architectural structure even as it folds the structural design into its own. "The image is a plane that relates to the other planes of the space," Lin has said, adding, "The image relates to the space as a whole that includes all objects in that space, be it furniture, other art works, or bodies that move through that space."

Subtly working against our expectations, Lin's floors and day beds shift the conventional relationship between viewer and painting to set up an encompassing situation that grafts the painting to the room and includes the audience's relaxed actions upon the work in the construction of its meaning. *Untitled* (2002) is a simple wooden floor painted with enlarged flower motifs on which are strewn cushions for people to lie or sleep on. Within the space of the gallery, the floor sculpture encourages visitors to drop out of the relentless activity of art viewing, to lie down on its softly hued surface and rest instead. Acting as a complement as well as a challenge to the space it inhabits, Lin's intervention alters the prescribed functions of the exhibition space and opens up new possibilities of spatial and social relations within the highly encoded context of the museum. Reverting back to the decorative motifs' origins, the piece domesticates public space. As viewers relax on the floor sculpture, which enfolds the body like an envelope, its surface gives rise to private acts in a personal space. In a manner reminiscent of the interiorized space of traditional oriental gardens, the imagery becomes part of the emotional and psychological world of the viewer—entering through the eye and engaging the body in performance. Through parody, dislocation, and surprise, Lin's painting installations, like the oriental garden, realign the boundary between the body and the environment, making it indistinguishable as one exists within the other in an endless circularity of action and metaphor.

Michael Lin was raised in California and first began working with Taiwanese fabrics in 1996 upon his return to Taipei after completing his BFA at the Art Center College of Design in Pasadena, California (1993). Solo exhibitions include *Spaces Within*, Asian Art Museum, San Francisco (2004); *Grind*, P.S. 1 Contemporary Art Center, Long Island City, New York (2004); Contemporary Art Museum, St. Louis (2004); Asian Art Museum of San Francisco (2004); 21st Century Museum of Contemporary Art, Kanazawa, Japan (2004); Eslite Gallery, Taipei (2004); Galerie Urs Meile, Lucerne, Switzerland (2003); Palais de Tokyo, Site de création contemporaine, Paris (2002); Atrium Stadhuis, Stroom, The Hague (2002); and IT Park Gallery, Taipei (1999). Group exhibitions include *Painting 4: Ingrid Calame, Katharina Grosse, Michael Lin, Jimmy O'Neal*, Rose Art Museum, Waltham, Massachusetts (2003); Asia-Pacific Triennial of Contemporary Art, Brisbane, Australia (2002); *Asianvibe*, Espai d'Art Contemporani de Castello, Spain (2002); *Urgent Painting*, Musée d'art moderne de la Ville de Paris (2002); International Istanbul Biennial (2001); Venice Biennale (2001); *The Gravity of the Immaterial*, Institute of Contemporary Art, Taipei (2001); *Very Fun Park*, Hong Kong Art Center (2000); and Taipei Biennial (2000).

—LS

Walking in the Town by Touch—From the Acupuncturist's Studio
2004
Drafting tape and vinyl on wood
16 ft. (4.8 m) long approx.
Courtesy of the artist

Having lost what sight he had at the age of ten, Mitsushima Takayuki relies on touch, immediate kinesthetic experience, and his distant memory of color to arrive at his visual vocabulary. Mitsushima's abstract and linearly sequenced works are composed of a chain of single-frame compositions representing events based on real as well as fictional experiences. The rhythms of the colored shapes, the figure-to-ground relationships, and the temporal movement from one surface to the next function like an innovative musical score. His works are also reminiscent of the way individual panels in a screen painting function as structural design elements for the viewer in motion. Using his fingers to guide the building up of formal compositions, Mitsushima records spatial experiences with colored vinyl on wood panels or clear acrylic sheets, or creates images using a special copier that raises the ink into a low relief on paper.

Much of Mitsushima's work is based on his experience of the city. Following in the footsteps of modernism's flanêur, he takes the city into his body as a pleasure, and with the help of sound recordings of his walks, creates images expressing the flow of time, the shape of the street, the space of architecture, and the curves of trees and leaves. Within this experience he hears the sound of his own movements, the chatter of conversations, the sounds of buses. "By touching, shapes become comprehensible. By listening, the expansion of towns becomes comprehensible," the artist has noted. He navigates the blemishes, the potholes, and the uneven curbs, though not without surprises and jolts. Mitsushima creates symbols for his urban encounters, such as a continuous overlapping loopy line for a bicycle. He also has interpreted a stay at the hospital and how speech changes pitch in conversation.

Although Mitsushima's works seem to share the pictorial language of modernists such as Isamu Noguchi or Hans Arp, they do not derive from a direct knowledge of Western concepts, formalist, psychological, or otherwise. Mitsushima does, however, share the modernists' belief that reductive forms are carriers of the core signifiers of universal ideals. And for Western viewers, certain parallels can be found in the work of John Cage, who was influenced by Zen philosophy and promoted focused experience of the real world as having therapeutic value.

Japan has a long tradition of blind ceramic artists who were considered to have a special relationship to the sensuousness of materials and an extrasensitive sense of touch. Although Mitsushima shares phenomenologically this way of being in the world, his works are conceptually driven, especially in his use of the translation of sound and dramatic incidences as a basis for his narrative abstractions. There is a genre of Japanese painting that depicts a blind poet walking in the landscape on a spiritual quest; Mitsushima's works convey a comparable experience.

Mitsushima Takayuki attended the Kyoto Prefectural School for the Blind and later graduated with a degree in philosophy, with a specialization in existentialist philosophy, from Otani University (1980). He began working with clay as an artistic medium after participating in the Formation Workshop Beyond Visual Perception, led by Yohei Nishimura, in 1992. Three years later, the work of the blind sculptor Flavio Tito inspired Mitsushima to make his first "touchable painting," leading him to the sensorial work he is known for today. By 1998 he and fellow artists Reiko Nakamura and Toshihiro Anzai began *Tactile Renga*, an experimental Web-based art project involving a collaborative recontextualizing of paintings originally made by Mitsushima. The paintings were digitally scanned, then modified and transformed by each artist, ultimately arriving back into the hands of Mitsushima to be transformed again into tactile forms. Mitsushima's solo exhibitions include *Each One of the Others: The Experience of the Sense of Touch— Mitsushima Takayuki*, Gallery K, Tokyo (2000), and *World of Mitsushima Takayuki*, Gallery TOM, Tokyo (1999). Group exhibitions include *Paintings of Hidaka Reiko and Mitsushima Takayuki*, Fukuoka Art Museum, Japan (2001); *Kitamura Ryoko and Takayuki Mitsushima*, Kobe Art Village Center, Japan (2001); *Workshop: To Touch, To Communicate*, Utsonomia Museum of Art, Tochigi, Japan (2001); *I Can Do It: Exploring the Senses of Sight, Hearing, Touch*, Fuchu Art Museum, Tokyo (2001); *Blind Exhibition*, Parthenon Tama, Tokyo (2000); *Encounter of a Variety of Expressions*, Tomioka City Museum, Japan (2000); and *Art Now '98, Overflowing Power of Expression: Aspects of "Outsider Art,"* Hyogo Prefectoral Museum of Modern Art, Kobe, Japan (1998).

—BSH

SHAO YINONG AND MUCHEN

Born 1961, Xining, China, and 1970, Lianong, China; live in Beijing, China

Assembly Hall Series: Pukou, Zhejiang
2002
Chromogenic print
48 x 66 7/8 in. (122 x 170 cm)
Courtesy of the artists
Page 93

Assembly Hall Series: Fifty Middle School, Huzhu Tuzu Autonomous County, Qinghai
2003
Chromogenic print
48 x 66 7/8 in. (122 x 170 cm)
Courtesy of the artists
Page 92

Assembly Hall Series: Anyuan Coal Mine, Jiangxi
2003
Chromogenic print
48 x 66 7/8 in. (122 x 170 cm)
Courtesy of the artists
Page 90

Assembly Hall Series: Sanchuan Mine Factory, Qinghai
2003
Chromogenic print
48 x 66 7/8 in. (122 x 170 cm)
Courtesy of the artists
Page 91

■ ■ ■ ■ ■ ■ ■ ■ ■ ■ ■ ■ ■ ■ ■ ■ □ ■ ■ ■ ■ ■ ■ ■ ■

In the past two and a half decades, China has transformed itself from a socialist, agricultural society into an urbanized, market-driven economy and a force to be reckoned with in the global community. Shao Yinong and Muchen are photographers whose work takes as its subject individual and collective memory of the era before globalization.

The four photographs from the *Assembly Hall Series* selected for *Past in Reverse* are intended to evoke memories of the Cultural Revolution, a period of political turmoil that lasted from 1966 until 1976. The Cultural Revolution occupies an ambiguous space in postsocialist China's collective memory, a source of both self-recrimination and inspiration. During this decade-long era of "permanent revolution" and ideological fervor, assembly halls were the center of community life and the site of tumultuous political meetings dedicated to class struggle.

Memories related to the Cultural Revolution and the assembly halls are as diverse as the people who experienced this era: some survived, even relished the experience; others were destroyed by it. Emblematic of this are the memories of the artists themselves, who were born nine years apart. The older Shao Yinong was born into a "landlord" family, a class that was singled out for "re-education" during this period. There are bitter memories of his house being confiscated and public humiliation of his family members. But as a young boy, Shao was also caught up in the excitement. One of his most enduring memories is of how he got his first Mao button. The villagers had crowded into the hall to criticize those who had been condemned as rightists, and who were assembled on the stage. As the crowd surged forward, Shao was carried away on someone's shoulders and seeing a Mao button, he grabbed it. Muchen's early childhood years, by contrast, spanned the waning years of the Cultural Revolution. In her experience, these halls were no longer places of violence

and cruel spectacle, but served more pedestrian functions, as places to endure sermons on Marxist thought by party elders and, as society returned to normal, places where personal rituals such as receiving a graduation diploma were played out.

Twenty-five years later, Muchen and Shao have traveled the country collecting hundreds of images of these halls as a documentation of their fate, and as a memorial to a time and a place on the verge of being obliterated by political revisionism and the forces of economic development. Mirroring the once uniform function of these halls, each image in the series is framed the same way. The photographs are symmetrically composed, shot from the very back of the hall with a wide-angle lens, so that the side walls and ceiling lead the viewer's gaze to the stage at the center. It is in the details that we can see how these spaces have been converted in a variety of ways. Some halls have been abandoned and fallen into ruin (Datong); others have been converted into factories (Anyuan coal mine) or warehouses (Sanchuan); and a smaller number have retained their original function as gathering places for the community (Pukou). In some halls, all signs of the previous era have been erased, while in others, traces of the "revolutionary spirit" remain, as in the faded political slogan on the back wall at Sanchuan, or the heightened red of the benches and frame around the stage at Pukou. Emptied of people and devoid of activity, Muchen and Shao's images of the assembly halls create an emotional distance, providing viewers space to retrieve and contemplate their own memories of this time and place.

Shao Yinong completed his BA at the Qinghai Normal University (1982) and his MFA in oil painting at the Central Academy of Fine Arts in Beijing (1987). Muchen completed her BA at the People's University of China in Beijing (1995), where she studied photojournalism. They began working together in 2000 on a project called *Family Register*, a photographic

record of the living members of their extended families that was presented in 2002 at the CourtYard Gallery in Beijing. Other solo exhibitions include Chinese Contemporary Art Gallery, London (2004). Group exhibitions include *Chinese Eyes: Contemporary Chinese Photography*, Goedhuis Contemporary at the Annex, New York (2004); Taipei Biennial (2002); *Alors, la Chine?*, Musée national d'art moderne, Centre Georges Pompidou, Paris (2003); *Chinese Plan: Rotate 360*, Paragold International Art Centre, Shanghai (2001); *Paris-Pékin*, Espace Pierre Cardin, Paris (2002); and *Virtual Future*, Guangdong Art Museum, Guangzhou (2001).

—LT

WILSON SHIEH

Born 1970, Hong Kong; lives in Hong Kong

Ceramic Series: Blue and White Bowl with Red Dragon
2002
Chinese ink and watercolor on silk
14 7/8 x 10 5/8 in. (38 x 27 cm)
Courtesy of Brad Davis and Janis Provisor, New York
Page 60 left

Ceramic Series: Cizhou Ware Pillow in Shape of a Tiger
2002
Chinese ink and color on silk
14 7/8 x 10 5/8 in. (38 x 27 cm)
Courtesy of Henry Au-yeung, Grotto Fine Art Ltd.
Page 61 right

Ceramic Series: Collection of Monochrome Porcelain
2002
Chinese ink and watercolor on silk
14 7/8 x 10 5/8 in. (38 x 27 cm)
Courtesy of Brad Davis and Janis Provisor, New York

Ceramic Series: Gu (Beaker-Shaped Vase) in White Glaze
2002
Chinese ink and watercolor on silk
14 7/8 x 10 5/8 in. (38 x 27 cm)
Collection of Matt Dillon, Hong Kong
Page 60 right

Ceramic Series: Terracotta Soldier of the First Emperor of Qin
2002
Chinese ink and color on silk
14 7/8 x 10 5/8 in. (38 x 27 cm)
Courtesy of Henry Au-yeung, Grotto Fine Art Ltd.
Page 61 left

Musical Instruments Series: Cello
1999
Chinese ink and color on silk
12 x 7 in. (30.48 x 17.78 cm)
Courtesy of Brad Davis and Janis Provisor, New York
Page 58 left

Musical Instruments Series: Lute
1999
Chinese ink and color on silk
12 x 7 in. (30.48 x 17.78 cm)
Courtesy of Brad Davis and Janis Provisor, New York

Musical Instruments Series: Viola
1999
Chinese ink and color on silk
12 x 7 in. (30.48 x 17.78 cm)
Courtesy of Brad Davis and Janis Provisor, New York
Page 58 right

Musical Instruments Series: Acoustic Karaoke
2004
Chinese ink, watercolor, and gouache on dyed silk
18 x 18 in. (45 x 45 cm)
Courtesy of the artist

Musical Instruments Series: Cello Suite for the Night
2004
Chinese ink, watercolor, and gouache on dyed silk
18 x 18 in. (45 x 45 cm)
Courtesy of the artist
Page 59 bottom

Musical Instruments Series: Harp and Dance
2004
Chinese ink, watercolor, and gouache on dyed silk
18 x 18 in. (45 x 45 cm)
Courtesy of the artist

Musical Instruments Series: Jungle Drum
2004
Chinese ink, watercolor, and gouache on dyed silk
18 x 18 in. (45 x 45 cm)
Courtesy of the artist
Page 59 top

Musical Instruments Series: Lute Brothers
2004
Chinese ink, watercolor, and gouache on dyed silk
18 x 18 in. (45 x 45 cm)
Courtesy of the artist

Musical Instruments Series: Piccolo Group
2004
Chinese ink, watercolor, and gouache on dyed silk
18 x 18 in. (45 x 45 cm)
Courtesy of the artist

Wilson Shieh uses the language of antiquity to explore the shifting dynamics of Hong Kong's social relations and political situation. Searching for a style that would afford him the stability of a tradition but flexible enough to allow for development and examination, Shieh was drawn to Chinese *gongbi* (fine brush) figurative painting, popular during the Tang (618–907) and Song (960–1179) dynasties, attracted by its meticulousness, stylistic repertoire, and long history of narrative conventions. Following the *gongbi* tradition, Shieh uses round, pointed brushes, often made of just one or two rabbit hairs, to draw contours that are then filled in with flatly applied water-based color on silk or gilded Japanese board. His small paintings rely on the style's apparent stability and control as counterbalance to subtle compositions that reveal, by the figural relations and iconographic choices, sharp social commentary.

Shieh grew up during the transitional period between the signing of the Sino-British Joint Declaration in 1984 and the handover on June 30, 1997. He experienced firsthand the mutations in the relationship between China and Hong Kong—from that of distanced landlord and tenant with opposing political systems to that of parent and child seemingly tolerant of their differences. Using metaphor and symbolism, Shieh expresses the discomfort of this transition, which ultimately revealed more differences than similarities. His *Ceramic Series* (2002) addresses this through the juxtaposition of figures, marked as contemporary Hong Kongese by such details as hair styles and fashionable accessories and tattoos, with contemporary objects manufactured for daily household use that are derived from antique Imperial ceramics. Each piece combines a ceramic object with a figure; the level of hybridity between the two denotes the figure's relationship with the past. *Blue and White Bowl with Red Dragon* shows a fashionable young man stepping out of a pool shaped like a traditional bowl designed in blue and white. The bowl symbolizes how a distant past can aid and support identity. But the past can also be a burden that restrains people with its weight and rigidity, as is suggested by Shieh's paintings in which objects overtake the body. In *Terracotta Soldier of the First Emperor of Qin*, a man literally unpacks the accoutrements of past battles to face the present. His individuality is overwhelmed by the huge pottery sculpture of an Imperial soldier, perhaps symbolizing how choice and personal identity can be erased by the presence of and responsibility toward the past. Throughout the *Ceramic Series*, painted with strong contour lines, the two elements of body and vessel can be read as representing the relationship today between mainland China and Hong Kong—an uneasy alliance that has left Hong Kong at a disadvantage, overcome by the pressure to adhere to mainland Chinese values. Some of the pieces depict a third, broken-up element scattered about the ground, painted with a thinner indecisive line, that possibly represents the overlooked fallout of unification.

Shieh continues his exploration of power relations and absurd juxtapositions in the *Musical Instruments Series* (1999/2004), in which men and women, their bodies transformed into traditional instruments, play one another, avoiding distinctions between heterosexual or homosexual pairings. One figure plucks at another who is strung like a taut cello or lute, creating a frail concert that can be broken by the smallest shift in interpersonal relations. Despite the fragility of the situation, the focus remains on our attempts at communication and harmonic relationships.

Wilson Shieh received his BFA (1994) and MFA (2001) from the Chinese University of Hong Kong. Solo exhibitions include Grotto Fine Art Ltd., Hong Kong (2002); Arc One, Span Galleries, Melbourne (2002); and the Hong Kong Arts Centre (1998). Group exhibitions include Hong Kong Biennial (2003); *Local Accent: Twelve Artists from Hong Kong*, Pickled Art Centre, Beijing (2003); *Painting HK*, 1a space, Hong Kong (1999); *Emotions*, L.A. Galerie, Frankfurt am Main (1999); *Bad Rice...Fooling the Gods*, Span Galleries, Melbourne (1999); and *Beyond the Future*, Third Asia-Pacific Triennial of Contemporary Art, Brisbane, Australia (1999). In 2003, Shieh was awarded the Hong Kong Biennial Award.

—LS

TADASU TAKAMINE

Born 1968, Kagoshima, Japan; lives in Kyoto, Japan

Common Sense
2004
Video projector, recycled materials, clay, earth, furniture, and computer with sound
Dimensions variable
Courtesy of the artist

The prominent, often masochistic, physical elements witnessed in Tadasu Takamine's early performances seemed to represent acts of verifying, via his own body, reality as experienced in this highly globalized world with diverse value systems. Though performance, coupled with an inclination toward exposing private acts, remains a key factor of this artist's work, his forms of expression are no longer confined to performance and its video documentation but extend to various practices, including animation and a site-specific installation inside an abandoned mine.

In his first clay animation, *God Bless America* (2002), the artist and his assistant, accompanied by the title anthem, worked nonstop to mold and animate a gigantic head of clay weighing two tons. Filmed in a red room and configured like a play within a play, the video documents eighteen days in the life of these two people as they vigorously engage in labor and simultaneously present its results. Although the work deals with the theme of America, it is not intended to address a specific political issue. It is more about a "sense of powerlessness," drawn from Takamine's personal response to that country.

In the recent exhibition *Living Together Is Easy*, at Art Tower Mito in Japan, Takamine was inspired to think about the challenges and opportunities of cohabitation. The outcome takes the form of an installation, *A Big Blow-job* (2004; pp. 70–73), which presents a ruinlike space in a dark room accompanied by light lounge music as if to alleviate the metaphorical gloom of the work. From a raised platform, the audience can see a ghostly spotlight cast from above that slowly illuminates and traces a text about common sense inscribed on the soil that unevenly covers the neutral gallery floor. Through the physical encounter with this highly theatrical setting, viewers can trace both the physical and the psychological paths of the artist's self-investigation under particular circumstances. For San Diego, this work has been reincarnated under the new title *Common Sense*. The artist's life-size quest for understanding reality within the American context may, like that illuminating spotlight, reveal much to American audiences.

Tadasu Takamine graduated from the Department of Crafts at Kyoto City University of Arts and Music (1991) and later attended the International Academy of Media Arts and Sciences in Gifu, Japan (1999). He works in video, installation, and performance. Solo exhibitions include *A Lover from Korea*, Tanba Manganese Memorial Museum, Kyoto (2003); *Do you want what you want as you want*, Kodama Gallery, Osaka (2001); and *Fuyu-no-Umi*, Contemporary Art Institute, Sapporo, Japan (2000). Group exhibitions include *Living Together Is Easy*, Art Tower Mito, Japan (2004); *Roppongi Crossing: New Visions of Japanese Art 2004*, Mori Art Museum, Tokyo (2004); 50th Venice Biennale (2003); Kyoto Biennial (2003); *Continuity and Transgression*, National Museum of Modern Art, Tokyo (2002); and *Facts of Life: Japanese Contemporary Art*, Hayward Gallery, London (2001). Recent performances include *K.I.T.*, ICC InterCommunication Center, Tokyo (1999), and *Performance in Hiroshima*, Hiroshima City Museum of Contemporary Art (1998).

—SN

Theater
2003
Two-channel video; color, sound
25 min.
Courtesy of the artist
Pages 114–17

■ □ ■ ■ ■ ■

Like many of his generation, Wang Jianwei volunteered for military service and then worked as a laborer in the countryside during the Cultural Revolution. These experiences profoundly shaped his perspectives on power and authority, and much of his work addresses the impact of mass society on the individual.

Wang's documentaries, such as *Living Elsewhere* (2000) and *I & We* (2003), portray the effects of China's rapidly changing society, specifically, how the expansion of the cities poses a harsh challenge to those who come to urban centers from rural peasant societies. Since 2000, Wang has broadened his practice to include scripted multimedia theater and he now combines documentary footage, animation, and text with live performance and music. *Ceremony* (2003) is such a *Gesamtkunstwerk*, in which realism converges with metaphoric images and symbolic narratives to dramatize the clash of history and its abrasive effect on the relationships between people. *Ceremony* draws on the story of Ts'ao Ts'ao, the prime minister who appropriated the imperial throne under the Han Dynasty. Wang's work explores the historical fabric of "truth" by referencing three different pieces of writing that relate this story.

Theater is a film historiography of the Chinese legend of the White-Haired Girl, and it incorporates Wang's current interest in theater, his attraction to the Cultural Revolution as a subject, and his critique of the uses of narrative by the authoritative state as a way to manipulate one type of loyalty or another, even when that loyalty runs contrary to one's self-interest. In Wang's telling of the story, the White-Haired Girl (Xi'er) appears at a Buddhist temple in Yan'an, a city in the northern part of the country where the Communists set up their base in the late 1930s. Sometime in the 1940s, members of a work team see her taking and eating the ritual food that is being left at the temple, an action so taboo that she is thought to be an immortal. She then tells the workers the story of her miserable life, and this narrative is repeated four times, in different filmic versions, within Wang's video: Wang's own reconstruction, using actors, of a lost 1940s film version; long segments from two filmic adaptations, one a drama from 1950, and the other a ballet opera from 1965; and a version in which the actors tell stories about their own lives.

Using such layering, Wang presents a comparative history of the story and creates a network of relations between filmic texts. We journey through the space of history produced by each individual work as a way to deconstruct the past and as a step in locating new ways to approach the present. To emphasize the importance of historical context, he matches documentary footage from the 1940s through the 1960s with the filmic productions of White-Haired Girl. The retelling of classics (as determined by State ideology) and the posing of alternative antigovernment versions have been common practices throughout China's pre-modern and modern history. Wang has also been influenced by the ideas of postmodern theorist Michel Foucault, who urged readers to complicate the interpretation of a text by looking at the hierarchies of meaning and to draw conclusions by looking at the text itself, and across texts, to discover its political impact and the underlying, even if unconscious, politics of its construction.

As an art school student at the Chengdu Painting Institute (1983–85) and Zhhejiang Academy of Fine Arts, Hangzhou (1987) (presently the China Academy of Fine Art), Wang Jianwei studied in the Western oil painting course and subsequently began his art career as a painter. He later taught himself video and has since produced works in video, film, multimedia, and experimental theater, including *Ceremony*, preformed at the Institute for Contemporary Art, London, the Musée national d'art moderne, Centre Georges Pompidou, Paris, and in Beijing (2003). Solo exhibitions include *Giant Steps*, Asia-Australia Arts Centre, Sydney (2004), and *The Works of Wang Jianwei*, Hong Kong Arts Centre (1992). Group exhibitions include *Alors, la Chine?*, Musée national d'art moderne, Centre Georges Pompidou, Paris (2003); *Chinese Modernity: Subversion and Poetry*, Culturgest, Lisbon (2003); *Run Jump Crawl Walk*, East Modern Art Center, Beijing (2002); *Facing Elsewhere: Contemporary Chinese Video Art*, Palm Beach Institute of Contemporary Art, Lake Worth, Florida (2002); São Paulo Biennial (2002); *Living in Time*, Hamburger Bahnhof, Berlin (2001); *Translated Acts*, Haus der Kulturen der Welt, Berlin, and Queens Museum of Art, New York (2001–2); Shanghai Biennial (2000); *Yamagata International Documentary Film Festival*, Japan (1999); *Beijing-London*, Institute for Contemporary Art, London (1999); and *Cities on the Move*, Louisiana Museum of Modern Art, Humlebaek, Denmark, P.S. 1 Contemporary Art Center, Long Island City, New York, and Hayward Gallery, London (1999). Wang was awarded the 5th Video Cube Prize at FIAC in Paris (2001).

—BSH

WANG QINGSONG

Born 1966, Heilongjiang Province, China; lives in Beijing, China

Knickknack Peddler
2002
Chromogenic print
47 1/4 x 157 1/2 in. (120 x 400 cm)
Courtesy of the artist and CourtYard Gallery, Beijing
Pages 54–55

White Frosted Peony
2003
Chromogenic print
102 3/8 x 43 1/4 in. (260 x 110 cm)
Courtesy of the artist and CourtYard Gallery, Beijing
Page 56

Red Peony
2003
Chromogenic print
102 3/8 x 43 1/4 in. (260 x 110 cm)
Courtesy of the artist and CourtYard Gallery, Beijing

White Peony
2003
Chromogenic print
102 3/8 x 43 1/4 in. (260 x 110 cm)
Courtesy of the artist and CourtYard Gallery, Beijing
Page 57

Wang Qingsong is a conceptual photographer who, since the mid-1990s, has intermixed signs of the globalized economy and mass culture with compositions and motifs found in traditional and modern Chinese visual cultures as well as in masterpieces from the Western art canon. He uses these easily recognizable images to engage Chinese and Western audiences in a dialogue about the clash of cultures, especially in an era of globalization. Wang's work spans 2,000 years of China's cultural history, quoting famous court paintings from the Tang (618–907) and Song (960–1279) dynasties, Buddhist sculpture, post-1949 revolutionary art and public monuments, and New Year's prints from Chinese folk culture. He lampoons China's love affair with its new-found wealth and the imported commodities that have fueled the consumerist frenzy that has accompanied the country's economic development.

In *Knickknack Peddler*, Wang re-creates the composition of a Song Dynasty painting by Li Song (active 1190–1230), well known for its depiction of life in the Chinese marketplace more than a thousand years ago (p. 34, fig. 18). In Li's version, a peddler sets down his pack of curiosities as a group of children and their mothers gather round to inspect them. Children are shown straining and dragging their mothers to the enticing display. Wang updates the scene so that the pack is now filled with a dazzling array of Chinese and foreign toys and souvenirs, items typically found in the small shops and street markets of contemporary China. Teletubbies, Snoopy dolls, toy panda bears, a Monkey King mask from *The Journey to the West*, Chinese flags, balloons, firecrackers, noodles, and myriad other items are arranged in a tantalizing tableau. Like the items in the peddler's pack, the cute children are dressed in a hybrid Chinese-Western style. The vibrant reds, greens, blues, and yellows of their clothing recall the cheerful colors of Chinese New Year's prints and accentuate the colors of the market items—perhaps equating the children (now consumers in a global economy) with the cheap items

dangling before them. In a wry nod to his own commodification within the international art market, the artist, dressed as the peddler, looks out at us (the next customer) as he reaches for a set of postcards of his own artwork. To the far right, a toddler, the artist's son, Yangyang, cries in protest.

Most recently, Wang has created a series of photographs of artificial flowers and rocks set amongst clouds—subject matter found in traditional ink paintings (*guohua*) routinely displayed in public spaces such as restaurants, hotel lobbies, and waiting rooms. Wang uses the peony, a symbol of prosperity and China's national flower, to subvert its connotation of brilliance. The staged lighting and atmospheric mist create a seductive scene, at once artificial and dreamlike. The bright stage lighting points out to us that the flower petals are, in fact, made from vegetable, beef, and lamb slices—ingredients used in a northern dish, Mongolian Hot Pot. The symbolic resonance of the peony has been turned on its head, now more suggestive of unhealthy overconsumption than of vital prosperity. Wang photographs each flower arrangement over several days, documenting the gradual decay of the piece, as the once fresh and beautiful flowers begin to rot and smell. The blood dripping from the meat petals is suggestive of the violence being done to China's society and culture and the unsavory values that lie just below the attractive surface. The next photograph documents the flower and rock after they have been placed in a freezer for five days. Covered in a thick frost, the tableau evokes the decadence that lies at the heart of China's prosperity and the artist's despair at the country's spiritual impoverishment.

Wang Qingsong graduated from the Sichuan Academy of Fine Arts, Chongqing, with a degree in oil painting (1991). In 1996, he moved from his muscular figure paintings toward conceptual photography. The phenomenon of China's push for modernization

and its ensuing economic and cultural implications fuel his amusing social critiques. Such commentaries are acutely present in his extensive photographic series *Glorious Life*, first shown during a solo exhibition at the Wan Fung Art Gallery, Beijing (2000). Other solo exhibitions include *Romantique*, Salon 94, New York, and CourtYard Gallery, Beijing (2004); *Present-day épices*, Saidye Bronfman Contemporary Art Center, Montreal (2003, traveled to Cambridge Galleries, Ontario, and South Alberta Art Gallery); Foundation Oriente, Macao (2002); and Marella Arte Contemporanea, Milan (2002). Group exhibitions include *Between Past and Future: New Photography and Video from China*, International Center of Photography and Asia Society and Museum, New York (2004); *Photosynkyria: Photography as Narrative Art*, Thessaloniki Museum of Photography, Greece (2004);

Spellbound Aura: Chinese Contemporary Photography, Museum of Contemporary Art, Taipei (2004); *Contemporary Chinese Photography*, Rudolfinum Art Museum, Prague (2003); Prague Biennial (2003); *Fashion and Style*, The Museum Moscow House of Photography, Russia (2003); *Special Projects*, P.S. 1 Contemporary Art Center, Long Island City, New York (2002); *Chinese Modernity*, Museum of the Foundation Armando Alvares Penteado, São Paulo (2002); *Promenade in Asia–CUTE*, Art Tower Mito, Japan (2001); and Taipei Biennial (1998).

—LT

YANG FUDONG

Born 1971, Beijing, China; lives in Shanghai, China

Liu Lan
2003
35mm film; black and white, sound
14 min.
Courtesy of the artist and ShanghART Gallery, Shanghai
Pages 66–69

■■■■■■■■■■■■■■■■■■■■■■■□■■

Yang Fudong makes experimental films, videos, and photographs that focus on the challenges facing his generation and reflect the spirited nostalgia that is currently sweeping Shanghai, where the artist resides. In his prodigious body of work, Yang presents three types of landscapes that serve as the environment for shaping relationships between peers: the city; famous literati gardens; and lush panoramic views of mountains, valleys, lakes, and rivers. Within these settings, there is a strange and disturbing tension in the interactions among the characters. Yang's seemingly retro cinematic style has been compared with the work of Yuan Muzhi and other movie directors from the 1920s and 1930s. However, Yang does not take on the narrative complexities of traditional cinema; rather, he presents only the surfaces of these cinematic tropes, often leaving out the connective links that allow for the construction of meaning. In Yang's films, vagueness and uncertainty prevail, leaving it to viewers to fill in the gaps with their own dreams, fantasies, and phantoms. The artist leaves clues for the viewer to decipher, and then denies that the clues were placed in the film for any particular purpose. He refers to this "abstract imagery" as "a force that, by coincidence, makes you progress in terms of your critical point of view."

The setting of *Liu Lan* is reminiscent of scenes depicted in Chinese literati landscape and screen paintings. The story is about a girl who works in the fishing industry in a village near Lake Tai. Just awakening to puberty, she ferries a young man in a fashionable light suit carrying a suitcase, a city dweller, across the lake, under the watch of an old woman. The cues are confusing, as the clothing of the two protagonists is not from the same historical period. Such conflicting details add to the unbelievable and dreamlike quality of the film. Yet the folk tale is grounded in reality, as it is not unusual for different qualities of time—that of the city and that of the countryside—to converge in China. However, the signifiers are so overladen as to lose their meaning, and we are left with a drained sentiment. The larger implication of Yang's work may be that even though starting out with a desire to achieve something is perhaps a valuable plan, in the end, life takes its own path, leaving behind memory, as well as desire.

Yang Fudong graduated from the China Academy of Fine Arts, Hangzhou (1995), with a degree in oil painting. After moving to Shanghai two years later, he learned computer technology and immediately became interested in making digital films. The approaches to his conceptual work have been as diverse as their themes, drawing on the style of Chinese films of the 1920s and 1930s to evoke nostalgia in certain films, while showing interest in dilemmas that arise out of idealistic attitudes in other work. Solo exhibitions include The Renaissance Society, Chicago (2004); Marian Goodman Gallery, Paris (2004); Galerie Judin Belot, Zurich (2004); and Douglas Hyde Gallery, Dublin (2003). Group exhibitions and film screenings include *China Now*, Gramercy Theater, Museum of Modern Art, New York (2004); *Between Past and Present: New Photography and Video from China*, International Center of Photography and the Asia Society and Museum, New York (2004); *Alors, la Chine?*, Musée national d'art moderne, Centre Georges Pompidou, Paris (2003); *Happiness, A Survival Guide for Art and Life*, Mori Art Museum, Tokyo (2003); *Utopia Station* and Chinese Pavilion, 50th Venice Biennale (2003); *Documenta 11*, Kassel, Germany (2002); Guangzhou Triennial (2002); *Urban Creation*, 2nd Shanghai Biennial (2002); 7th International Istanbul Biennial (2001); Yokohama Triennial (2001); *Living in Time*, Hamburger Bahnhof, Berlin (2001); *CITYZOOM*, Hannover, Germany (2000); *Fuck Off*, Eastlink Gallery, Shanghai (2000); and *Useful Life*, Shanghai (2000). Yang was a finalist for the Hugo Boss Prize in 2004.

—BSH

YANGJIANG CALLIGRAPHY GROUP

Formed 2002, Yangjiang, China; live in Yangjiang

Calligraphy Project: In the Interior Woods
2004
Calligraphy scrolls, paintings, potted plants, stones, tile, wax, wooden bridge, surveillance cameras, desk, and blood-pressure monitors
Dimensions variable
Courtesy of the artists and ShanghART Gallery, Shanghai
Page 138

The four artists of Yangjiang Calligraphy Group—Zheng Guogu, Sha Yeya, Chen Zaiyan, and Sun Qinglin—reside in Yangjiang, a small seaside town two hours outside of Guangzhou. *Calligraphy Project: In the Interior Woods* is the latest in a series of projects by the group aimed at both reviving and subverting one of China's most venerable and conservative cultural practices. Only one member, Chen Zaiyan, has been formally trained in calligraphy, a process involving years of studying the writings of canonical calligraphers. The other three artists are completely unschooled. Their lack of training is inherently subversive to an art form that requires the would-be calligrapher to first master the techniques and styles of famous practitioners before being allowed to invent his or her own personal style.

The Yangjiang group's choice of subject matter is a further provocation. Instead of the poems and private letters that are the subject of traditional calligraphy, their writings are riffs on the types of headlines seen in international and domestic news and tabloid magazines, such as "15 female workers were frisked nude for one hour" and "The World Trade Center remains cleaned up." Some of the calligraphy is no more than graffiti and incomprehensible scribbles.

For *Past in Reverse*, the group has created an installation modeled after a traditional Chinese garden. Designed as miniature mountainscapes, typical gardens include a waterfall, rocks, and a winding path leading to an arched bridge over a meandering stream. The conceptual and material basis of this garden installation is calligraphy. Hanging scrolls of the group's calligraphy are displayed on the walls; the waterfall is made of wads of crumpled calligraphy encased in wax; discarded rice paper forms the water beneath the bridge. A television monitor, two computer monitors, and a video projector display different parts of the installation on the walls. Melding the signs of traditional literati culture with the high-tech gadgets of today's consumer-oriented urban culture, the Yangjiang group creates an imaginary space where their new genre of calligraphy can exist. As we confront the space, we may ask ourselves, "What's going on here?" Two blood-pressure monitors are provided for us to test our psychosomatic reaction as we grapple with this question. Perhaps the true subject is not the installation itself, but how we respond to it.

The Yangjiang Calligraphy Group is led by conceptual artist, photographer, architect, and calligrapher Zheng Guogu, who graduated from the printmaking department of the Guangzhou Academy of Fine Arts (1992). The other members are Sha Yeya, a sculptor and furniture maker, who graduated from the Affiliated Middle School of Guangzhou Art Institute (1990); Chen Zaiyan, a graduate of the calligraphy department of the China Art Institute (1994); and Sun Qinglin, a local calligrapher in Yangjiang. Their projects and exhibitions to date include *In the Interior Woods*, Villa Arson, Nice, France (2004); *Fabricated Paradises*, Centre d'art contemporain, Le Parvis, France (2003–4); *Are you going to enjoy calligraphy or measure your blood pressure?*, ShangART Gallery, Shanghai (2002); and *2002 in Shanghai, Yangjiang some event occurring*, ShangART Gallery, Shanghai (2002).

—LT

SHIZUKA YOKOMIZO

Born 1966, Tokyo, Japan; lives in London, England

Untitled (Hitorigoto)
2002
Digital C-type print
24 1/2 x 20 1/2 in. (62 x 52 cm)
Courtesy of Cohan and Leslie, New York
Page 130 left

Untitled (Hitorigoto)
2002
Digital C-type print
24 1/2 x 20 1/2 in. (62 x 52 cm)
Courtesy of Cohan and Leslie, New York
Page 130 right

Untitled (Hitorigoto)
2002
Digital C-type print
24 1/2 x 20 1/2 in. (62 x 52 cm)
Courtesy of Cohan and Leslie, New York
Page 131 left

Untitled (Hitorigoto)
2002
Digital C-type print
24 1/2 x 20 1/2 in. (62 x 52 cm)
Courtesy of Cohan and Leslie, New York
Page 131 right

Untitled (Hitorigoto)
2002
Digital C-type print
24 1/2 x 20 1/2 in. (62 x 52 cm)
Courtesy of Carlos Mota, New York

Untitled (Hitorigoto)
2003
Digital C-type print
24 1/2 x 20 1/2 in. (62 x 52 cm)
Courtesy of Ninah and Michael Lynne, New York

When You Wake
2002
Two-channel video; color, sound
8 min.
Courtesy of Cohan and Leslie, New York
Pages 132–33

Estrangement is common to the diasporic experience, and isolation is a common trope for urban living. Add Japanese behavioral codes for social interaction—politeness and distance in exposed situations—and you start to approach the motivation for Shizuka Yokomizo's portrayals. The framing of her photographs, taken in interior spaces, reinforces the boundaries of architecture and shows how the body carves out a comfortable, immediate protective bubble around itself. As the artist has said, "I am trying to give priority to the subject's autonomous existence in the image."

In the *Untitled (Hitorigoto)* series, Yokomizo photographs people she knows, always in natural lighting, at the moment when they are no longer connecting to her. Waiting until they literally space out, she photographs them when they have retreated into their internal world. By using a very slight degree of digital manipulation to enhance the luminosity of the figures, who become saturated by their own light source, she gives them an almost religious aura. The artist's fascination with the use of light in European figure painting is apparent in these works. At the same time, the tight and semi-dark spaces where light is controlled yet dramatically present would seem natural in, for example, a traditional Japanese house. Light—directional, auratic, or penetrating, each time differently conceived—is the artist's way of visually encoding the individual sitter. The idea of portraiture moves into a spiritual realm of appearances and is realized in the metaphoric quality and shape of light, that ephemeral natural element that gives photography its unique qualities and possibilities.

Central to *When You Wake*, a two-channel video that documents elderly people waking up from a night's sleep, are the liminal moments between consciousness and

unconsciousness. Sleep and death, in the context of old age, are no longer particularly distant. Images shift from the fragility of the aged to panoramic views of the sky, mountains, or the sea. The sound of breathing mixed with soothing music provides rhythm, and the simple act of waking from sleep becomes less a routine and more a source of wonderment. The position of the clothed bodies—sometimes horizontal, other times partly reclining—surrounded by bed linens is reminiscent of how figures are composed in traditional Japanese prints. Yokomizo surrenders herself to the private world of her subjects and maintains a respectful distance from them during the reawakening that follows sleep (and presumably, dreaming). The video ends in a room that functions as a communal space, with an ensemble of characters sitting around waiting, enjoying one another's company, just being.

After graduating with a degree in philosophy from Chuo University in Japan (1989), Shizuka Yokomizo moved to London, completing her BFA at the Chelsea College of Art and Design (1993) and her MFA at Goldsmith's College (1995). Solo exhibitions include *Forever (and Again)*, Cohan and Leslie, New York (2003); Museo d'Arte Contemporanea, Rome (2002); *Dear Stranger*, The Approach, London (2000); and *Sleeping*, Wako Works of Art, Tokyo (1997). Group exhibitions include *The Last Picture Show: Artists Using Photography, 1960–1982*, Walker Art Center, Minneapolis (2003–4); *The Furtive Gaze*, Museum of Contemporary Photography, Chicago (2003); *Days Like These*, Tate Triennial Exhibition of Contemporary British Art, Tate Britain, London (2003); 50th Venice Biennale (2003); *Strangers*, First ICP Triennial of Photography and Video, International Center of Photography, New York (2003); and *The Fantastic Recurrence of Certain Situations: Recent British Art and Photography*, Sala de Exposiciones del Canal de Isabel II, Madrid (2001).

—BSH

FIGURE AND PLATE CAPTIONS

Works in the exhibition are indicated by an asterisk (*).

Fig. 1
Catalogue for *Contemporary Art in Asia: Traditions/Tensions*, Asia Society and Harry N. Abrams, New York, 1996; Photo © Chatchai Puipia

Fig. 2
Catalogue for *Cities on the Move: Urban Chaos and Global Change—East Asian Art, Architecture and Film Now*, Hayward Gallery, London, 1999; Photo © Hayward Gallery Publishing, Manchester

Fig. 3
Catalogue for *Under Construction: New Dimensions of Asian Art*, Japan Foundation Asia Center in collaboration with the Tokyo Opera City Art Gallery, Tokyo, 2002

Fig. 4
Catalogue for *Translated Acts: Performance and Body Art from East Asia, 1990–2001*, Queens Museum of Art, New York, and Haus der Kulturen der Welt, Berlin, 2001; Photo © Kim Atta

Fig. 5
Wang Qingsong, *China Mansion*, 2003; Chromogenic print, 60 1/4 x 236 1/4 in. (60 x 600 cm); Courtesy of the artist and CourtYard Gallery, Beijing

Fig. 6
Cai Guo-Qiang, *Bigfoot's Footprints: Project for Extraterrestrials No. 6*, 1991; Gunpowder on paper, 78 3/4 x 267 3/4 in. (200 x 680 cm); Collection of the San Diego Museum of Art; Photo courtesy of the artist

Fig. 7
The Miraculous Interventions of Jizo Bosatsu (detail), Japanese, Kamakura period, 13th century; Handscroll, ink and color on paper, 12 x 563 3/4 in. (30.5 x 1431.9 cm); Freer Gallery of Art, Smithsonian Institution, Washington, D.C., Gift of Charles Lang Freer F1907.375; Photo © Smithsonian Institution

Fig. 8
Yiso Bahc, *Untitled (Sky of San Antonio)*, 2000; Four cameras, four projectors, wood, and drywall, 15 x 130 3/4 in. (38 x 332.1 cm); Installation view, originally commissioned by ArtPace, San Antonio; Photo: Seale Studios; © Mr. Daeyeol Ku, Estate of Yiso Bahc

Fig. 9
Okakura Tenshin; Photo © Tenshin Memorial Museum of Art, Ibaraki, Japan

Fig. 10
Wen Zhenheng (Chinese, 1585–1645), *Picture of the Pine-Shaded Studio*, 17th century; Hanging scroll, ink and colors on silk, 63 x 17 3/8 in. (160 x 44 cm); Collection of Qingbixuan

Fig. 11
Kim Ho-Suk, *The History of Korea's Resistance Against Japanese Colonialism: Comfort Women*, 1990; Ink on paper, 70 7/8 x 70 7/8 in. (180 x 180 cm); © Kim Ho-Suk

Fig. 12
Nam June Paik, *TV Buddha*, 1974; Video installation with statue; Collection Stedelijk Museum, Amsterdam

Fig. 13
"Ke Tsi-Hai Makeover as Zhou Jie lun," *Yishukan Weekly Magazine*, June 6, 2002

Fig. 14
Cai Guo-Qiang, *Venice Rent Collection Courtyard*, Venice, Italy, 1999; Courtesy of the artist; Photo: Elio Montanari

Fig. 15
Cai Guo-Qiang, *Venice Rent Collection Courtyard* (detail)

Figs. 16–17
Stills from Cao Fei, Ou Ning, and U-Thèque Organization, *San Yuan Li*, 2003; Video, black and white, sound, 40 min.; Courtesy of the artists

Fig. 18
Li Song (Chinese, active 1190–1230, Southern Song Dynasty), *The Knickknack Peddler*, Song Dynasty, 1212; Ink and light color on silk, 9 1/2 x 10 1/4 in. (24.2 x 26 cm); The Cleveland Museum of Art, Andrew R. and Martha Holden Jennings Fund, 1963.582

Fig. 19
Yasumasa Morimura, *Blinded by the Light*, 1991; Chromogenic print and transparent medium, 78 3/4 x 142 7/8 in. (200 x 363 cm); Courtesy of the artist and SHUGOARTS, Tokyo

Fig. 20
Tsuyoshi Ozawa, *Nasubi Gallery—Takashi Murakami exhibition [Little Aperto]*, 1995; Wooden milk box with small Murakami works; Courtesy of the artist and Ota Fine Arts, Tokyo

Fig. 21
Makoto Aida, *Beautiful Flag (War Picture Returns)*, 1995; Two two-panel sliding screens, hinges, charcoal, homemade paint with Japanese glue, and acrylic, 66 1/2 x 66 1/2 in. (169 x 169 cm) each; Courtesy of the artist and Mizuma Art Gallery, Tokyo; Photo: Kei Miyajima

Fig. 22
Kaoru Arima, *Untitled ("Cold")*, March 15, 1998; Pencil, colored pencil, and acrylic on newspaper, 14 1/4 x 10 1/8 in. (36.2 x 25.7 cm); Courtesy of the artist and Gallery Cellar, Nagoya

Fig. 23
Dumb Type, *PH*, 1990–93; Performance still; Courtesy of the artists; Photo: Shiro Takatani

Fig. 24
Yoon Oh, *Song of Sword*, 1983; Color woodcut print, 9 7/8 x 11 7/8 in (25 x 30 cm); © Yoon Oh

Fig. 25
Marcel Duchamp, *Tu m'*, 1918; Oil and pen on canvas, with bottle brush, three safety pins, and a bolt, 27 1/2 x 119 5/8 in. (69.8 x 303 cm); Collection of Yale University Art Gallery, New Haven, Connecticut, Gift of Katherine S. Dreier

Fig. 26
Yiso Bahc, *World's Top Ten Tallest Structures in 2010*, 2003; Plasticine, aluminum foil, tape, and block, 67 x 102 3/8 x 31 1/2 in. (170 x 260 x 80 cm); © Mr. Daeyeol Ku, Estate of Yiso Bahc; Photo: Betti-Sue Hertz

Fig. 27
Bill Viola, *Five Angels for the Millennium*, 2001; Video/sound installation, i. "Departing Angel"; Courtesy of Bill Viola Studio; © Bill Viola; Photo: Kira Perov

Plates

Wang Qingsong

Pages 54–55
Knickknack Peddler
2002
Chromogenic print
47 1/4 x 157 1/2 in. (120 x 400 cm)
Courtesy of the artist and CourtYard Gallery, Beijing

Page 56
White Frosted Peony
2003
Chromogenic print
102 3/8 x 43 1/4 in. (260 x 110 cm)
Courtesy of the artist and CourtYard Gallery, Beijing

Page 57
White Peony
2003
Chromogenic print
102 3/8 x 43 1/4 in. (260 x 110 cm)
Courtesy of the artist and CourtYard Gallery, Beijing

Wilson Shieh

Page 58 left
Musical Instruments Series: Cello
1999
Chinese ink and color on silk
12 x 7 in. (30.48 x 17.78 cm)
Courtesy of Brad Davis and Janis Provisor, New York

Page 58 right
Musical Instruments Series: Viola
1999
Chinese ink and color on silk
12 x 7 in. (30.48 x 17.78 cm)
Courtesy of Brad Davis and Janis Provisor, New York

Page 59 top
Musical Instruments Series: Jungle Drum
2004
Chinese ink, watercolor, and gouache on dyed silk
18 x 18 in. (45 x 45 cm)
Courtesy of the artist

Page 59 bottom
Musical Instruments Series: Cello Suite for the Night
2004
Chinese ink, watercolor, and gouache on dyed silk
18 x 18 in. (45 x 45 cm)
Courtesy of the artist

Page 60 left
*Ceramic Series: Blue and White Bowl with Red Dragon
2002
Chinese ink and watercolor on silk
14 7/8 x 10 5/8 in. (38 x 27 cm)
Courtesy of Brad Davis and Janis Provisor, New York

Page 60 right
*Ceramic Series: Gu (Beaker-Shaped Vase) in White Glaze
2002
Chinese ink and watercolor on silk
14 7/8 x 10 5/8 in. (38 x 27 cm)
Collection of Matt Dillon, Hong Kong

Page 61 left
*Ceramic Series: Terracotta Soldier of the First Emperor of Qin
2002
Chinese ink and color on silk
14 7/8 x 10 5/8 in. (38 x 27 cm)
Courtesy of Henry Au-yeung, Grotto Fine Art Ltd.

Page 61 right
*Ceramic Series: Cizhou Ware Pillow in Shape of a Tiger
2002
Chinese ink and color on silk
14 7/8 x 10 5/8 in. (38 x 27 cm)
Courtesy of Henry Au-yeung, Grotto Fine Art Ltd.

G8 Public Relations and Art Consultation Corporation
(Shi Jin-hua, Wu Yue-Jiao, Yeh Yu-Nan, Lu Hao-Yuan, and Xu Huang)

Page 62
Four photographs from *Stray Dogs Project
2002
Thirty-three black-and-white photographs, one text, and two maps
Photographs: 23 3/8 x 23 3/8 in. (60 x 60 cm) each
Text: 23 3/8 x 23 3/8 in. (60 x 60 cm)
Maps: 35 3/8 x 35 3/8 in (90 x 90 cm) each
Courtesy of the artists

Page 63
Eight photographs from *Messaging Project
2002
Fifteen black-and-white photographs and three texts
Photographs: 23 3/8 x 23 3/8 in. (60 x 60 cm) each
Texts: 23 3/8 x 23 3/8 in. (60 x 60 cm) each
Courtesy of the artists

Pages 64–65
Three photographs from *Jamming Communication Project
2002
Nine black-and-white photographs and one text
Photographs: 23 3/8 x 23 3/8 in. (60 x 60 cm) each
Text: 23 3/8 x 23 3/8 in. (60 x 60 cm)
Courtesy of the artists

Yang Fudong

Pages 66–69
Stills from *Liu Lan
2003
35mm film, black and white, sound
14 min.
Courtesy of the artist and ShanghART Gallery, Shanghai

Tadasu Takamine

Pages 70–73
A Big Blow-job
2004
Video projector, recycled materials, clay, earth, furniture, and computer with sound
Installation at Living Together Is Easy, Art Tower Mito, Japan
Photos courtesy of the artist

Soun-gui Kim

Pages 74–75
*Aléa
1997
Video projector, small speakers, DVD player, and wood cart
24 x 36 x 24 in. (60.9 x 91.4 x 60.9 cm)
Courtesy of the artist

Page 76 left
*Pap-gré
2001
Video projection, ceramic vase, and pedestal
23 5/8 x 23 5/8 in. (60 x 60 cm)
Courtesy of the artist

Pages 76 right, 77
Three photographs from the *Lunes series
2003
Gelatin silver prints
32 5/8 x 23 5/8 in. (83 x 60 cm) each
Courtesy of the artist

Mitsushima Takayuki

Page 78
Sympathetic Vibration Lines II
2002
Drafting tape and vinyl on canvas
31 1/2 x 39 3/8 in. (80 x 100 cm)
Courtesy of the artist

Page 79 top left
Strum
2002
Drafting tape and vinyl on paper
16 1/2 x 15 3/8 in. (42 x 39 cm)
Courtesy of the artist

Page 79 bottom left
Drinking Canned Coffee
2002
Drafting tape on paper
15 3/4 x 12 5/8 in. (40 x 32 cm)
Courtesy of the artist

Page 79 right
The Voice of Blue
2002
Vinyl on paper
16 1/2 x 15 3/8 in. (42 x 39 cm)
Courtesy of the artist

Yiso Bahc

Page 82
**Wide World Wide*
2003
Acrylic and oil on canvas, paper labels, and light fixtures
Painting: 95 1/4 x 163 3/8 in. (242 x 415 cm)
Installation: 104 3/8 x 200 5/8 x 9 7/8 in. (265 x 510 x 25 cm)
Courtesy of Mr. Daeyeol Ku and friends of Yiso Bahc
Photograph by Jong-Myung Lee

Page 83 left
World Chair
2001
Wood and acrylic
35 7/8 x 25 1/4 x 18 1/8 in. (91 x 64 x 46 cm)
Courtesy of Mr. Daeyeol Ku and friends of Yiso Bahc

Page 83 right
Untitled as an Escape, Blackhole Yes, the Room
Installation at alternative space POOL, Seoul, December 22, 2001–January 7, 2002
Courtesy of Mr. Daeyeol Ku and friends of Yiso Bahc

Page 84 left
Artist's sketch, *Nothing Sculptures + Calendar*
Unfinished, 2004
Pencil and colored pencil on paper
8 1/2 x 11 in. (21.6 x 27.9 cm)
Courtesy of Mr. Daeyeol Ku and friends of Yiso Bahc
Photograph by Jung-sik Cho

Page 84 center top
Nothing Sculptures + Calendar: January
Unfinished, 2004
Wood, paper, and molding putty
7 7/8 x 7 7/8 x 11 7/8 in. (20 x 20 x 30 cm) approx.
Courtesy of Mr. Daeyeol Ku and friends of Yiso Bahc
Photograph by Jung-sik Cho

Page 84 center bottom
Nothing Sculptures + Calendar: March
Unfinished, 2004
Molding putty
4 x 4 x 11 7/8 in. (10 x 10 x 30 cm) approx.
Courtesy of Mr. Daeyeol Ku and friends of Yiso Bahc
Photograph by Jung-sik Cho

Page 84 right top
Nothing Sculptures + Calendar: February
Unfinished, 2004
Metal, molding putty, and plastic
7 x 4 x 15 3/4 in. (18 x 10 x 40 cm) approx.
Courtesy of Mr. Daeyeol Ku and friends of Yiso Bahc
Photograph by Jung-sik Cho

Page 84 right bottom
Nothing Sculptures + Calendar: April
Unfinished, 2004
Wood, Styrofoam, and paint
6 x 6 x 11 7/8 in. (15 x 15 x 30 cm) approx.
Courtesy of Mr. Daeyeol Ku and friends of Yiso Bahc
Photograph by Jung-sik Cho

Page 85 top
Don't Look Back: Not Until the End of Development
1998
Site-specific installation, Taipei Biennial
Plywood, wood, linoleum, electrical wiring, and light bulbs
© Mr. Daeyeol Ku, Estate of Yiso Bahc

Page 85 bottom
Don't Look Back: Biennale Garbage
1998
Site-specific installation, Taipei Biennial
Garbage from other artists' installations
© Mr. Daeyeol Ku, Estate of Yiso Bahc

Hee-Jeong Jang

Page 86
**Flower Painting with Bird and Butterfly*
2004
Acrylic and gloss medium on floral fabric
40 1/2 x 63 3/4 in. (102.9 x 161.8 cm)
Courtesy of the artist

Page 87
**Flower Painting with Bird and Butterfly*
2004
Acrylic and gloss medium on floral fabric
40 1/2 x 63 3/4 in. (102.9 x 161.8 cm)
Courtesy of the artist

Page 88
**Flower Painting with Bird*
2004
Acrylic and gloss medium on floral fabric
12 1/2 x 69 5/8 in. (32 x 177 cm)
Courtesy of the artist

Page 89
**Grass Painting with Butterfly and Insect*
2004
Acrylic and gloss medium on floral fabric
24 in. (61 cm) diameter
Courtesy of the artist

Shao Yinong and Muchen

Page 90
**Assembly Hall Series: Anyuan Coal Mine, Jiangxi*
2003
Chromogenic print
48 x 66 7/8 in. (122 x 170 cm)
Courtesy of the artists

Page 91
**Assembly Hall Series: Sanchuan Mine Factory, Qinghai*
2003
Chromogenic print
48 x 66 7/8 in. (122 x 170 cm)
Courtesy of the artists

Page 92
**Assembly Hall Series: Fifty Middle School, Huzhu Tuzu Autonomous County, Qinghai*
2003
Chromogenic print
48 x 66 7/8 in. (122 x 170 cm)
Courtesy of the artists

Page 93
**Assembly Hall Series: Pukou, Zhejiang*
2002
Chromogenic print
48 x 66 7/8 in. (122 x 170 cm)
Courtesy of the artists

Cao Fei

Page 94
**Game Series: Plant Contest*
2000
Chromogenic print
70 7/8 x 47 1/4 in. (180 x 120 cm)
Courtesy of the artist

Page 95
**Game Series: Finger-Guessing Game*
2000
Chromogenic print
47 1/4 x 70 7/8 in. (120 x 180 cm)
Courtesy of the artist

Page 96
Game Series: Wine Vessels Floating in the Meandering River
2000
Chromogenic print
70 7/8 x 47 1/4 in. (180 x 120 cm)
Courtesy of the artist

Page 97
Game Series: Football
2000
Chromogenic print
70 7/8 x 47 1/4 in. (180 x 120 cm)
Courtesy of the artist

Michael Lin

Page 98
Lisboa, Cama de Día
Emulsion on wood
94 1/2 x 94 1/2 x 15 3/8 in. (240 x 240 x 39 cm)
Courtesy of the artist and Galerie Urs Meile, Lucerne

Page 99
Untitled
2002
Emulsion on wood
354 5/16 x 236 3/16 in. (900 x 600 cm)
Courtesy of the artist and Galerie Tanit, Munich

Page 100
Atrium Stadhuis den Haag
2002
Emulsion on wood
164 x 82 ft. (50 x 25 m)
Courtesy of the artist

Page 101
Kiasma Day Bed
2001
Emulsion on wood
141 3/4 x 141 3/4 x 17 3/4 in. (360 x 360 x 45 cm)
Courtesy of the artist

Flyingcity Urbanism Research Group
(Oak Jung-ho, Jang Jong-kwan, and Jeon Yong-seok)

Page 102 left
Talk Show Tent and *Street Vendors Flag*, part of
Drifting Producers: Cheonggyecheon Project
2003
Digital print
59 x 31 1/2 in. (150 x 80 cm)
Courtesy of the artists
Text: "During our research we heard many stories, but the images of everyday life were harder to come by. Flyingcity's *Talk Show Tent* was conceived to listen carefully to the street vendors' stories. Eleven of their [vendor's] tents stood there as a protest against the city government's new developmental policy. It was not desirable to have their voices reduced to the simple anger of an interest group, so we chose a form to attract people's attention—a form suggesting quieter voices rather than the usual loud ones heard in a demonstration. This led to a talk show–like event with installations of flags and tents designed like the umbrellas popular among street vendors. The demonstrating street vendors were evicted by force on November 30, 2003, by the city government."

Pages 102 right, 103
Stills from *Talk Show Tent*, part of
Drifting Producers: Cheonggyecheon Project
2003
6mm digital video, transferred to DVD; color, sound
21 min.
Courtesy of the artists

Page 104 left
Electric Fan, part of
Drifting Producers: Cheonggyecheon Project
2003
Digital rendering
Courtesy of the artists

Page 104 right
Metal Workshops Production Network Diagram, part of
Drifting Producers: Cheonggyecheon Project
2003
Digital print
45 1/4 x 29 1/2 in. (115 x 75 cm)
Courtesy of the artists
Text: "The title *Drifting Producers* refers to the production system network in this area. There are strong relations between the workshops, and this network is very flexible. The above diagram represents the kind of production line we discovered. It is organized as a so-called front-rear production system. For example, *Uljigeumsok* (raw metal plate)–*Younggwangjumul* (iron casting)–*Bugwangbunchechil* (painting

with heat treatment)—*Worldteuksujomyong* (final product, lighting parts in this case, which are also sold here). Such production lines allow for the competitiveness of that area. If one shop is taken out of the line, then costs cannot be kept low. Each shop is run in such a way that it can adjust itself to a new network, created by an unexpected order of a small quantity or of a new design, while sustaining existing networks. The interdependency and informal economy of the site are hard to grasp, and so tend to be mythologized. We heard rumors that illegal gun parts or bayonets for local gangs were produced there. People even talked about the possibility of making armored tanks! It's hard to say if those stories are true. What's evident is that such invisible but strong networks in Cheonggyecheon are sources of exaggerated rumors."

Page 105
This Is Not an Electric Fan
2003
PowerPoint™ presentation, 120 slides
6 min.
Courtesy of the artists

Cai Guo-Qiang

Page 106
Bird of Light
Digital rendering of proposal for airplane and roman candles at Miramar Air Show night program
Courtesy of the artist

Page 107
**Painting Chinese Landscape Painting*
Digital rendering of proposal for six T-34 skywriting propeller planes at Miramar Air Show day program
Performed October 15, 2004
Courtesy of the artist

Page 108
Drawing for Man, Eagle and Eye in the Sky, Siwa, Egypt
2004
Gunpowder on Japanese paper, backed on wood panel
30 1/2 x 204 3/4 in. (77.5 x 520 cm)
Courtesy of the artist
Photo by Hiro Ihara

Page 109
Explosion Event: Light Cycle over Central Park
New York, 2003
Courtesy of the artist
Photo by Hiro Ihara

Hiroshi Fuji

Page 110
Kaekko Bazaar Neon Sign
2001
Installation at *Labyrinth of Pleasure*, Museum of Contemporary Art, Taipei
Photo courtesy of the artist

Page 111 left
Kaekko Bazaar Plan for the San Diego Museum of Art
2004
Pen and colored inks on paper
Courtesy of the artist

Page 111 right
Kaekko-Shop
2003
Installation at Echigo-Tsumari Art Triennial
Courtesy of the artist
Photo by S. Anzai

Page 112
Vinyl Plastics Connection: Dragon and Turtle
2003
Installation at Hakata Lantern Festival, Fukuoka City, Japan
Photo courtesy of the artist

Page 113 top
Vinyl Plastics Connection Info Cafe
2000
Installation at MOMA Contemporary, Fukuoka, Japan
Photo courtesy of the artist

Page 113 center
Vinyl Plastics Connection
2000
Installation at Pusan International Contemporary Art Festival, South Korea
Photo courtesy of the artist

Page 113 bottom
Vinyl Plastics Connection: Vegetable Shirt by Jin Sato
2002
Recycled vegetable packing
Courtesy of the artist

Wang Jianwei

Pages 114–17
Stills from *Theater
2003
Two-channel video; color, sound
25 min.
Courtesy of the artist

Kim Young Jin

Pages 118–20
Stills from *I, My, Me
2004
Two-channel synchronized video projection, pleated screen, two DVD players, and two projectors
Dimensions variable
Courtesy of the artist

Page 121
Stills from Globe
2001
Video; color, sound
12 min.
Courtesy of the artist

Ryoko Aoki

Page 122 left
Chrysanthemum Seal
2004
Ink on paper
8 1/4 x 11 3/4 in. (21 x 30 cm)
Courtesy of the artist and Kodama Gallery, Osaka

Page 122 right
Dancing Mountain
2003
Ink, pencil, acrylic, and gesso on cardboard
9 x 15 3/4 in. (23 x 40 cm)
Courtesy of the artist and Kodama Gallery, Osaka

Page 122 bottom
*Sleeping Boy
2004
Ink and felt-tip pen on paper
Triptych: 13 7/8 x 9 7/8 in. (35.1 x 25 cm) each
Courtesy of the artist

Page 123 top left
Woods
2003
Ink, felt-tip pen, watercolor, and collage on paper
14 1/2 x 8 1/2 in. (37 x 21 cm)
Courtesy of the artist and Kodama Gallery, Osaka

Page 123 top right
*Wallpaper
2003
Ink on paper
13 7/8 x 9 7/8 in. (35.1 x 25 cm)
Courtesy of the artist

Page 123 bottom left
Woods
2003
Ink and felt-tip pen on paper
14 x 17 in. (35.5 x 43 cm)
Courtesy of the artist and Kodama Gallery, Osaka

Page 123 bottom right
Woods
2003
Ink and felt-tip pen on paper
11 3/4 x 16 1/2 in. (30 x 41 cm)
Courtesy of the artist and Kodama Gallery, Osaka

Page 124 top left
Wedge
2003
Ink and felt-tip pen on paper
5 3/4 x 5 3/4 in. (14.6 x 14.6 cm)
Courtesy of the artist and Kodama Gallery, Osaka

Page 124 top right
Bamboo Shoot
2003
Ink on paper
14 1/4 x 20 1/2 in. (36 x 52 cm)
Courtesy of the artist and Kodama Gallery, Osaka

Page 124 center
Tanabata
2004
Ink and felt-tip pen on paper
Triptych: 8 1/4 x 11 3/4 in. (21 x 30 cm) each
Courtesy of the artist and Kodama Gallery, Osaka

Page 124 bottom
**Island Pattern*
2004
Ink on paper
14 1/2 x 25 in. (37 x 63.5 cm)
Courtesy of the artist and Kodama Gallery, Osaka

Page 125 top left
Looking Through Bamboo Blind
2003
Ink and felt-tip pen on paper, with collage
10 x 13 3/4 in. (25.4 x 35 cm)
Courtesy of the artist and Kodama Gallery, Osaka

Page 125 top right
**Frame*
2004
Ink on paper
Diptych: 13 7/8 x 9 7/8 in. (35.1 x 25 cm) each
Courtesy of the artist

Page 125 bottom
Green Bamboo
2004
Felt-tip pen on paper
Triptych: 9 3/4 x 13 3/4 in. (24.7 x 35 cm) each
Courtesy of the artist and Kodama Gallery, Osaka

Hung Yi

Page 126
Everyone Can Be President
Performance photograph in *United Daily News*, March 25, 2004
Courtesy of the artist

Page 127 left
**The Incense Burner of Bei-Gang: Happy Buddha*
2001
Pen and ink drawing, papier-mâché sculpture, and metal temple lamps
43 1/4 x 55 1/8 x 25 in. (110 x 140 x 64 cm)
Courtesy of the artist

Page 127 right
Self-Portrait
2002
Digital image
Courtesy of the artist

Page 128
"Proletarian Sculpture," article on Hung Yi in *Minsheng Newspaper*, July 28, 2002
Courtesy of the artist

Page 129 left to right
1993, "New Art Paradise" Food and Drink Place
2001
Ballpoint pen on paper
11 5/8 x 8 1/4 in. (29.7 x 21 cm)
Courtesy of the artist

1998, "Bunny" Food and Drink Place
2001
Ballpoint pen on paper
11 5/8 x 8 1/4 in. (29.7 x 21 cm)
Courtesy of the artist

2000, The First Artist to Exhibit in Railway Warehouse 20, "Happy Buddha"
2001
Ballpoint pen on paper
11 5/8 x 8 1/4 in. (29.7 x 21 cm)
Courtesy of the artist

Shizuka Yokomizo

Page 130 left
**Untitled (Hitorigoto)*
2002
Digital C-type print
24 1/2 x 20 1/2 in. (62 x 52 cm)
Courtesy Cohan and Leslie, New York

Page 130 right
**Untitled (Hitorigoto)*
2002
Digital C-type print
24 1/2 x 20 1/2 in. (62 x 52 cm)
Courtesy Cohan and Leslie, New York

Page 131 left
Untitled (Hitorigoto)
2002
Digital C-type print
24 1/2 x 20 1/2 in. (62 x 52 cm)
Courtesy Cohan and Leslie, New York

Page 131 right
Untitled (Hitorigoto)
2002
Digital C-type print
24 1/2 x 20 1/2 in. (62 x 52 cm)
Courtesy Cohan and Leslie, New York

Pages 132–33
Stills from *When You Wake*
2002
Two-channel video; color, sound
8 min.
Courtesy Cohan and Leslie, New York

Leung Mee Ping

Page 134
In Search of Insomnious Sheep: Day Scene
2004
Digital photograph of rehearsal for *In Search of Insomnious Sheep*
Courtesy of the artist

Page 135
In Search of Insomnious Sheep: Night Scene
2004
Digital photograph of rehearsal for *In Search of Insomnious Sheep*
Courtesy of the artist

Page 136
Memorize the Future
1998–2002
Installation of 10,000 shoes made of human hair
Dimensions variable
Photo courtesy of the artist

Page 137
Old Ladies' House
2001
Site-specific installation for Old Ladies' House, Macao
Photographs and metal holder
Photo courtesy of the artist

Yangjiang Calligraphy Group
(Zheng Guogu, Sha Yeya, Chen Zaiyan, and Sun Qinglin)

Page 138 left
Calligraphy Project: In the Interior Woods
Digital rendering of proposal for *Fabricated Paradises*, Centre d'art contemporain, Le Parvis, France
2003
Courtesy of the artists and ShanghART Gallery, Shanghai

Page 138 right
Calligraphy Project: In the Interior Woods
2004
San Diego Museum of Art floor plan, gallery 15
Courtesy of the artists and ShanghART Gallery, Shanghai

Pages 139–40
Calligraphy Project: In the Interior Woods
Installation at *Fabricated Paradises*, Centre d'art contemporain, Le Parvis, France
2003–4
Courtesy of the artists and ShanghART Gallery, Shanghai

Page 141
Sea of Subversion
2002
Installation of ink on crumpled rice paper
Dimensions variable
Courtesy of the artists and ShanghART Gallery, Shanghai

WRITERS' BIOGRAPHIES

Betti-Sue Hertz is curator of contemporary art at San Diego Museum of Art. She holds a BA from Goddard College, Plainfield, Vermont (1975) and an MFA from Hunter College, New York (1982), and is a doctoral candidate in art history at the Graduate Center, City University of New York (2001). In 1991 she organized *Las Casitas: An Urban Cultural Alternative* for the Smithsonian Institution, Washington, D.C. She was director of Longwood Arts Project, Bronx, from 1992 to 1998, where she organized numerous gallery exhibitions, public art projects, and international programs such as *1990s Art from Cuba: A National Residency and Exhibition Program* (1997). Hertz curated *Beyond the Borders: Art By Recent Immigrants* (1994) and co-curated with Lydia Yee *Urban Mythologies: The Bronx Represented Since the 1960s* (1999), both for the Bronx Museum of Arts. At the San Diego Museum of Art, Hertz has curated *I-5 California: Four Decades of Contemporary Art* (2001), *Axis Mexico: Common Objects and Cosmopolitan Actions* (2002), *Regina Frank: Whiteness in Decay* (2003), *Of Earth and Sky: Elements in Abstraction* (2003), and *Shahzia Sikander: Flip Flop* (2004). Her writings have appeared in numerous exhibition catalogues, books, and periodicals.

Taehi Kang is a theorist, art historian, critic, and professor based in Seoul. She holds a BA from Sogang University, Seoul (1970), an MA in art history from Louisiana State University (1984), and a PhD in art history from Florida State University (1988). Her writings include essays for *Nam June Paik Retrospective: Videotime, Videospace* (1992) and *Lee Bul: Theatrum Orbis Terrarum* (2003). She contributes regularly to art periodicals and magazines such as the *Journal of the Korean Association of Art History Education* and *Vehicle: Contemporary Visual Art*. Kang has been a visiting professor of art history at Chiba University, Japan, and currently teaches art theory at the Korean National University of Arts, Seoul, where she is director of the Korean Art Research Center.

Li Xianting is an art critic, art historian, and freelance curator living in Beijing. After graduating in 1978 from the Beijing Academy of Fine Arts, Department of Traditional Painting, Li was editor of the magazine of the Chinese Artists Association (*Meishu*) until 1983. In 1985 he co-founded *Zhongguo Meishubao*, the first Chinese newspaper dedicated to contemporary art. He has written numerous critical and art historical books and articles, including *Dream 2001: Contemporary Chinese Art Exhibition* (2001), *Cross-Pressures: Contemporary Photography and Video Art from Beijing* (2001), *Towards a New Image: Twenty Years of Contemporary Chinese Painting* (2001), *Chinese Art at the Crossroads* (2001), *Constructed Reality: Conceptual Photography from Beijing* (2001), *Wang Qingsong: Golden Future* (2002), *Image Is Power: The Art of Wang Guagyim, Zhang Xiaogang, and Fang Lijun* (2002), *Yang Yong* (2002), *Alors, la Chine?* (2003), and *i/We: The Paintings of Zheng Fanzhi, 1991–2003* (2003). He co-curated the influential exhibition *China Avant-Garde* at the China Art Gallery in Beijing (1989), and curated *New Art in China* for the Hong Kong Arts Centre (1993), *Mao Goes Pop* for the Museum of Contemporary Art, Sidney (1993), and *Passage to the Orient* at the 45th Venice Biennale (1994). Li is a noted lecturer on Chinese art and is on the editorial advisory board for *Visual Arts + Culture* (London).

Midori Matsui is an art critic, literary theorist, and professor based in Yokohama. She holds a BA in English and American literature from the University of Tokyo (1988), and received her PhD in comparative literature from Princeton University (1996). She has contributed essays to numerous publications, including *Feminism and the Politics of Difference* (1993), *Takashi Murakami* (1994), *Painting at the Edge of the World* (2001), *I Don't Mind if You Forget Me: Nara Yoshitomo* (2001), *Consuming Bodies: Sex and Contemporary Japanese Art* (2002), and *Happiness: A Survival Guide for Art + Life* (2003). In 2002, she published *Art in a New World: Post-Modern Art in Perspective*. Matsui is a regular writer for *Parkett* and *Flash Art*.

Sachiko Namba is a writer, curator, researcher, and lecturer living in Wakkanai City on Hokkaido Island, Japan. She received her BA in anthropology from the University of London (1991) and an MA in visual arts administration from the Royal College of Art, London (2000). She contributed artist entries for the catalogue accompanying the Shanghai Biennial (2002) and is a regular writer for *Art Monthly* (London), *Art AsiaPacific* (New York), and numerous Japanese art newspapers and magazines. Namba was junior lecturer in the Department of Inter Media Art, Faculty of Fine Arts, Tokyo National University of Fine Arts and Music (2001–3). Her curatorial projects include *"know what I mean?": Young German Artists in Britain*, Goethe-Institut Gallery, London (1999), *democracy!*, Royal College of Art, London (2000), and *Interweaving Cultures*, Jim Thompson Thai House Museum, Bangkok (2005).

Lucia Sanroman is a researcher, writer, and curator, and is currently project assistant in contemporary art at the San Diego Museum of Art. She received her BA in art history from the University of Victoria, British Columbia (1997), and an MA in contemporary art history from the same university (2003). Sanroman wrote a weekly art column for *Monday Magazine* (Victoria) and as a freelance curator organized, among others, *Visible Knowledge: Women's Worlds in Art* for the Maltwood Art Museum and Gallery, Victoria (2000), and *Visual Transitions: Mexican Artists in British Columbia* for the Consulate General of Mexico, Vancouver (2000 and 2001).

Lydia Thompson is a researcher, lecturer, and writer based in San Diego. She received her BA in East Asian studies from Middlebury College, Vermont (1982), and an MA in art history (1989) and a PhD in early Chinese art and archeology (1998) from New York University Institute of Fine Arts. Thompson studied language and Chinese literature and art history at Tamkang University, Taipei (1982), and was a graduate student in the history department of Shandong University, Jinan, China (1994). She has contributed essays to specialized publications such as *Oriental Art* and *Asia Major* and was coauthor with Xu Huping of the catalogue accompanying the exhibition *Symbols of Power: Masterpieces from the Najing Museum*, Bowers Museum of Cultural Art, Santa Ana, California, for which she acted as consultant curator (2002). Thompson is a lecturer at the University of California, Los Angeles.

Zhang Zhaohui is an art critic, curator, and art historian living in Beijing. He received his BA in museum studies from Nankai University, Tianjing (1988), and holds an MA in curatorial studies from Bard College, Annandale-on-Hudson, New York (1998). He has written *Cultural Metamorphosis: The Art of Xu Bing and Cai Guo-Qiang* (2004) and contributed essays for *Red Hot: A Special Exhibition of Contemporary Chinese Art* (2001), and *Site + Sight: Translating Cultures* (2002). Zhang had a regular column in the Web-zine *china-gallery.com* and writes for *Yishu: Journal of Contemporary Chinese Art and Asian Art News*. He curated the exhibition *New Urbanism: Chinese Contemporary Art* held at the Guangdong Museum of Art in 2002 and Melbourne in 2004, and co-wrote and edited the accompanying catalogue. Zhang is currently a PhD candidate in art history at the Central Academy of Art in Beijing.